P9-DTA-592

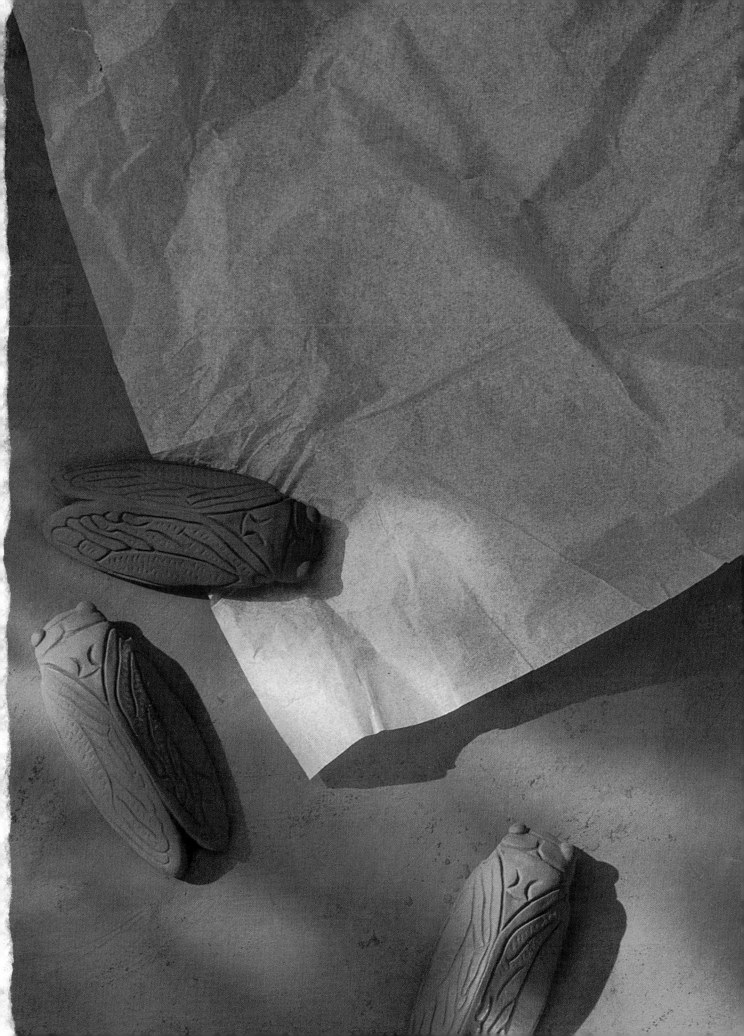

# colors of
# Provence

## Michel Biehn

Original photographs

by Heinz Angermayr

Translated by

Rosanna M. Giammanco Frongia

Stewart, Tabori & Chang

New York

To Alexandrine Galli

"...A worthy Marseillaise, caught
on a business trip, Mlse Bourado
proceeds, sitting straight on her donkey,
a bag crammed with provisions,
set snugly on her knees..."

Copyright © 1996 by Flammarion, Paris

Translated by Rosanna M. Giammanco Frongia, Ph.D.
Editors/U.S. edition: Alexandra Childs and Kim Yorio Rubin

Originally published by Flammarion, 26 rue Racine, Paris 75278 Cedex 06, France.

Editorial direction: Ghislaine Bavoillot
Art direction: Marc Walter—Bela Vista
Production: PAO Octavo Editions
Photo separations: Colourscan France

All Rights Reserved. No part of this publication may be reproduced, stored in a retrieval system,
or transmitted in any form or by any means, electronic, mechanical, photocopying, recording or
otherwise without written permission from the publisher.

Published in 1997 and distributed in the U.S. by Stewart, Tabori & Chang, a division of U.S.
Media Holdings, Inc., 115 West 18th Street, New York, NY 10011

Distributed in Canada by General Publishing Company Ltd., 30 Lesmill Road, Don Mills,
Ontario, M3B 2T6, Canada. Distributed in Australia by Peribo Pty Ltd., 58 Beaumont Road,
Mount Kuring-gai, NSW 2080 Australia. Distributed in all other territories by Grantham
Book Services Ltd., Isaac Newton Way, Alma Park Industrial Estate, Grantham, Lincolnshire,
NG31 9SD, England.

Library of Congress Cataloging-in-Publication Data

Biehn, Michel.
      [Couleurs de Provence. English]
      Colors of Provence / Michel Biehn ; photographs by Heinz Angermayr.
            p. cm.
      Includes bibliographical references.
      ISBN 1-55670-619-7
      1. Provence (France)—Pictorial works. 2. Colors—France—Provence—Guidebooks. 3.
Provence (France)—Guidebooks. 4. Photography, Artistic. I. Angermayr, Heinz. II. Title.
DC611.P958B5   1997                                          97-11487
944.9—dc21

Printed in Italy
10 9 8 7 6 5 4 3 2 1

# Contents

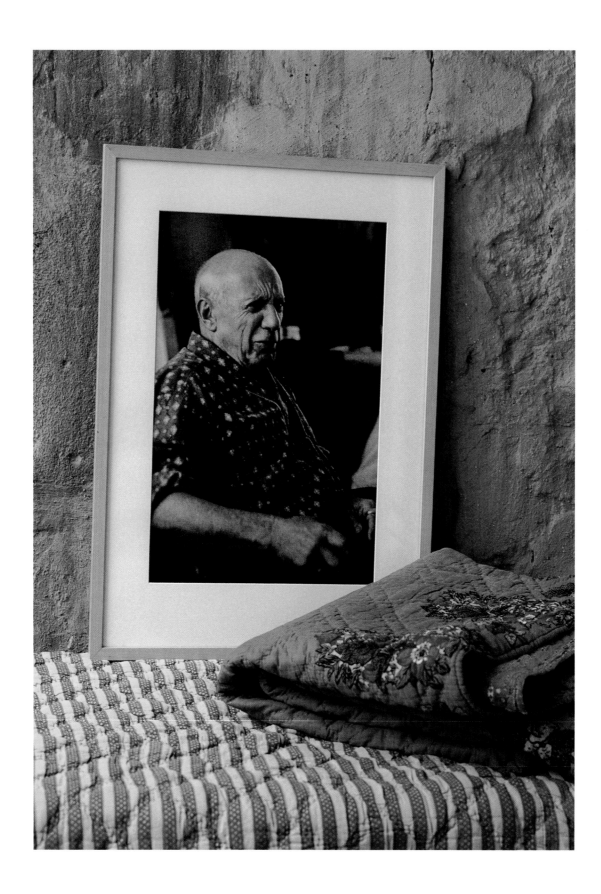

# Provence,
# Land of Colors

*At the center of the Charles Demery Museum in Tarascon, among old records and boutis, a photo of Pablo Picasso dressed in one of the first block-printed Souleiado shirts (opposite page).*

From the Provence of Mistral and Léo Lelée with its tambourins and cicadas, its red and yellow striped standards, its dark *panetières* and its *buffets à glissants* in polished walnut, to that of Picasso with its red and black corridas and the first, sublime Souleiado shirts block-printed by Charles Demery in his small, private workshop in Tarascon; from the Provence of Van Gogh with its sunflowers, its wheat fields, its red vineyards and its blooming gardens, to that of Christian Lacroix in fuchsia pink, absinthe green, and saffron yellow, its Camargue cross, its *boutis*-embroidered hearts and its lovely girls from Arles dancing to the music of gypsy guitars; from the lavender fields of the Valensole tableland to the ocher cliffs of Roussillon, from the counterforts of Sainte-Victoire to the Bibemus stone walls of the *bastides* around Aix, from the vegetable stalls of the markets of Provence to the flowery *indienne* cottons dyed with madder, indigo, and woadwaxen, everything here is color, color vibrating in the bold light of the sun of Provence. Today, the colors of Provence, its flavors and scents, have conquered the world. Provence is in. From Tokyo to Toronto, from Stockholm to San Francisco, yellow ocher and red ocher color the walls of restaurants that send forth delicious effluvia of basil, thyme, and rosemary, and the shop windows of Provence display the gaiety of printed cotton fabrics and the bounty of pottery brimming with oil, lavender, and Marseilles soap.

Do you remember how in the 1970s the antique dealers in the Alpilles region used to furnish the beautiful local homes with tables from Spanish convents and rare period pieces? Inside, walls were uniformly white, with walnut-stained beams and "exposed" stone. The roughcast of ancient exteriors was removed and a "neo-Provençal" look was forced on everything. Burlap—brown or beige, sometimes orange or grayish blue—decorated the windows. And from the workshops of goatherd craftsmen from Larzac or Luberon issued strange table lamps of woven wool yarn in natural sheep's colors, which were placed on the required *pétrin*—an antique bread-kneading table—side by side with giant vases of moonwort.

Later, second-hand furnishings became fashionable, and soon all painted furniture was

*Souleiado fabric patterns are taken from the exceptional collection of engraved wood blocks preserved in the factory's lofts in Tarascon.*

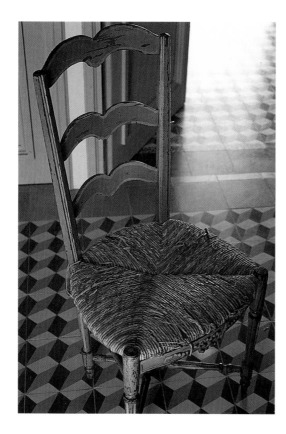

*Provençal seats were often covered with twisted straw like this 18th-century chair* (left).
*The striped cloth and flower-printed fabrics of these seashore traditional costumes from the first half of the 19th century are an inspired mix of hemp, linen, silk, and cotton fibers* (opposite page).

stripped to show blond pine, "the color of honey and ripe wheat"; at the same time the cheerful, sugary polychromy of Massier ceramics and Vallauris *barbotines*, ceramics with finely applied paste-on-paste decorations, were discovered.

It was then that two American authors, Pierre Moulin and Pierre Le Vec, introduced us to a new Provence in their bestseller, *L'Art de vivre en Provence*, as seen from America. The stone exterior walls were again roughcast, this time in the colors of Italy; the olive tree and the lavender flower lent their hues to painted chairs and shutters; wrought iron, uniformly painted in a dark green, furnished the gardens; Provençal fabrics took over the whole house; and rush-bottomed banquettes called *radassiers* and jars from Anduze became symbols of the art of living.

At the same time, the fashion of American quilts reminded us of their distant ancestors, the

*Detail of polychrome door from an 18th-century Uzès armoire* (right).

wonderful, decoratively stiched quilts from Marseilles called *piqués* and the quilted, embroidered needlework called *boutis*, while the cashmere shawl fashion placed Provençal prints in a different light. Later, the lively printed cottons called *indiennes*, because they copied Indian fabrics, replaced cashmere swirls and pretty, eighteenth century Provence took center stage. This was the Provence of Raspal's *L'Atelier des couturières*, of flowered, stitched bed quilts, of furniture painted gray and of white-and-indigo-striped sheets, all soon complemented by the unadorned accents of a close Swedish cousin, Gustavus III.

Today, Provence seems to rediscover some of its customary simplicity, and in the pages of the magazine *Côtes Sud*, tawny fabrics made of linen and coarse, rough hemp and furniture painted in soft patinas stand out against walls washed with yellow or red ocher tints and concrete tile floors decorated with polychrome designs. But what about the lovely armoires, the credenzas, and the

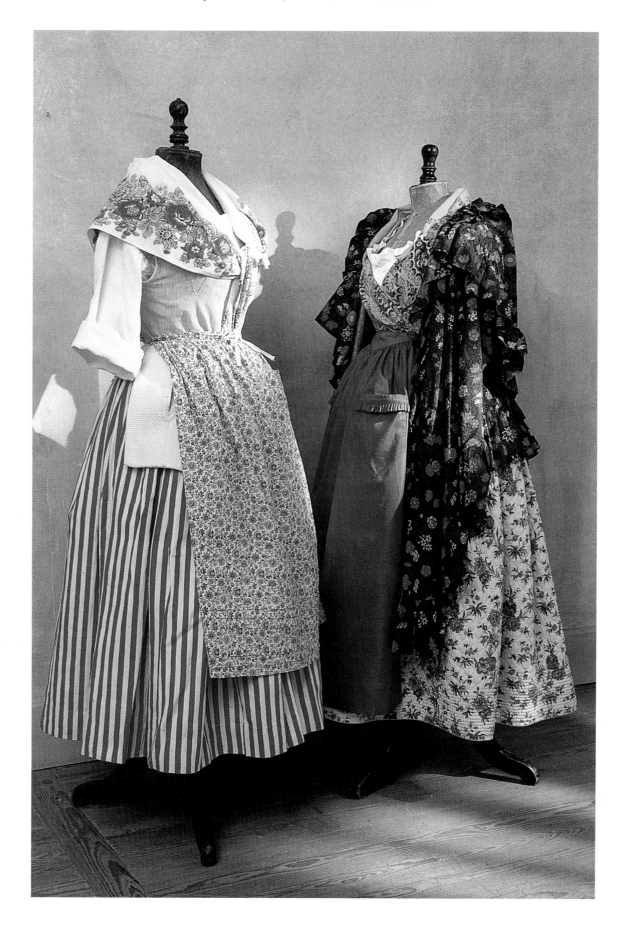

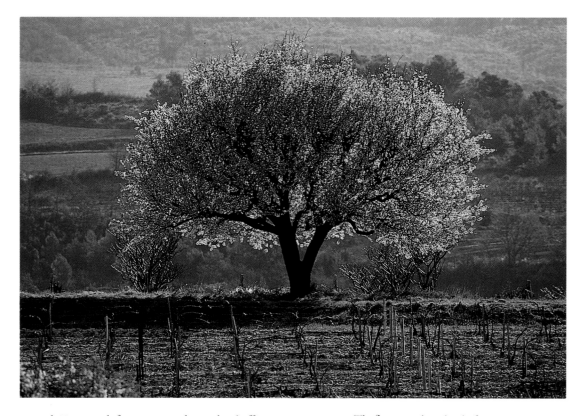

typical Provençal furniture such as the *buffets à glissants*, two-tier buffets with sliding panels; the *estagniés*, étagères for displaying pewterware; and the hanging cupboards for bread called *panetières*? This lovely, fawn-colored walnut furniture, veined brown and black and polished and shined by two centuries of applying furniture paste, is no longer fashionable. It is rejected in favor of industrial-style or office furniture and a lot of modest pine furniture finished with a coat of paint or with recent, artfully applied "patinas."

All of this is meant to state the obvious: Provence, its land, its flowers, its fruits, its painters, its antique dealers, its artisans, its popular art and its fabrics, its materials, and its colors have been influencing taste and fashion for a long time, and taste, here as elsewhere, changes. And Provence is made of all those Provences, as if fashion limited itself to highlighting in succession, one day here, tomorrow there, sometimes gently, sometimes ironically or with caricature, the beauty and bounty

*The flowering almond is the first tree to herald spring's triumph over winter.*

of this magnificent land. But Provence has been beautiful for thousands of years, and our golden stones, our almond orchards will see many more millennia....

Today, color is triumphant everywhere, in images, photographs, advertising, clothing, the home. The extraordinary advances and recent mastery in the chemistry of colors have made this possible. We should remember that for centuries textile dyers could print a cotton fabric green only by superimposing yellow on blue. But while indigo blue was "a good, strong dye," meaning it was colorfast and resitant to water and light, the yellow obtained from fustic, sumac, or woadwaxen— *genestrelle* in Provençal—was a "small dye," meaning it faded at the first washing. This is why the color green has mostly disappeared from ancient printed fabrics. Not until 1808 was it

possible to obtain a colorfast green in one application.

In the paintings of Pieter Brueghel the Elder, the peasants of the sixteenth century are for the most part depicted wearing garments made of brown or beige cloth, that is, of natural fiber colors, without dyes. At the time, in fact, color was a luxury confined to the élite. We are far from the fluorescent, hallucinatory polychromy of the synthetic fibers displayed on clothes racks in our department stores. And in a kind of poetic justice, today's fashionable people wear black in the city and white and beige linen while on vacation.

Around 1900, Méliès produced the first color film by painting the film by hand on a stencil, image by image, like the medieval Benedictine monks who illuminated manuscripts or like an eighteenth-century *pinceauteuse* who, with a slender paintbrush made of her own hair, would color tiny flowers on a *toile de Jouy*. Technicolor made its appearance only

in 1928 in the United States, and the first color television appeared in 1953.

The 1950s, on the other hand, saw an explosion of color in the home and in fashion, undoubtedly a reaction to the gray of the long war years. The Third Reich had imposed a restricted world of violent, perverted colors. The black and gray of uniforms, of smoke and ashes served as a backdrop to the red of the Nazi flags, of fire and blood, while the yellow star stood out as a symbol of infamy. Immediately upon liberation, Europe joyfully rediscovered its colors. Blue rejoined red and white in the display of the Allied flags. The charred battlefields grew green again. And in the energy of the economic boom, industry manufactured cars, textiles, and consumer goods that could no longer be without color. But the happiness of the postwar period and technological progress alone cannot fully explain this explosion of colors. To that, we should add the psychedelic hippie happening of the 1960s, a reaction to another war—the Vietnam

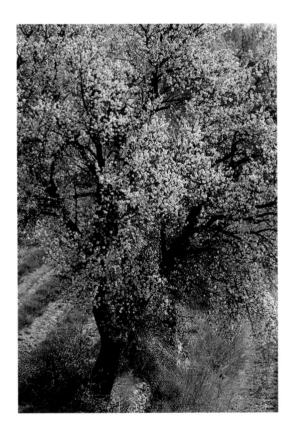

*The mauve of the wisteria flowers and the gray of stone and paint are often contiguous on farmhouse walls* (top). *Almond trees blanketed by a delicate snow of white or pink flowers* (left).

*Wild oats and blooming lavender revel in summer's triumph on the Lure Mountain.*

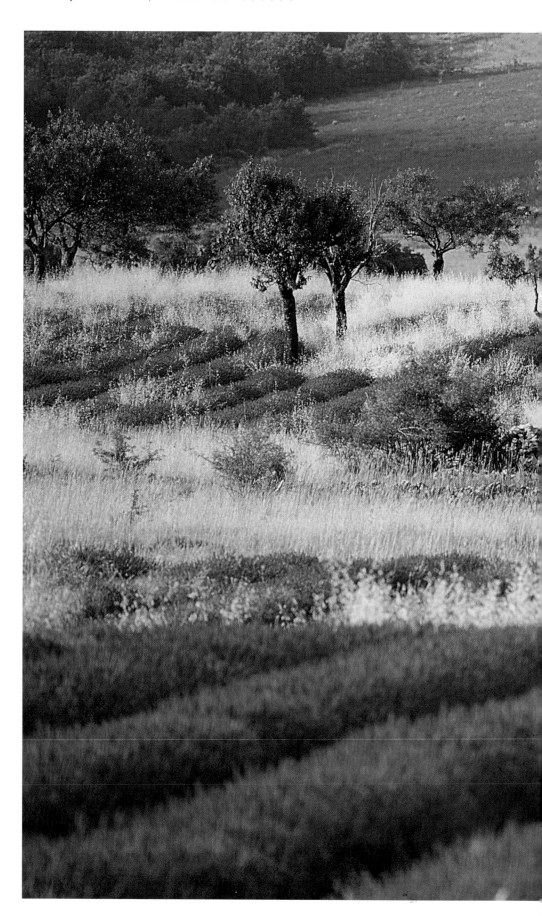

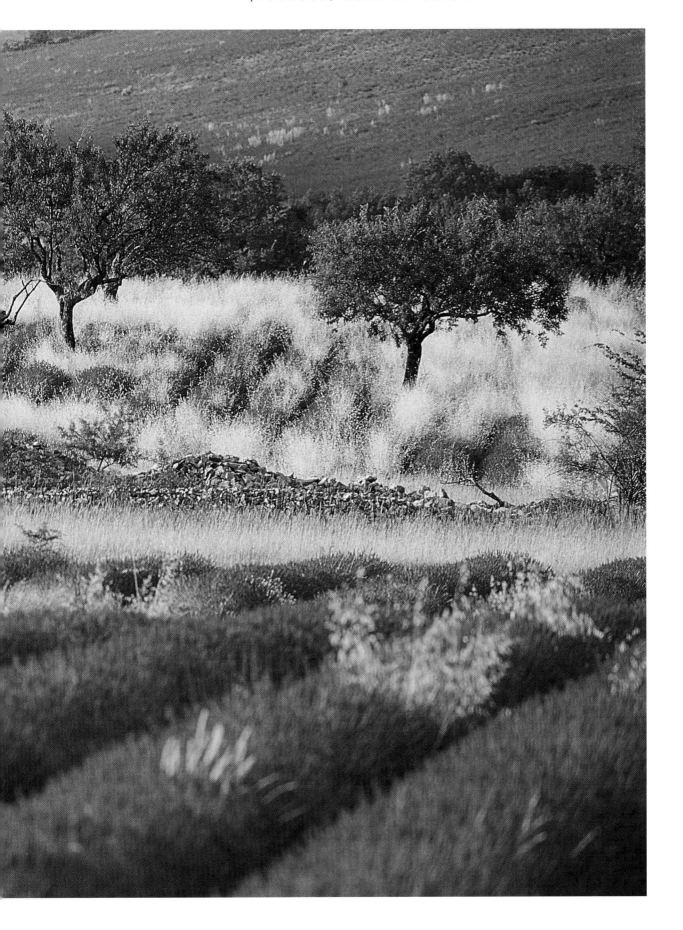

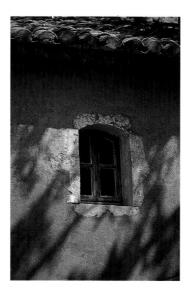

*A Roussillon window* (left).
*These old containers stained by sulfates
were used to treat vineyards and cherry
trees* (bottom left).
*Sunflowers and small black Caromb figs*
(bottom right).

war—along with the process of world internationalization, the mixing of cultures, and mass tourism.

In those years, the turquoise of lagoons, the blue of desert men, the Indian pink of saris and the saffron yellow of Buddhist monks' robes enriched the color palette even more. Thus, for its summer 1993 collection and to celebrate its sixtieth anniversary, the famous Lacoste shirt put aside its original whiteness and borrowed sixty different colors.

While for centuries color was considered either a substance or a fraction of light, only recently is it being treated as a sensation. Color is nothing without the sensitivity of the beholder. In fact, it seems that in the process of being perceived, color radiates a force whether we are aware of it or not, and twentieth-century advertisers have learned to master the colors' effects with the virtuosity of medieval craftsmen who used color in the stained-glass windows of cathedrals to create an atmosphere that would uplift the faithful. Today, we are rediscovering the importance of color in salesmanship, in desire-creating advertising, or for relaxation and stimulation. Color can uplift our spirit or make us melancholy. It can make us aggressive or just as easily transport us into a mood of serenity, give us sensations of coolness or heat, space, or enclosure. Color manipulates our everyday behavior.

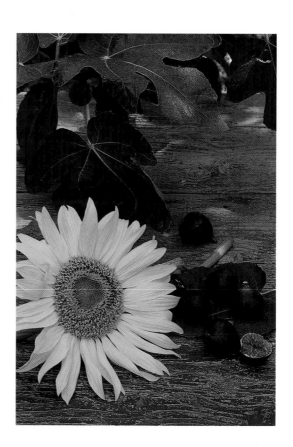

All of this, however, should be placed in its proper perspective, since we do not perceive all colors equally. Moreover, although we can count seven colors in the rainbow, the eye can in fact distinguish over seven hundred different hues. Also, a color is forever wedded to the material it

intensity in this land. "The Empire of the Sun," Frédéric Mistral called it. And in fact, the light's intensity creates a strange magic that painters, ceramists, decorators, and poets have forever been trying to unlock .

I will tell you about my Provence, the Provence

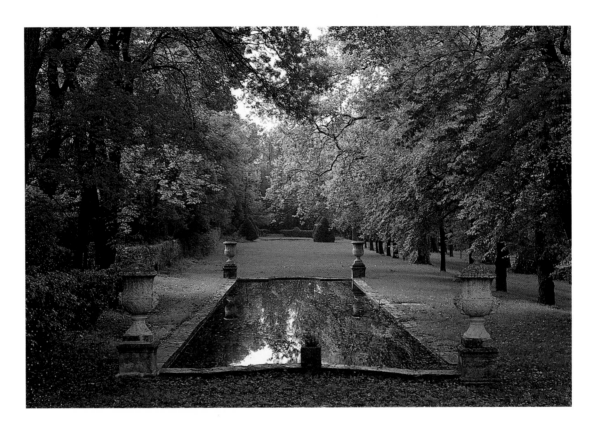

*The beautiful Albertas Gardens, south of Aix-en-Provence, were designed to frame a magnificent castle that was never built.*

colors; therefore, the same intense blue will be perceived very differently when it colors the sea or when it paints a boat. Finally, a color exists only in relation to the colors surrounding it and the quality of the light that discloses it.

And it is precisely the light, the astonishing quality of the light radiating from the sun of Provence, that explains why colors have a unique

of my childhood in the 1950s, when the Provençal dialect was still spoken in many villages and on a dusty road in July it was still possible to come across a blue horse-drawn cart loaded with a large pile of wheat sheaves.

I am going to describe the objects that had accumulated from generation to generation in the large family house where I used to spend my summer vacation, plain, magnificent everyday objects: the earthenware glazed with delicate iridescent effects, the flowered bedspreads patiently quilted by grandmothers, the wicker baskets, the yellow waste-silk drapes hanging from the

The dining room walls of Chateau de l'Ange in Lumières were finished with a red ocher wash (opposite page).

windows, even the gold and coral jewelry no one wore anymore, which was often taken out of the large chest drawer just for the pleasure of admiring it. Of course, the colors of Provence are nature's colors, the colors humans have appropriated for their use, for painting, dyeing, and glazing. Through Marseilles, a door opened onto other worlds, the people of Provence discovered and assimilated before others all the colors of China, India, Persia, Africa, even the New World. I will tell you the story of these travels, of exotic products such as the orange and the indigo tree, of tomatoes and madder root. I will bring back to life the craft of the coral worker, the salt worker, the ocher worker and the *bugadière*, the washerwoman. I will describe in detail the ancestral technique of making woad for blue dyeing, or the delicate *boutis* embroidery that embellishes wedding day petticoats. I will excite your taste buds with soup made with *petit épeautre* (the small, hard Provençal mountain wheat) and with a dish of rice and the small Mediterranean rock crabs the Provençal people call *favouilles*. I will move you as I retell Saint Barbara's martyrdom and the loves of Lady Sermonde and Guillaume de Cabestan.

But in addition to the tales, I would like this book to help you better understand and love the beautiful, peaceful harmony that has forever inhabited the land of Provence.

*Ocher ores, natural pigments from the quarries of Roussillon, Gargas and Rustrel, bestow their color on all of Apt country.*

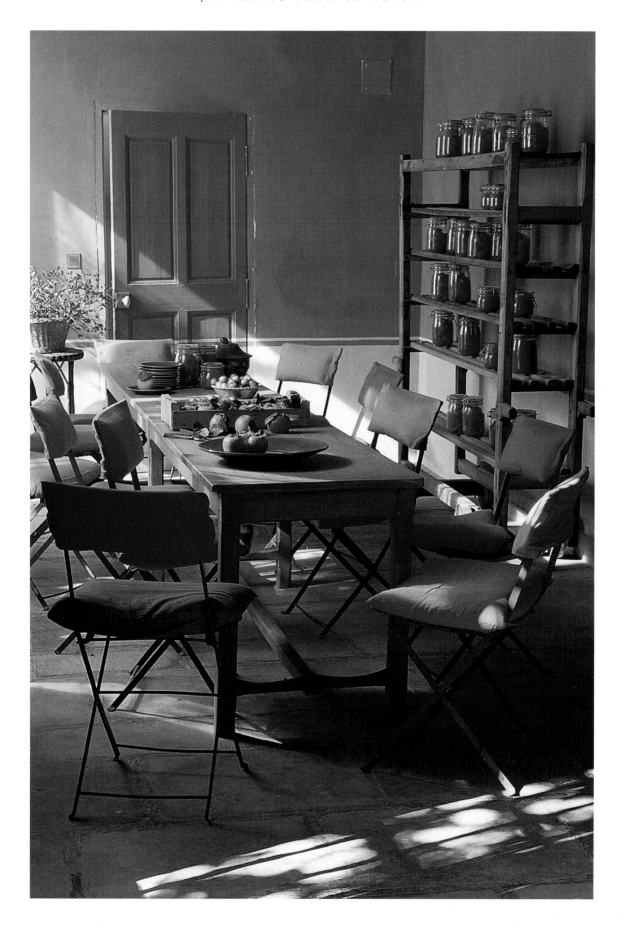

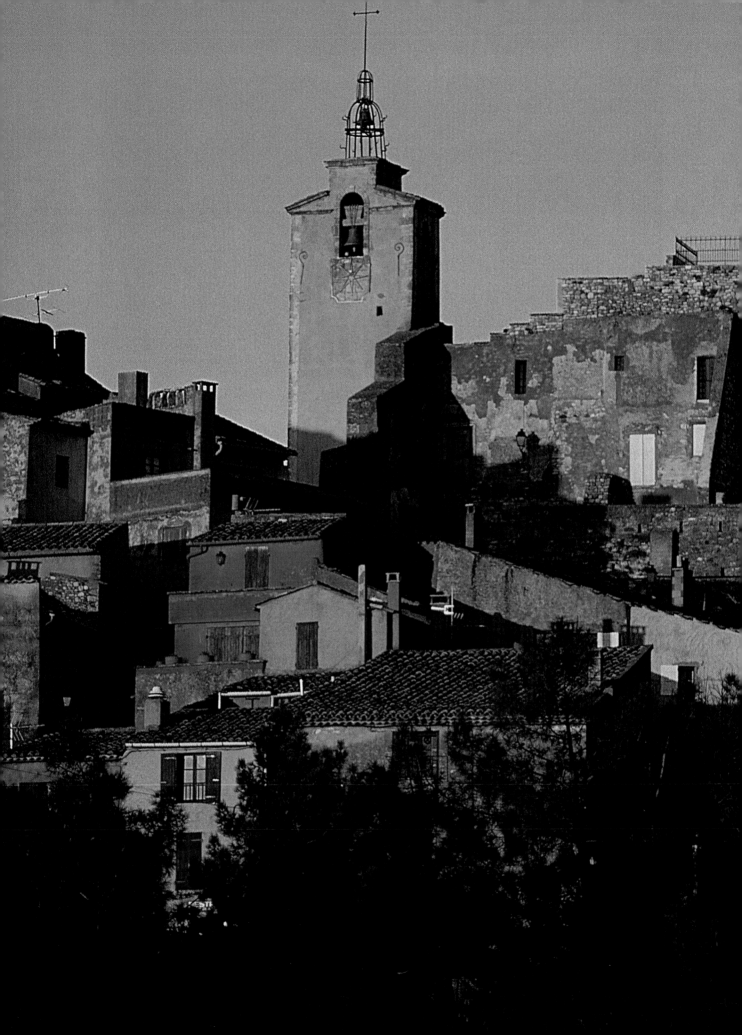

# Red

The road followed rather closely the dry bed of the Durance River, snaking its way along a range of hills.
It entered the valleys and came out again, crossed olive orchards and willow groves, stretched along
the lanes of Italian poplar trees, crossed over streams. All was still, as if in boiling plaster.
The horse's trot slowly made the rows of taut trees with cardboard foliage turn slowly, on each side of the
road, like the stiff spokes of a wheel. Sometimes, small pale farmhouses, their eyes closed, the nose in the
dust, dribbling a bit of straw, appeared between two mulberry trees. In the general stillness, Angelo
perceived on the hill slope a red moving stain. It was a peasant woman dressed in a petticoat
who was coming down the hill, running...
—Jean Giono, Le Hussard sur le toit

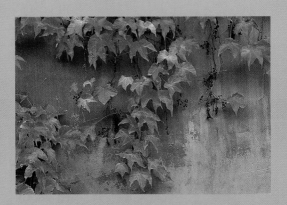

*The town of Roussillon at sunset (page 18). In October, barren vineyards take on the lovely colors of fall (right).*

turned into roof tiles or into square terra-cotta floor tiles, the ocher that colors the cliffs of Roussillon and the bauxite that turns Sainte-Victoire's counterforts crimson.

The people of Provence who gave the tomato the pretty name *poumo d'amour,* 'love apple,' were not mistaken about the extremely strong symbolism of red. The color of fire and running blood, the color of sensual, passionate love, red is warm, fluid, violent, intrinsic to life. It is the first color that speaks to small children: the cherry on the cake, the irresistible strawberry. It is red thread that young girls used to sew their cross-stitched initials on the white linens of their trousseau.

Red explodes, is male, invigorates, incites to action. It is the red of Spain's red pimento that adds fire to *rouille,* an *aïoli* sauce made with red pimento and an ingredient of the fisherman's *bouillabaisse.* It is the red of the flags that carries you away, and the Provençal flag has red and yellow stripes. It is the red cap, the Phrygian cap of the Marseilles revolutionaries, that became the universal symbol of the French Revolution. At the end of the eighteenth century, the sailors and fishermen from Marseilles wore the *barreto,* a large red wool-knit cap, whose color would range from vermilion to dark brown and was often trimmed in black. This cap was brought to Paris by Marseilles' *sans-culottes* and was quickly adopted by the revolutionaries.

In fact, how was the red in the thread, in the flag, and in the quilted petticoat made? What were the secrets of the master dyers from Marseilles, Avignon, and Nîmes? This is the fine history of the cochineal and the oak tree's kermes, of Turkish red and madder root.

The red that comes from the bowels of the earth is of a totally different kind: this is the clay that is

I spent a good part of my childhood in Aix-en-Provence. Displayed on the glass-case shelves of the Museum of Natural History and surrounded by stuffed animals, were pinned butterflies; blocks of green fluorine, rose quartz, and marcasite; kidney-shaped stones; a small, somewhat sad monkey in its cage; and an unbelievable philodendron that had spent itself by stretching its giant creeper several times around the entire room, and whose few leaves could not in any case hide the lovely plaster-of-Paris reliefs on the ceiling, all bathed in a smell of bird droppings and Marseilles soap—I had discovered strange, oblong objects of a reddish brown color, covered with an evenly grained,

delicately cracked shell: they were fossilized dinosaur eggs. The small, handwritten label said they had been found at Tholonet, a few miles' distance from Aix-en-Provence. Thus it was that my friend Nicolas and I decided to discover this cache of dinosaur eggs. And so we spent countless Thursday afternoons surveying the red ravines colored by bauxite and crowned by pine trees, between Beaurecueil and Châteauneuf-le-Rouge, to look for what, in our children's imagination, must have resembled a gigantic bird nest or an

reddish brown to yellow. It is the village of Roussillon and its surrounding ocher quarries. In this village the stones, the plaster on the front of houses, even the paint on the doors and shutters are all the same color, in an infinity of shades. Finally, between Aix-en-Provence and Marseilles is the Aubagne plain where for centuries clay has been extracted for use in making roof tiles, floor tiles, crockery and *santons*, which are colored clay figurines that people Nativity scenes.

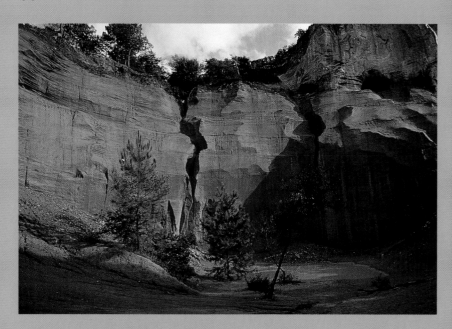

*On the cliffs of Rustrel, the green of the pines makes the red ocher sing (right). Oxblood red, this 18th-century wall case from an old Avignon drug store now decorates the kitchen walls of a* mas, *a traditional farmhouse in the Alpilles (opposite page, bottom).*

elephant cemetery. Finally, one day when we had been caught by the rain, we were shocked and delighted to see one of these eggs become quickly dislodged by the reddish water gullying down the hillside, helped by the rain from the sky, a perfect, almost intact egg, an extraordinary specimen, even more beautiful, or so it seemed to us, than the one on display at the museum. I learned later the great importance of this deposit, unique in the world, which today is a protected area, passionately studied by paleontologists the world over.

At a distance of a dozen or so miles, beyond the Luberon mountain range, are other lands with hues ranging from dark red to orange, from

*Red ocher is made of an infinity of hues ranging from pale orange to the darkest wine-dregs red (left).*

# The Love Apple

The Spanish and Portuguese conquistadors came back from the New World with their holds laden with gold and precious stones and innumerable spices, and fruits and plants unknown in Europe up to that time. Among all the wooden crates planted with fragile cuttings that survived the rigors and dangers of the trip were a few sacks of tomato seeds. The tomato has perfectly acclimatized all around the Mediterranean; however, it made its appearance in Provence only in the eighteenth century, and for a long time afterwards it was used merely as an ornamental plant.

The tomato becomes part of Provençal cooking only in the nineteenth century. Yet today Provence is one of the largest tomato-growing regions. This summer fruit will also grow throughout the year in greenhouses. Of course, field-grown tomatoes are much richer in flavor, and their growing season stretches from May to September. Most of the tomatoes sold today are of a strange, uniform red and have a perfect shape, as if produced in a mold. This probably reassures less knowledgeable consumers. Fortunately, in the summer our peasant markets display all kinds of tomato varieties of all sizes and colors, each variety possessing qualities that are better than others for a particular purpose.

For their salads, the people of Provence prefer tomatoes that are not too ripe, very firm, just starting to turn red, when they are still pale pink with traces of green. For dressing, they add just a trickle of olive oil, a few basil leaves, and a few grains of salt. No vinegar or mustard, as the natural acidity of the tomato and its delicate perfume suffice by themselves. The same dressing also goes perfectly over a salad of "Russian" tomatoes, consumed when they are ripe yet still firm. These are large, irregularly shaped tomatoes, with marked sections like a pumpkin, sometimes with yellow speckles. The consumer who does not know them well could be deceived by their appearance; in truth, they are exquisite and their sugary, juicy flesh is strongly scented, making this a truly exceptional fruit.

*Olivettes* are small, long, firm tomatoes: they are perfect for sauces and *coulis*, a simple puréed tomato sauce, while round tomatoes, emptied of their juice and seeds, are easily stuffed with leftovers of chopped stew meat and rice and slowly baked in a slow oven.

However, since the tomato is a fruit, I will now explain how to prepare a delicious preserve with ripe tomatoes. You will need tomatoes from the height of summer, very red and engorged with sunlight. Choose somewhat large, firm tomatoes, because the skin has to be removed. To do that, immerse them for one or two minutes at the most in a deep, wide pan of boiling water. Remove them from the pan using a skimmer. When they are no longer hot, you will find that the skin can be easily removed. In addition to being indigestible, the

*Large "Russian" tomatoes, full of flavor, juice, and fragrance (right). Young garlic and basil are the inseparable companions of the 'love apple' (opposite page).*

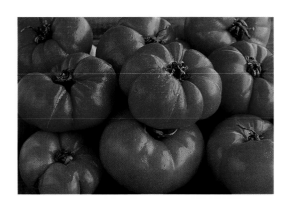

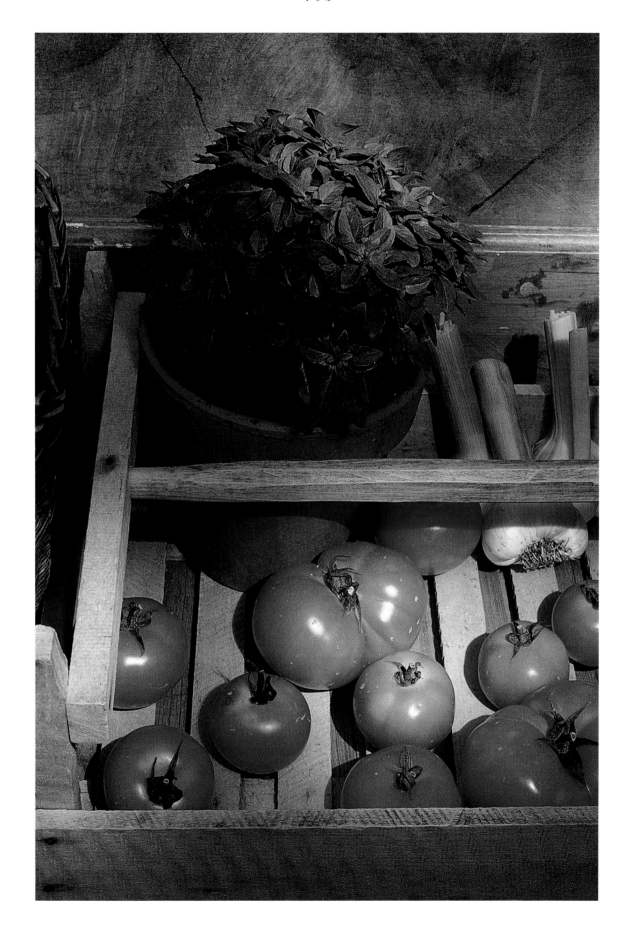

skin of the tomato has the unfortunate property of hardening as it boils in sugar, therefore once preserved, it is disagreeable to the tongue.

After peeling, remove the tough part near the stem, then cut the tomatoes into bite-size pieces and weigh them. Add 1 ½ pounds of sugar for each 2 pounds of tomatoes. Split 3 vanilla beans. Scrape the inside of the beans with a small knife, then put everything in the pan together with the tomatoes and the sugar. Cover with a large, clean cloth and let sit overnight. The following day, bring to a boil over a low flame, stirring occasionally.

Let cook about ten minutes, then turn off the heat and let the pan cool. At this point, add a glass of good, aged Martinique rum and resume cooking as before. The preserve is ready when a drop of juice dropped on a plate sticks to it. You may transfer the marmalade immediately to the jars without waiting for it to cool.

This preserve is very good spread on a buttered slice of country bread for breakfast, or as a snack; it can also be served as a dessert with a small basket of sheep's milk cheese or a small piece of *chèvre*.

*The Vieux Nîmes Museum*
*preserves many textile-related records,*
*like these samples of 18th-century*
*madder-dyed woollens (opposite page).*

# Kermes, Cochineal, and Madder Root

For centuries, the eggs of a tiny parasitic insect, the kermes, and the ground roots of madder, a marshy plant, were the only materials that could dye fabrics red, vermilion, or scarlet, crimson, or Turkish red.

Vermilion and scarlet red were obtained by harvesting the minuscule eggs of an insect, the kermes, from oak trees. The female insect, clinging to the tree's branches, at the time of laying its eggs would cover itself with a sort of carapace to protect the eggs filled with red color. Harvesting kermes was similar to gleaning, a right of the poor, hallowed by custom. It took place around May, and the harvesters were women and children who had taken care to let their nails grow, the better to detach the small capsules from the tree's bark. This done, the "seeds" were strewn on large canvas sheets and doused with vinegar to kill the insects. Finally, they were left to dry under the sun and then sifted through a sieve. The resulting red powder was sold in Arles, in the port of Crau.

One day however, the Brazilian cochineal arrived from America. This insect, a relative of the kermes but a parasite of the cactus tree instead of the oak tree, was much richer in coloring substance. Its success considerably reduced the importance of kermes-harvesting in Provence, without the latter disappearing, however.

The introduction of madder farming in Provence could be the subject of a thrilling adventure tale, that of the eventful life of Johannis Althonia, Jean Althen. This Armenian was captured at a young age by a band of Arabs who sold him into slavery. He was taken to Anatolia where he worked in madder plantations for fourteen years.

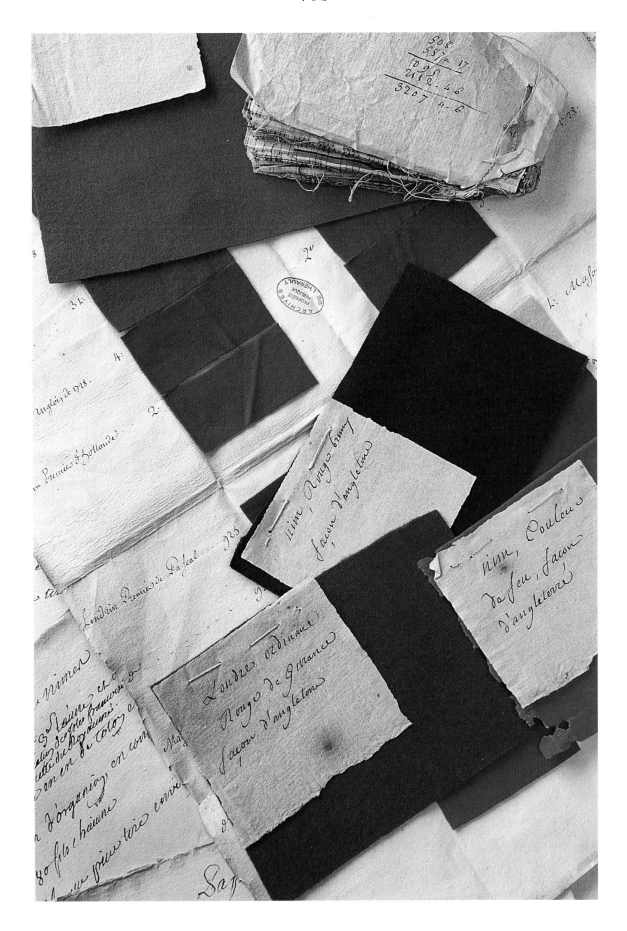

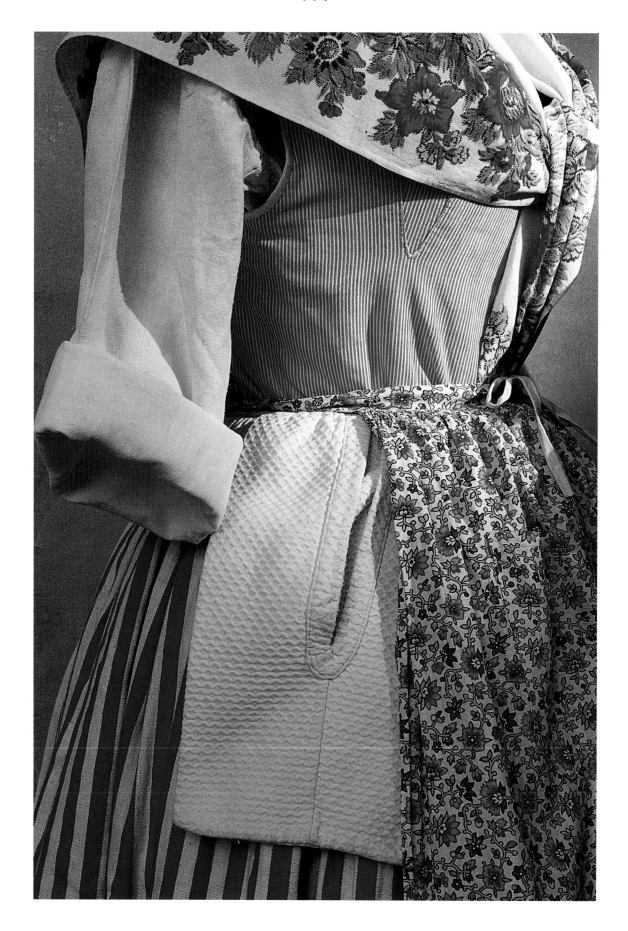

He was finally able to escape and after many adventures reached the port of Marseilles in 1754. He then set out to turn into advantage the skills he had acquired in captivity and introduced *garance*, the madder plant, in the South of France. Thus were born the *garancières*, madder-dyeing establishments that were instrumental in turning to profitable use vast expanses of barren lands that were too heavy or wet and where only reeds grew. After setting up one such large establishment in Caumont, Jean Althen died there in 1774, poor and forgotten. It was only much later, when the cultivation of madder proved quite successful in Provence, with up to fifty mills grinding madder root night and day, eight months out of the year, in the district of Vaucluse alone, that Jean Althen was granted public recognition. Today, a Vaucluse village, Althen-des-Paluds, bears his name.

The madder plant was sown in March. Harvesting took place in the fall of the following year. The madder roots were exposed to the sun to dry, and then they were taken to the mill. The resulting powder was put into sacks and sold.

Before starting the *garançage*, that is, the dyeing or printing on cloth of all the tones from brown to red, the cloth had to be prepared. First it was bleached to remove oil and dressing that had been applied during the spinning and weaving processes. Then the cloth was soaked in a cow-dung solution to fix the mordant substances to the cotton. The mordants were various metal salts that were devoid of coloring properties but whose reaction with the coloring agents resulted in

*Work costume from the first half of the 19th century, where everything is dyed with madder: the stripes on the "Siamese" skirt and the dimity corset and the printed flowers on apron and shawl (opposite page). Stitched quilt printed on a Turkish red background, circa 1850 (top).*

permanently fixing the color to the fabric. The mordant associated with red and pink tints was aluminum acetate, which the worker impressed on the cloth with the help of a flat wooden block, later a rotating copper drum. Afterwards, the cloth was immersed in a madder-root bath that acted as a photographic developer, producing the desired color. After this bath, the whole fabric was red and had to be bleached once again: it was spread out on a grassy meadow for four days, then soaked once more in a cow-dung bath, then left four more days outdoors on the grass. Finally, it was washed. Now only the brown, red, and pink designs were visible on a white background. The above description gives some idea of the folly of printing on fabric in the past; it took place, it is true, at a time when the time and labor spent in this process had a totally different meaning.

Madder root also made it possible to dye cotton fabrics a solid red, the most beautiful of these reds being Adrianople red, called Turkish red today, which the people of Provence used in great quantities.

# The *Marquette*

There was a time when in all the homes all the women used to spin wool, hemp, or ramie. With the resulting thread, on primitive hand looms they would weave cloth, which they would then cut and sew with petit-point stitches into day and night shirts, petticoats, sheets, towels, and dishcloths. And there was a time when all the girls would mark these linens with their initials, cross-stitched in red thread.

The girls were introduced to sewing from a very early age. They learned how to sew from their mothers, and this skill was passed on from one generation to the next without any great changes. Later, in school, the teacher would continue this instruction. First the girls learned the front stitch, the simplest of the sewing stitches, and once they knew how to pull a thread, they were entrusted with the tasks of patching and making hems. At the age of eight years, they would start learning how to cross-stitch so that one day they could mark their initials on their trousseau linens. Often, as proof of their newly learned skills, just before marking their trousseau, the girls would complete a sampler of their apprenticeship: the *marquette*.

The *marquette* was a square piece of canvas on which little girls embroidered samples of their skills. Sometimes they would include some mending, buttonholes, or openwork embroidery,

*All the trousseau pieces were marked with the initials of the young woman who embroidered them in red cross-stitch embroidery (opposite page).*

scalloping and whipstitches. Or they would use colored thread to embroider flower garlands, a cute kitten and two doves, a tiny house, a stone planter with an orange tree, or a basket of cherries. This sample work was always framed all around by the letters of the alphabet, cross-stitched in red and the cross-stitch was called the "marking stitch." Sometimes, several types of alphabet characters were displayed, and so embroidery became illumination. The letters would swell up, elongate into intertwined branches and boughs or be covered with scrolls and flowers.

This marking stitch was used by all the girls for their trousseaus. It marked the dishcloths and coarse day shirts that peasant women wore, made of hemp cloth called *rousseto* because of the light rusty color bled by the fiber, as well as the elegant shirts made of light muslin. The only difference was that the red cotton thread used for marking was more or less fine, according to the thickness of the fabric.

Even on rich trousseau linens, an ornamental embroidery of white on white did not exclude the small red initials discreetly stitched into a corner. For this mark had a highly symbolic meaning. The period in which the young girls completed their sampler, and were thus ready to begin embroidering their trousseau, coincided with their first communion.

It was also the time of their first menstruation. If the menarche did not appear at this time, a girl was considered to be late. So this red thread symbolized a woman's blood. It indicated much more than a mark of ownership: it placed on her linens the mark of her womanly body, thus transcribing a deep, secret, intimate message, that of all women.

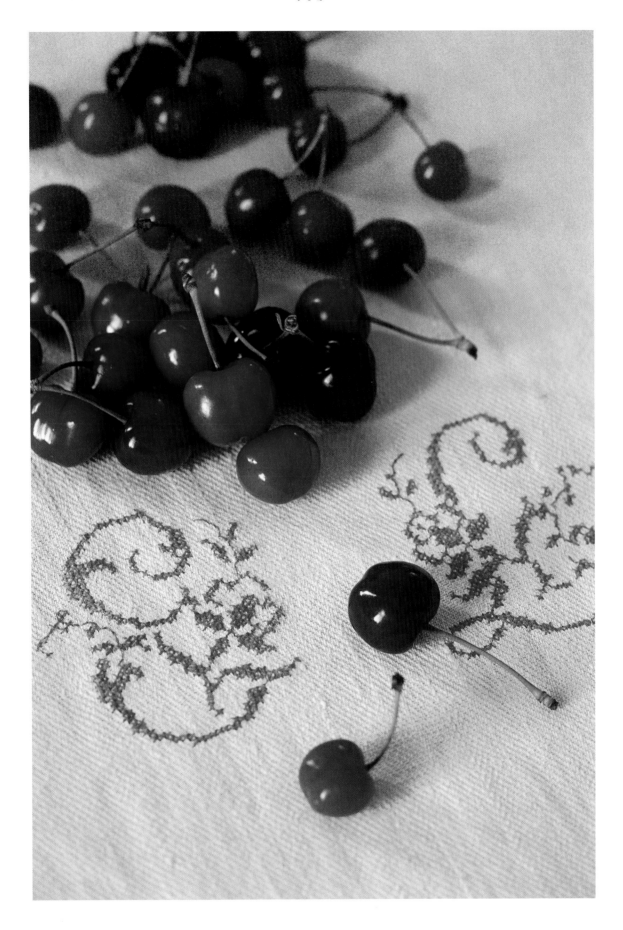

# Roof Tiles and Floor Tiles

With the exception of the cowherd huts in the Camargue, built with reed roofing, and the piled-up stones of the *bories*, ancient drywall structures similar to the *nuraghe* of Sardinia and the Irish *broch*, all construction in Provence, in towns as well as the countryside, is roofed with Roman tiles. The Romans used two types of tile that differed slightly from those in use today. There was a flat tile for the drainage of water, called *imbrice*, and a rounded tile, called *tegula*, which covered the part where the two flat tiles met. Around the tenth century, these tiles were also given a trapezoid shape. And in all likelihood, at the beginning of the twelfth century the manufacturing and setting of tiles was made considerably simpler, as only one type of tile was now made, used at the same time for covering and for water drainage.

More often than not, tile works were established in the same place where the clay was extracted. First, clay was kneaded with water in large basins, then it was taken to the mixing machine for additional kneading. Afterwards, it was shaped into roof tiles or into square cover tiles that were placed underneath the roof tiles. The cover tiles were just clay sheets, about three-fifths of an inch thick, cut on a template, shaped in wooden molds, dried, and baked. As they came out of the oven they were soaked in large quantities of water to prevent their crumbling. A good tile had to have no visible lime spots so as not to crack at the first frost. The tile had to be capable of bearing the mason's weight without shattering. Finally, it had to yield a clear sound. The tile's color was a function at the same time of the color of the earth and the temperature at which it was baked. Tiles came in a great variety of light shades, all the pinks, the beige roses, the pale orange hues, and darker colors up to red ocher. Each tile was different, and their assembly on a roof created a true colorful mosaic since the masons would set them in no particular order. Only time blended these colors sometimes by covering them with moss or lichen. Also, up to the end of the eighteenth century, pieces of crushed tile were added to the construction mortar to make it adhere better.

*To make the color of tomettes, the hexagonal floor tiles, uniform, they were soaked in a red ocher solution before baking.*

Therefore, some of the rose color of the tiles went into the walls, and this contributed in a delicate way to unifying the building. Clay was plentiful in Provence, and for centuries roof tiles were made in Marseilles, Arles, Aubagne, Lambesc, and Auriol. However, it was the tiles from Aubagne that enjoyed the best reputation.

open air until they reached the right texture for the operation that was to follow. One by one, they would be dipped in water containing some red ocher so as to make their color uniform. The tiles were then left out to dry, then baked in wood-fired ovens. Baking could take up to a week, with the fires kept going day and night. Today, most floor-

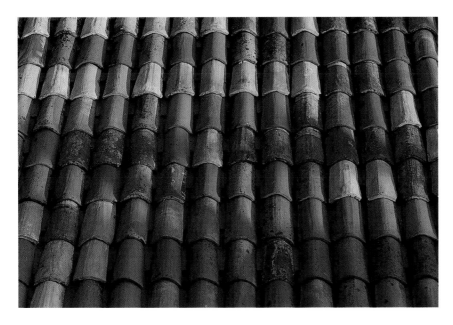

*The color of roof tiles varied according to the clay but also to their position in the baking oven, as they were exposed to different temperatures.*

The manufacture of *mallons*, the square floor tiles called *malouns* in the Provençal dialect, differed slightly from roof-tile manufacturing. A finer earth was required, all impurities were removed, and the mortar was carefully kneaded. The resulting paste was spread out, and squares were cut from it. Some tiles were square, while others were triangular or had six or eight sides. The hexagonal tiles were called *tomettes* and were the most popular shape after the square tiles, made, like them, in various sizes.

But the uniqueness of the floor tiles lay in their color. After being cut, they were left in the

tile manufacturers no longer dip the tiles into ocher water. Hence the tiles take on different hues, just like roof tiles.

The tiles used for wall surfaces, such as the inside surface of vats, the laying of kitchen gardens, and the framing of dovecotes, were square and had a layer of oven-baked enamel: their colors were yellow ocher, red ocher, or sea green.

# The Red Village

About twenty years ago I visited Venice for the first time. The first shock came as I was leaving the train station, when all of a sudden everything was in motion and dream became reality. The second shock came a few days later, on the lagoon, as I came upon the village of Burano. Everything was painted blue, red, mauve, yellow, green, orange, and gray. The house stairs, the bridges, the canals of this miniature Venice lent themselves perfectly to the interplay of colors. Everything—

hued roughcasts, these wisteria-colored bridge handrails, these laid-on tints that have no relation to the surrounding nature? To me, the Provence of my childhood was beautiful with its gray shutters and its sand-colored plaster; this did not prevent wheat fields from turning green in springtime and gold in July, or sunflowers from bursting with yellow, or the sky from being blue—never more blue than when the mistral swept it of all clouds.

In Provence, local sand was always used for wall plastering. It was unthinkable to bring in sands of different colors on horse-drawn carts to

*In Roussillon, ocher is present in plasters and washes, of course, but also in the very stones used to build houses.*

boats, doors, shutters, walls, balconies, chimneys—was colored as if the town had been painted by children. And everything was beautiful, just right, in perfect harmony, a plain Italian fishermen's village, the naïve and happy expression of its inhabitants, in the translucent jewel box of the lagoon. In reliving the shock I experienced with this vision, I sometimes ask myself why today we try to color all the villages of Provence artificially.

Where do these red and yellow houses come from, these lavender blue shutters, these salmon-

plaster the houses of a town. Nor is it typical of the Provençal peasant's mentality to want to stand out by painting his house a different color. At the most, he would endow it with his personality, his identity, by choosing the color of the exterior woodwork, which might be painted a strong red, a dark green, or blue—sometimes the same blue used for carts—or even any of the shades of gray. Hence, the towns blended perfectly with the landscape. The whole town of Roussillon is red, red like its earth, its stones, its sand, its ocher quarries, and this splendid, natural red ocher monochrome happily complements the

surrounding pine woods and is found again on the cliffs, the country paths, and the hollow furrows around the foot of the grapevine.

The Romans were already using the ocher of Roussillon, which they carried on donkey back over the Julien Bridge and through the Lourmarin Valley that led to Marseilles. From there, ocher departed by sea for the four corners of the Empire. They named the place *Vicus russulus,* or red village. But legend tells another tale, tragic and beautiful, like so many medieval legends.

Once upon a time, at the end of the twelfth century, there lived in Roussillon a lord by the name of Raymond d'Avignon. He was married to the lovely Lady Sermonde, and for a few years they knew a sweet, peaceful happiness. But

time went by, and more and more often Raymond would be gone for long days, hunting in the woods. Lady Sermonde had a page, a young troubadour by the name of Guillaume de Cabestan. And while the lord was a-hunting, the castle would resound with song and laughter. Soon Guillaume and Sermonde became lovers; no one knows how, but Raymond was soon apprised of his misfortune. Seeing himself betrayed, he decided to take revenge. The following day, he invited Guillaume to go hunting with him; when they were alone in the forest he stabbed Guillaume, beheaded him, and tore out his heart. He hid the head and the heart in a sack and left the corpse to wild boars and wolves. Back at the castle, he instructed his cook to prepare the handsome troubadour's heart for lunch. Deceived, Lady Sermonde served herself the meal. At that point, Raymond took the decapitated head out of the sack and, holding it by the hair, told his wife that she had just eaten her lover's heart.

Sermonde got up without uttering a word, left the castle, ran up to the cliff's edge, and threw herself into the void. From that day on, the blood of Lady Sermonde and Guillaume de Cabestan tinged the landscape crimson.

*A house in Roussillon, red like all the other houses in town.*

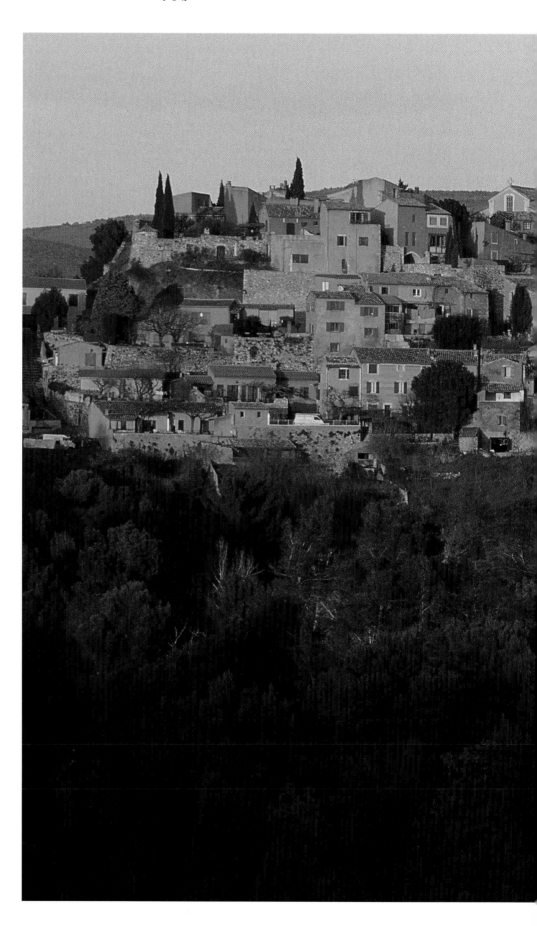

Ocher hues are
even more intense in
the light of the
setting sun.

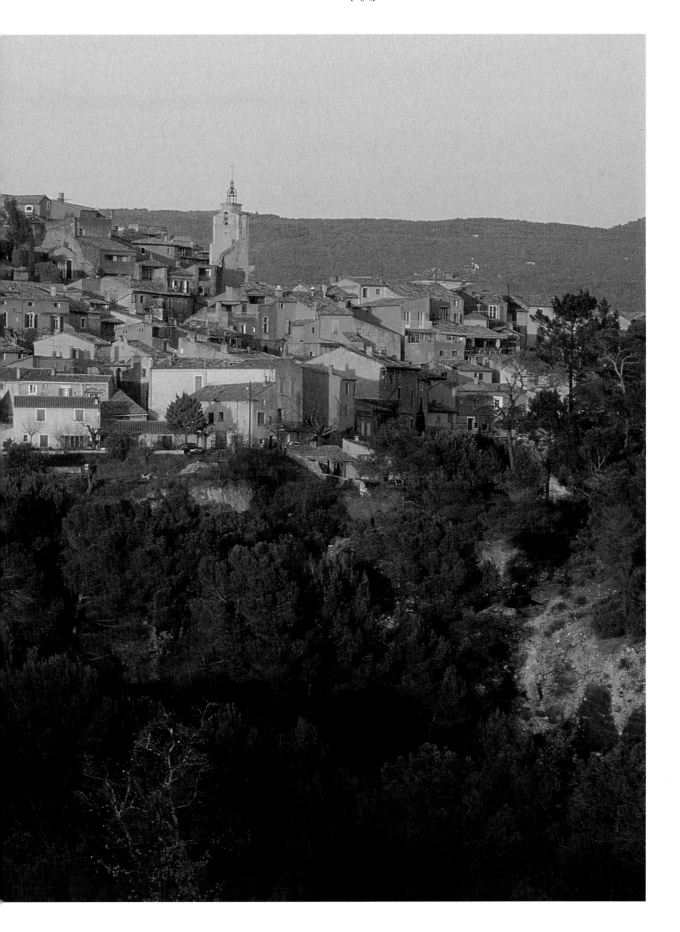

# Orange

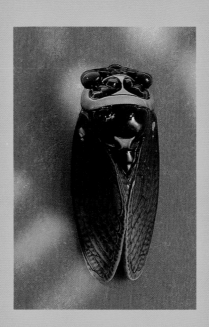

Like young women who adorn their bodies
with fair red-gold brocaded robes
on a feast day, so you oranges,
you are flowers by your scent, fruits by your flavor.
Fire globes, you hold within the coolness of snow!
And when I gaze at your glistening skin,
how can I not think of my woman friend,
the fair-cheeked lass with the grainy golden behind?
—Arabic poem

My uncle Victor had given me my first pocket knife. I was perhaps seven years old. He had taught me to do all kind of things with it, such as carving the bark of a walking stick—when you removed some of the bark, rustic brown ornamental reliefs appeared on a white background—or fashioning highly effective whistles to frighten my girl cousins and my aunts when, hidden behind a door, I would blow with all my might into the small piece of wood. A few days before Christmas he had also taught me to turn clementine oranges into charming oil lamps. First you had to cut the fruit's skin horizontally, two-thirds from the top, and remove the orange's "cap." Then with gentle, almost religious movements, you had to move the blade between skin and flesh, a very difficult thing to do, trying to avoid spoiling either one. Finally, you had to remove the orange's sections, which you ate very quickly, leaving the shell intact. This done, you still had to remove the thin white filaments and pellicule that stuck to the skin, except for the stem at the center. Then you poured a few drops of oil on the bottom of the shell and lit the stem, which served as wick. There! You had a small lamp with which to light the crèche on Christmas Eve. Then you would cut a star-shaped opening at the top of the shell's cap and place it on the lamp. My God, what a lovely smell when the flame licked and lightly caramelized the star's edges! And my God, how magical these small orange translucent lamps were in their quivering, trembling light! I think this was my first experience of being moved by the vibrations of the color orange.

*Orange is the color of fall, and the oak leaves in the hills and the cherry and peach trees' leaves on the restanques and the plain, turn ember-red for an instant before being carried away by the mistral (page 36). A Louis Sicard faïence cicada, circa 1900. The insect brought happiness to the whole house (page 37).*

*These small oil lamps, a Christmas Eve tradition, are made by children with the rind of the clementine orange (opposite page).*

The color orange takes its name from the fruit, and is derived from the Persian *narandji*. When, at the end of the Crusades, orange-tree cultivation spread along the shores of the Var region, reaching down to Grasse and Menton, the extreme seduction of this new color for a long time marked Provençal tradition. The color orange stands between red and yellow, at the crucial point of the most intense radiance of the color spectrum. From it emanates a warm, luxurious energy. It excites the appetite—all kinds of appetite.

It is the color of the sun as it rises, when the eastern wind blows and will soon bear rain-heavy clouds, and of the sun as it sets, when the mistral blows and the sky will soon be strewn with stars and the following day will be bright and clear.

It is the color of coral fished off the shores of Corsica and Sardinia, which in the past century embellished the golden complexion of our market women selling flowers, fruit, and fish.

It is the color of delicious rice with *favouilles*, when the intense red of the crab shells mixes in the pot with the yellow of the saffron's pistils.

It is also the color of gourds, so popular here that they are among the presents that Nativity scene characters offer the newborn child. The "gourd man," dressed in a large, dark linen *blaudo*, a type of smock and a large, red-checkered *moucadou* (handkerchief) around his neck, carries on his head a huge orange pumpkin.

Finally, it is the overall color of the ocher cliffs rising between Roussillon, Gargas, and Rustrel, before the yellow mill and the red mill make their choice.

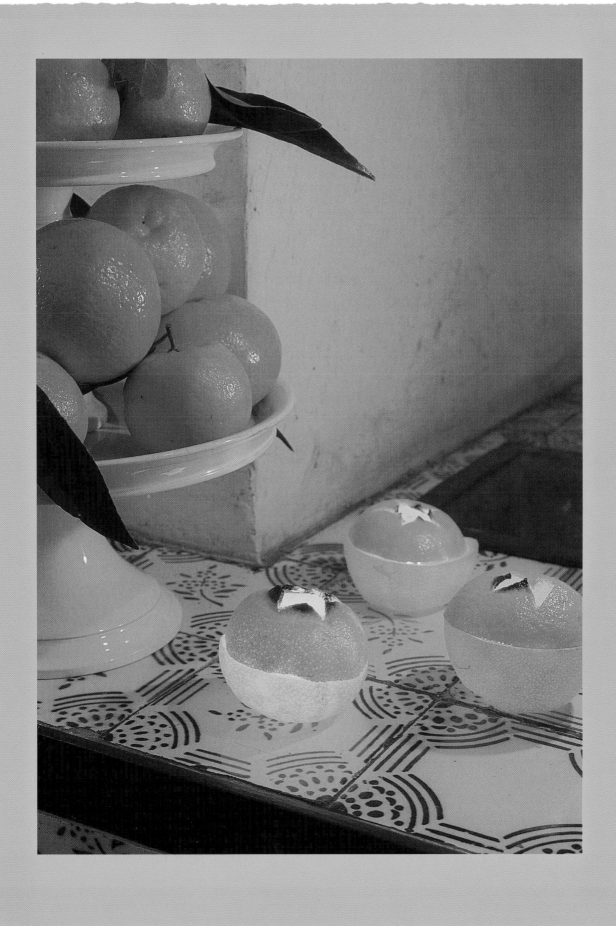

# Oranges and Orange Groves

The orange tree is a mythical tree. It is the golden fruit tree of the garden of the Hesperides, blessed by the gods, sung by poets, and cherished by kings. Like so many other marvels, it was born in China. From there it was imported into India, then Persia. Its cultivation spread to all the Mediterranean countries under Moslem rule, starting with the period of the Arab conquests in the eighth century. When the Crusaders landed in Palestine in the twelfth century, they were astonished at the beauty and abundance of the orange trees. Upon returning home, they brought back a few plants that they tried to grow in Hyères, a home port for the Crusades' ships. The tree would soon make the region's fortune, as it began exporting the flowers for use in perfume making and the fruits for consumption, so much so that the Hyères Islands took the name "Gold Isles."

But whereas the mild climate of the Var shores and, later, the region around Grasse and Menton were ideally suited to orange-tree growing, everywhere else temples worthy of its glory had to be built to protect it from winter: thus it was that Renaissance agronomists invented the orangery, a greenhouse designed specifically for orange trees. Because this small tree with intensely green shiny leaves and white flowers that release an exquisite fragrance, this producer of splendid, delicious fruits, is fragile. The cold will hurt it and the frost will kill it. Although the first orangeries were built by the kings of Frances as they returned home from the Italian wars, it was not long after that the lords of Provence took up the fashion. Soon most of the lovely residences and villas in Provence displayed one of these elegant greenhouses, with a southern exposure, where the orange-tree vases could be sheltered in winter.

At first, the orange trees were planted in wooden half-barrels, which were truly ugly. Later, large, glazed clay pots were used, Italian-style.

This was a more elegant but fragile solution, since twice a year the pots had to be moved from the greenhouse to the garden and from the garden back to the greenhouse. Therefore, orange-tree tubs were devised; they met with immediate success everywhere but in Provence, where the large clay pots continued to be used. Beginning in the seventeenth century the potters of Anduze, who were already adept at fashioning large jars to store oil and olives, made these immense pots broadening to a pedestal, decorated in front with relief patterns, their specialty. Anduze is a small town in the Cévenne Mountains, sheltered against the rock of Saint-Julien, on the shores of the Gardon River, where several generations of potters such as the Boissets and the Gautiers became famous by making these vases. These large pots were mounted "on a rope," a time-consuming technique consisting of winding a rope around a bundle of sticks, placed on the potter's wheel. This done, the potter would apply the clay by hand, shaping it as he went along. Once this was completed, the sticks had to be removed, then the rope, and the sides of the vase were then smoothed down, fashioning the friezes and medallions. Now came the delicate drying stage, which had to be slow and continuous, so as to avoid cracking the vase. Once dry, the vase was soaked in slip, a clay solution, to neutralize the red of the Anduze clay. It was then sprinkled with lead, copper, and manganese oxides, which mottled it with yellow, green, and brown specks. These large urns from Anduze, once planted with orange trees, were extremely heavy. Therefore, a small wooden cart was devised, perfectly adapted to the urn's shape, to carry it with greater ease.

The orange tree was not just a decorative plant that was brought outdoors in the summer

*Orange zest must be dried before it can be used as an ingredient in many Provençal recipes such as daube, pieds et paquets, bouilli, bourride, and bouillabaisse (opposite page).*

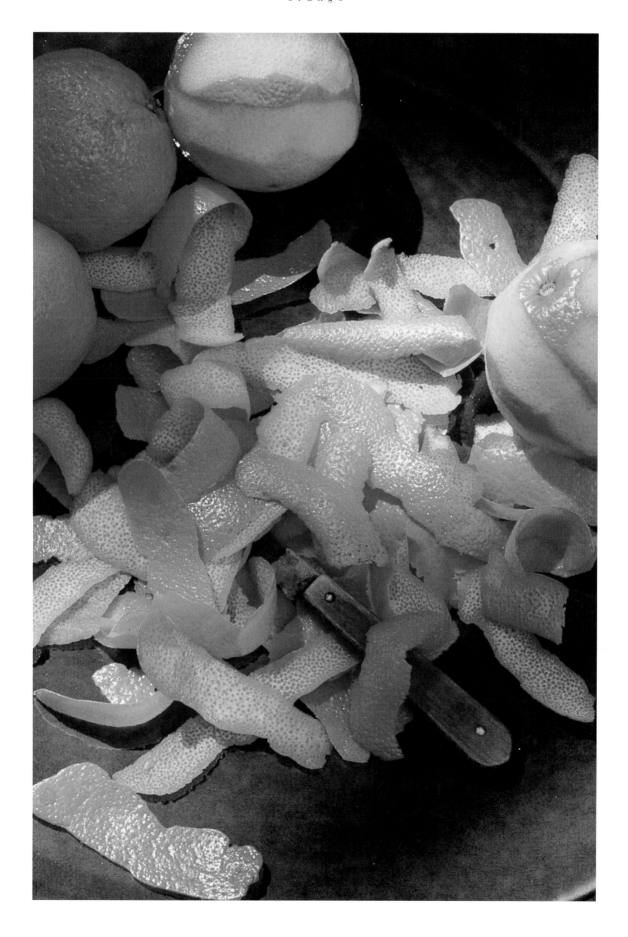

and displayed in regular rows on villa terraces. Its magnificently colored fruits brought their own warmth to winter and became the present all the small children of Provence received or dreamt of receiving at Christmas time. Above all, the orange became the preferred ingredient in the preparations of the Apt confectioners, the cooks of Marseilles, and Grasse's perfume makers.

There are sweet oranges, the more common kind, and bitter oranges like the *bigarades*, also known as Seville oranges. The flowers of the Seville orange are distilled into the orange-flower water that scents most of Provençal pastries. Seville oranges are mostly used for preserves or marmalades. Long ago, Apt confectioners would prepare a marmalade with small Seville oranges, which were then known as "Chinese" oranges, rounder than kumquats, smaller than clementines, of which the Marquis de Sade was very fond. There were green, yellow, and pink Chinese oranges, depending on the degree of ripeness of the fruit. Small jars of preserved Chinese oranges were sent to him, together with other provisions and books, to soften the rigors of his imprisonment in the Bastille: "a small jar of beef marrow, a raspberry jar, and an apricot jar; twelve glazed biscuits, a vial of lavender and one of eau de Cologne, the best and strongest; a half-bottle of orange-flower liqueur." And on another occasion he ordered: "one sausage, one stick of pomade, a jar of Chinese oranges; six regular biscuits, six glazed." But all of this was quite expensive, and Sade neglected to pay his bills. He therefore ran up a hefty account at both Monsieur Léger's and Monsieur Pin's, confectioners in Apt.

When he was finally released and returned to his castle in La Coste, the Marquis owed so much money that the confectioners brought him to trial for debts. But not even this cured him of his gourmandizing. When he set up residence in Paris with the lovely Constance Quesnet some time later, he sent for a suite of furnishings from La Coste to dress his house at Neuve-des-Mathurins Street. Unfortunately, several jars of preserved cherries and Chinese oranges ordered from Apt and traveling with the furnishings broke during the shipping, spoiling books and linens, staining the draperies and damaging the armchairs. Sade was appalled by this catastrophe.

The orange peel also became an indispensable condiment of Provençal cuisine. It goes well with meats and fish. It scents stews, *pieds et paquets* (pieces of stuffed tripe tied up with sheep's feet and slowly simmered in a broth with vegetables and white wine, a specialty of Marseilles), boiled meats, *bourride* (a fish stew with *aïoli*), and *bouillabaisse*. The dried peel is used. You must choose a beautiful orange that has not been damaged, with a smooth, even skin and, with a sharp knife, remove the zest in strips, taking care not to cut into the white part of the skin, which is bitter. Now all you have to do is let the zest strips dry for a few days on a pastry rack or on a basket before sealing them in a glass jar or a cannister. Thus dried, the orange peel will keep for several months.

However it is in Grasse, in the eighteenth century, that we find the most delightful way of using this golden, scented peel. Here, orange shells were made into *bergamotes*, also called *orangettes*, or small oranges. These were adorable boxes for storing dusting powder or rouge, pills, candy, or tobacco, made with an orange shell shaped on a mold and covered on the outside with cardboard and papier mâché; they were decorated with charming painted motifs and finished with *vernis Martin*, a lustrous resin-based varnish, which gave them a delicate, pale yellow hue. *Bergamotes* were gallant presents, as indicated by most of the inscriptions they carried, such as "This heart is yours alone."

*The interiors of these* bergamotes *from Grasse were decorated with orange rind molded on a shape. In the 18th century these delightful boxes made gallant presents* (opposite page).

# The Cicadas of Louis Sicard

Starting in mid-June, the song of the cicadas spreads over all of Provence: everything vibrates and echoes back, the pinewoods and the olive groves, the arid hills and the fertile plains. One hears them everywhere, even in the center of towns, as they celebrate the arrival of summer's heat. Actually, only the male cicadas make music, and their sole purpose in doing so is to seduce the females. Their abdomen is equipped with an astonishing natural musical instrument composed of two cymballike membranes that resonate under the repeated action of two powerful muscles. Before appearing in the open air for a very brief life of two to three weeks—this carefree life of singing that gives them their loose reputation—cicadas are first exposed to a long, subterranean life as larvae, which lasts at least two years. Their eggs are laid in the crevices of tree bark, in the folds of stems. Once opened, each larva, without taking the time to discover the world, makes its first transformation, learns to use its legs, then lets itself fall to the ground to hide in its depths. Sheltered underground, it then undergoes a slow development and four more transformations, each time receiving a more finished form.

As it approaches its last metamorphosis, the cicada bores a vertical tunnel and positions itself a few millimeters below the ground's surface, waiting for the favorable moment, just the time for a final beauty check. And so, finally ready, dressed in new colors, its eyes black and its wings green, it decides to make its appearance in full daylight. Thus it climbs on the first support it finds, the stem of a flower or a shrub, for the last transformation that will reveal it as a cicada. This last metamorphosis takes three long hours in which the insect is completely at the mercy of ants and wasps; many cicadas die in this critical period. Once the metamorphosis has been accomplished,

the new cicada takes wing, then alights on a branch, takes its first meal of sap, and starts singing.

This strange insect has struck mankind's fancy in all ages. The ancient Greeks chose it as the symbol of Apollo, god of music and poetry; the Chinese associated it with their funeral rites. Frédéric Mistral, a poet and passionate defender of the Provençal language and traditions, made the cicada the symbol of Provence and gave it a motto: *Lou soulèu mi fai canta.* "The sun makes me sing."

In 1895, when Mistral and his followers were influential over all the Midi, the Société Générale des Tuileries of Marseilles asked Louis Sicard (1871–1946), a faïence maker from Aubagne, to create a business gift with a Provençal theme. Thus it was that Louis Sicard modeled the first faïence cicada: with blue eyes and gray wings, it perched on an olive branch. The Marseilles Tuileries shipped these paperweights to their clients all over the world. The object was well received, and Sicard soon decided to reproduce the cicada on all his pottery: vases, cups, plates, candy dishes, umbrella stands, and olive jars. At first these objects were polychrome, in acidulous pastel shades, close to the colors of the *barbotine* porcelains of Jérôme and Delphin Massier, ceramists in Vallauris. Sicard marked them with a small black signature that seemed written in ink.

Soon, however, an orange-hued yellow, intense and bright as a sunset, would eclipse all the other colors and serve as a luminous backdrop to the naturally portrayed, small, scattered, gray cicadas. These pieces were signed in red by Louis Sicard with a paintbrush. Later, when the Sicard studio

*Faïence vases, candy boxes, and cicadas from the workshops of Louis Sicard in Aubagne, Massier in Vallauris, and Saint-Jean-du-Désert in Marseilles* (opposite page).

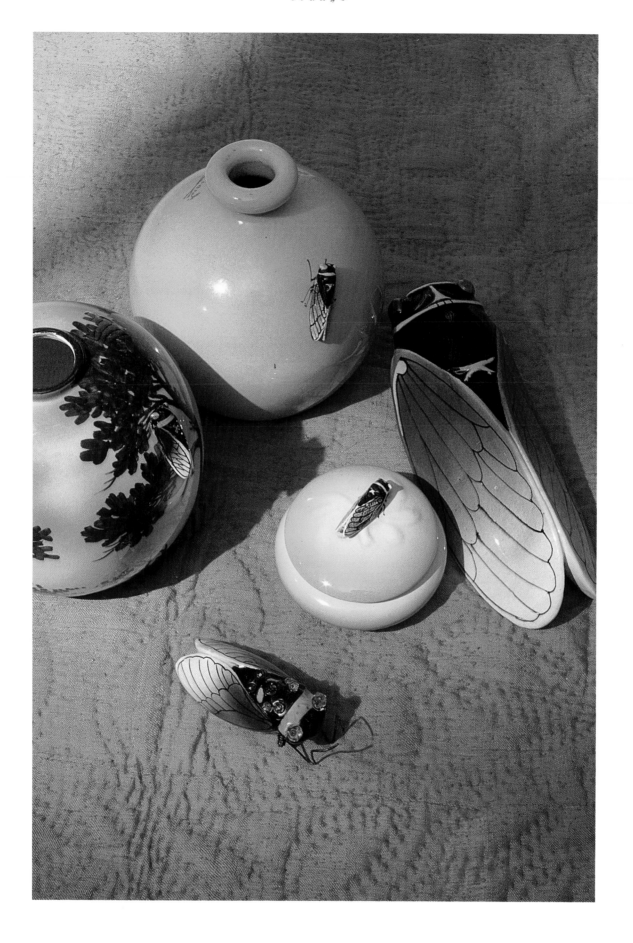

continued to reproduce the same objects in a lighter, harsher yellow, they were marked with a blue stamp.

Louis Sicard's cicadas surely met with great success, since they were immediately copied by all the Provençal pottery makers. Massier in Vallauris and Pichon in Uzès also made objects decorated with cicadas, sometimes unique pieces, often numbered, quality faïence for local customers. It was only after the 1950s, with the surge in tourism to Provence, that these objects could be found in gift shops.

Saint-Jean-du-Désert, the pottery works in Marseilles, already famous at the end of the seventeenth and beginning of the eighteenth century, under the inspiration and talent of artists such as Joseph Clérissy and his sons, in a last flourish of decadence succumbed to fashion and also put out a large number of cicada-shaped objects. But instead of the orange-hued yellow of Louis Sicard, which had already been copied by Jérôme Massier, they took the metaphor one step further and colored their vases in merging monochrome shades from yellow, through orange and pink, to mauve, an ideal sunset against which the silhouettes of Vincent and Mireille in Arlesian costumes stood out, along with farandole dancers and tambourin players, against a landscape of cypresses and large umbrella pines.

# Mediterranean Coral

A large basket of sardines under one arm, the other fist on her hips, a steelyard hanging from her belt, the fishwife from the Saint-Jean section is one of the more typical characters of the people of Marseilles, and one of the first to be immortalized by the makers of Christmas *santons*. A rough hemp-cloth apron protects her beautiful underpetticoat in printed, stitched *indienne pise;* her large shawl is crossed in front with both ends secured at the waist; the tendrils of her hairdo, always loose, are flying in the wind; and her ears, neck, and hands are embellished by gold filigree jewelry into which are set lovely coral cameos. She is either Neapolitan, or her mother was, or her grandmother before her. And her brother, father, or grandfather were either coral fishermen or coral workers.

For centuries, the appeal of coral has been its color, which ranges over all the shades from orange to pale rose to blood red, its miniature-tree shape, and its origins, since it must be sought in the secret depths of the sea. At once animal, vegetable, and mineral, coral has been endowed by folklore with great magic powers. It protects from lightning, keeps hate and jealousy away from the home, undoes sorcery, and overpowers fear and nightmares.

Since the beginning of time, the people of the Mediterranean rim have used coral in their treasures and their jewelry. But the Sicilian and Neapolitan coral workers were among the most famous. Coral brought wealth and fortune to small towns like Trapani in Sicily where, in the sixteenth century, a brilliant coral-work school became established. Trapani turned out splendid art objects for the high nobility and the most

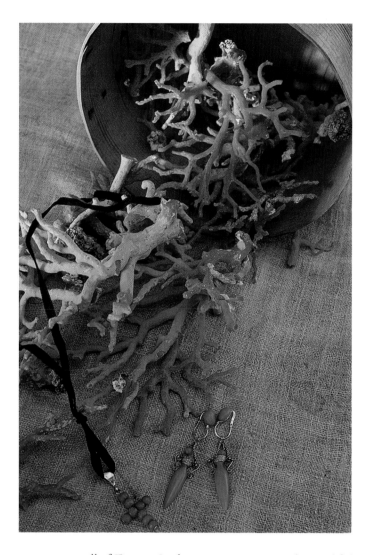

*Mediterranean coral branches and jewelry. The Directoire period, amphora-shaped pendant earrings are from Marseilles, and are delicately decorated with gold filigree.*

prestigious courts in all of Europe. In the seventeenth century, coral art in Europe reached its peak, given the ease with which the natural, strange shapes of this precious material lent themselves to the fantastic, splendid expressions of Baroque art. The eighteenth century preferred the gleam of pearls and diamonds to coral, and slowly the art of the *corailleur* declined. In the nineteenth century, fashionable city girls were reluctant to wear coral for fear they would be mistaken for daughters or wives of provincial artisans. In fact, these red jewels continued to be worn proudly by the wives of artisans, vegetable vendors, flower girls, and rich fishwives from Saint-Jean.

The coral fishermen of Marseilles were hired right on the same Saint-Jean dock, especially from Neapolitan immigrants. The most important Mediterranean coral deposits were found around Sardinia and Corsica. Like Naples and Barcelona, Marseilles had developed a market for raw coral. Now it too developed the art of coral work. In booths scattered all around the port, the small orange-colored trees were sculpted into strand pearls, crosses, cameos, or amphoras. Later, other craftsmen would mount them in delicate gold filigree, and these simple, charming jewels would be sold all over Provence.

orange

# Saffron

Saffron is a large crocus with purplish-crimson or linen-gray flowers and large, orange-yellow, strongly scented stigmas. The stigmas contain the coloring substance called saffron. Undoubtedly, this plant was brought to Provence by the ancient Greeks. In the past, saffron fields were widespread in the South, including the regions of Bouches-du-Rhone and Comtat Venaissin. Today, this "red gold" is still grown in Spain in the region between Castile and La Mancha and has always commanded incredibly exorbitant prices. It is true that harvesting saffron stigmas is a delicate operation. It is done in the fall of each year at sunrise, before the flower opens its petals at the first touch of the sun: the three stigmas must be pulled one by one, without damaging the flower, thus allowing it to grow new stigmas several times again during the season. The stigmas are then left in the shade to dry completely, before they are stored in boxes.

The saffron stigmas are orange when they are on the flower; once dried, they become red, although the color they lend to food is yellow. Actually, for a long time before it became a condiment, this spice gave the Provençal dyers a very beautiful yellow color. In the past, apothecaries would also make generous use of saffron as an ingredient in many medications. It also served to make a brilliant "Spanish rouge" for women's cheeks and lips.

Today, saffron is essentially a kitchen spice. There is a powder produced in the Marseilles region that is made of sweet pimento, turmeric, three percent saffron and "authorized coloring agents" that colors rice quite prettily and for a reasonable price but adds no fragrance to it—it's called *spigol*. However, genuine saffron has such a unique aroma, bold and delicate at the same time, that goes so beautifully with fish, that it is an indispensable ingredient in most *bouillabaisse* recipes.

Only its very high price prevented the very poor from using it. On the other hand, it is the aristocratic quality of saffron, together with fennel's charm and the sweetness of orange zest, that gave to a good number of potato soups or egg, spinach, or pea soup the glorious name of *bouillabaisse*.

I am not going to give you a *bouillabaisse* recipe, however, but a recipe for a delicious rice dish, halfway between an Italian risotto and a Spanish paella. This recipe of saffron rice with *favouilles* is the most "orange" of Provençal cuisine. *Favouilles* are small crabs that scamper everywhere on Mediterranean sea rocks; cooked, they acquire a magnificent orange-red color that is a perfect complement to the perfume, taste, and color of saffron rice.

In a pot of salted boiling water, put a bouquet garni composed of thyme, parsley, 1 bay leaf, the green part of a leek, and dried orange zest, plus about 10 *favouilles* to make a fish stock. In a casserole or sauté pan, low and wide, pour enough good olive oil to cover the bottom and sauté the rest of the *favouilles*, counting 6 small crabs per

*Saffron's pistils are orange
while in the flower; when dry, they
turn red, although the
color they yield is yellow.*

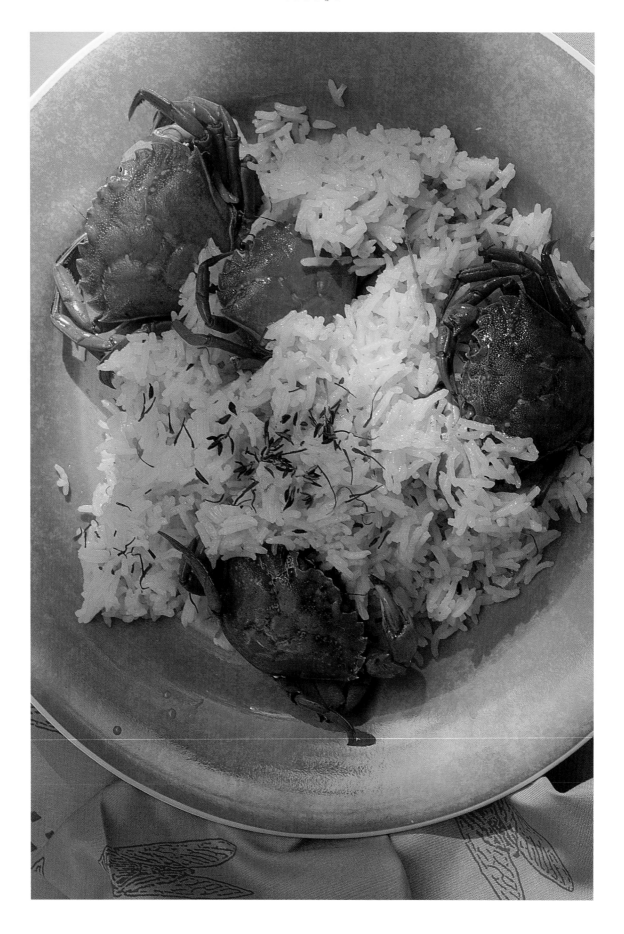

person. If you are able to tell them apart, or if you can withstand your fishmonger's jokes, choose the female crabs over the male. Throw them alive into the hot oil, and cover the pan immediately to prevent them from escaping. You will forgive the cruelty—the extraordinary aroma that will soon be released from the casserole will probably convince you that it was justified. Once the crabs are red all over, remove them from the pan and set them aside. Now add a finely minced onion to the pan, reduce the heat to low, then add 1 fistful of round Camargue rice per person and let the rice "toast" a few minutes, stirring it constantly, until it has become translucent. At this point, moisten with a glass of white wine, turn up the heat to medium, and let evaporate completely. Salt lightly (the crab stock is already salted) and add a good sprinkling of pepper and perhaps a small, minced Spanish pimento—this dish calls for a good amount of seasoning. Add a few pieces of ripe tomato, then start adding the stock that has been kept at a simmer. The rice must be cooked on a medium flame, adding the stock ladleful by ladleful as it gets absorbed by the rice, and stirring constantly to allow the rice to cook uniformly. After about fifteen minutes, the rice should be nearly cooked through, but taste it just to make sure. Add a few pinches of saffron threads and the sautéed crabs. Lower the flame and add a trickle of olive oil. Cook for five minutes more, then bring the dish hot to the table with grated Gruyère.

*Rice with saffron and favouilles.
Favouilles are small crabs that turn
bright orange-red when cooked, a perfect
complement to the fragrance, taste, and
color of saffron rice* (opposite page).

## Coucourdes and Coucourdettes

*Coucourdes*, also spelled *cougourdes*, are squash. In fact, in Provence this name was given to all cucurbits. There was the *coucourdo arange*—the large, round pumpkin—and the *coucourdo muscado*—the acorn squash. Of course, pumpkins are a bright orange inside as well as outside, while the acorn squash, whose flesh is also a superb orange, is caramel-colored on the outside. There was also the *coucourdo de Sant-Jan*, or Saint John's squash, a kind of squash melon, and the *coucourdo barbaresco*, a large, elongated squash. In short, *coucourdes* were all the kinds of squash that were cooked in a *tian*, a large, shallow clay baking dish, in a soup, or in a pie. And when a squash grew too big and became huge, stringy, and inedible, it was called a *coucourdasse*.

The *coucourdettes*, on the other hand, were *courgettes* or zucchini. However, the name was also given to a small squash, a kind of colocynth or bitter apple, that was left to dry and then used as shepherds' gourds or hunters' powder flasks. Some villages specialized in the production of these gourds into powder or buckshot flasks. Once they were thoroughly dried, these small gourds were pierced at one end. Through this orifice, the seeds were removed and the interior was carefully scooped out. Then the hole was closed either with a simple cork stopper or a screw-on stopper made of carved boxwood, sometimes of fine workmanship. Gourds were equipped with two small tie-handles to which a rope was attached so they could hang from the shoulder. Over time, these *coucourdettes* would take on a lovely red, waxed patina, and sometimes inspired shepherds would carve their dreams and hopes on them with

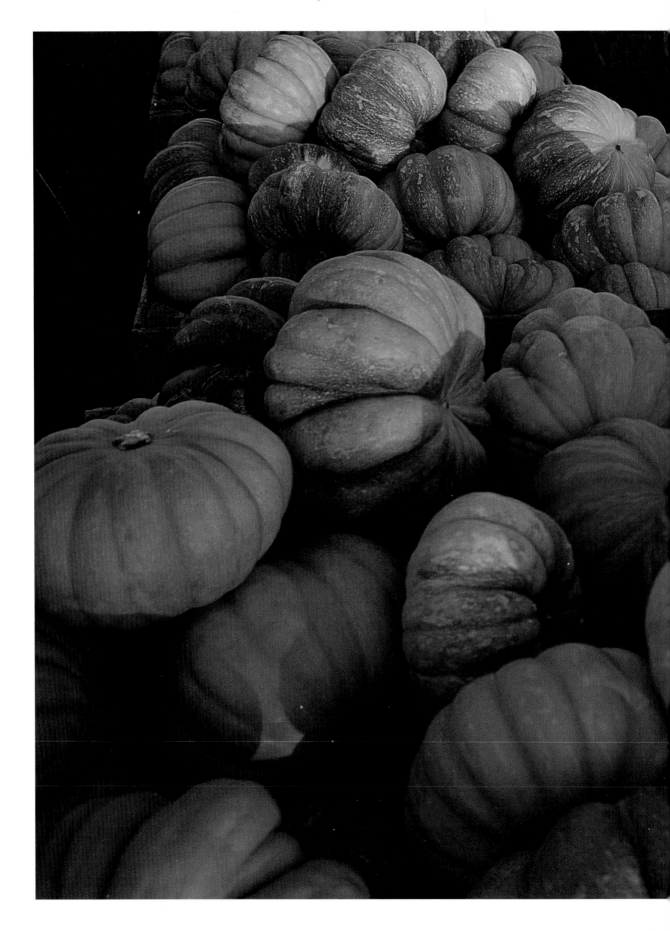

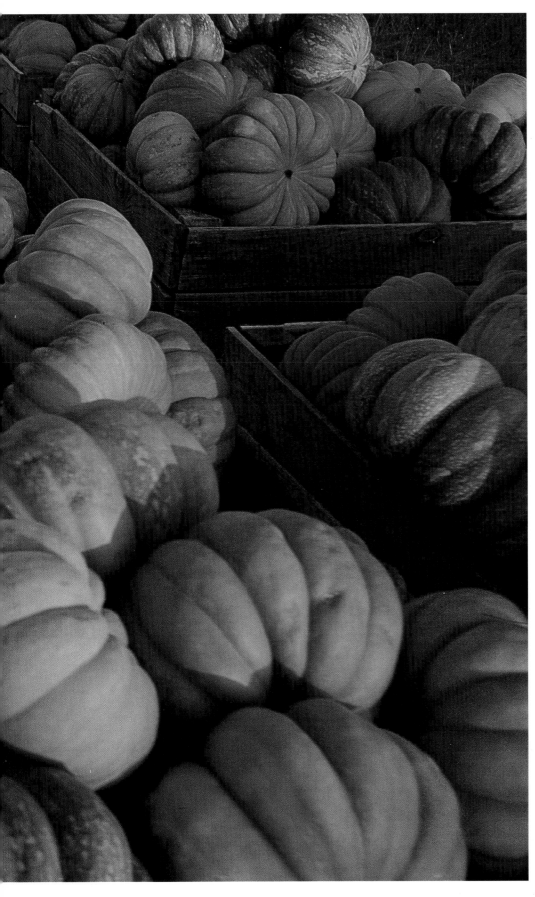

*Gathered in the fall,
large acorn squash
are placed in wooden
crates and will last the
whole winter.*

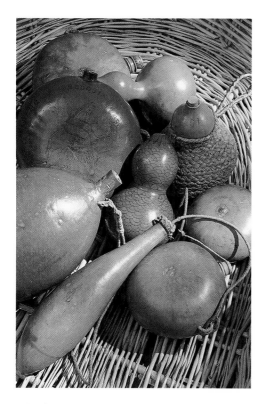

a knife. Journeymen also used and carved similar gourds. In Arles, the Arlaten Museum has some superb examples of these decorated gourds.

As long as they are picked when they are good and firm, heavy, full, and with no bruises or spots, squash will last the whole winter. Since they are easy to grow, planted in February through March and, with no other work needed, harvested starting in September, they are a basic Provençal food staple, supposedly so common and banal that a poor country lacking in resources is called a *pays de coucourdes*, a "squash country." What an injustice! Squash is a delicious vegetable.

*Powder or buckshot flasks made of small gourds, emptied out and dried (top of page).*
*The combination of olive oil, garlic, and pumpkin is a wonder of Provençal cuisine (opposite page).*

The cooks of Provence have invented a thousand recipes for squash: in soups, in gratins, with or without rice, with or without leeks, with or without garlic, with or without *crème fraîche*, and they are all exquisite. In the Provençal area of Drome, north of the Comtat, a marvelous dessert was prepared for Christmas Eve: the *fougasso de coucourdo*, or pumpkin cake. You start by selecting a superb pumpkin with smooth, firm skin, a pumpkin "with the pearl," meaning it has a drop of translucent sap at the stem. Cut a generous wedge and remove rind and seeds. Cut the flesh into small pieces, add a pat of butter, 2 tablespoons of water, and 2 tablespoons of powdered sugar, and let it melt in a covered pan over a very low flame. In the meantime, knead the equivalent of bread dough sufficient for a baguette, with 3 ounces of softened butter, until the butter has been completely absorbed by the dough. Separate the dough into two equal balls. Purée the stewed pumpkin in a food mill. If too liquid, let evaporate a few minutes on a high flame, stirring constantly.

Remove the purée from the heat and let cool. Roll out the first ball of pastry dough to an oval shape and a thickness of no more than half an inch, and place on a floured, buttered baking sheet. Once the pumpkin purée has cooled, spread it on top of the pastry crust, being careful to stop about three quarters of an inch from the edge. Now roll out the second ball of pastry dough like the first one and place it on top of the pumpkin filling. Make a few slashes with a knife, as for a plain *fougasse*, and carefully seal the edges of the two pastry layers. Let the cake rise for two hours in a lukewarm place. Then place it in a medium oven for about twenty minutes. When the pumpkin cake is golden and has risen, remove it from the oven, sprinkle it with a few drops of orange water, and dust with a little sugar. It is one of the more original and delicious of the "thirteen Christmas cakes."

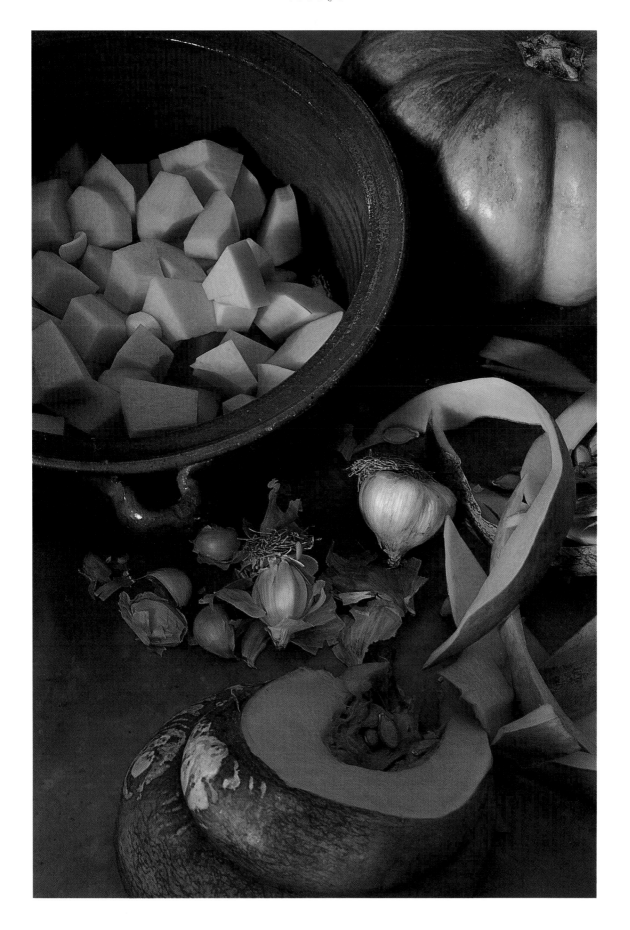

# The Ocher Mill

For madder, there were mills that ground the red madder roots. For white flour, there were windmills on all the hills, their sails stretched, and, at L'Isle-sur-la-Sorgue, all the water mills with their huge mossy wheels streaming water. There were woad mills, where a horse or a strong mule went round and round in circles to move the stone grinding the blue paste. There were olive oil mills dripping green, bitter oil. And in Rustrel, Apt, Gargas, and Roussillon, there were the yellow and the red mills. These ground the ocher ores and made paint.

A long time ago, the Romans were already extracting ocher from the ocher-ore deposits. But with the fall of the Roman Empire, the pages of history turned brutally, one after the other, and men were left to struggle with barbarism and war. This entire industry sank into oblivion. For centuries, then, ocher ores slept peacefully in the hills of the land of Apt until around 1780, when a resident of Roussillon by the name of Jean-Etienne Astier rediscovered that this yellow and red earth could be used to make a strong paint with solid, beautiful colors. He was a cooper; he became an ocher maker. He was quickly copied by other Roussillon residents. For over a century, ocher brough wealth to the entire region.

The first ocher makers were farmers. The quarries were on their land. Often, they divided their time between ocher and almond trees, olive groves, truffles or madder. On the letterhead of a letter sent from Rustrel on April 13, 1913, one could read: "Louis Bonnefoy, ochers and country oil, property owner and truffle farmer."

*In Roussillon, the Mathieu works,*
*an old ocher mill closed in the*
*1960s, is taking on a new life as a*
*repository of applied ochers*
*and pigments, and receives many*
*visitors each year.*

Ocher work was earth work, like farming, subject to the whims of the elements and borrowing techniques and know-how from traditional farming. The Roussillon oil mill was the first mill used by Jean-Etienne Astier to grind ocher. The extraction of ocher-bearing sands was done in quarries as well as underground galleries. Today, the underground galleries are completely abandoned; some have become mushroom beds. The two ocher works still active in Gargas and Rustrel are open-cut quarries. The process of extracting ocher has not changed, although mechanization and, later, electricity have considerably lightened the worker's burden.

First, one had to clear the land of trees and vegetation and remove the grassy soil, then apply a

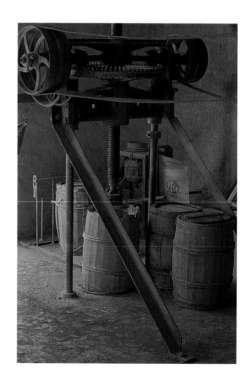

*The old red ocher mill at
the Mathieu works, where
ocher was reduced to
powder.*

layer of *stérile*, a "dead ground" of iron oxide and
ground sandstone. Only then could the sand be
extracted for washing. Sometimes there was water
nearby, but often water had to be searched for far
away and transported by cart. If a summer was too
dry, ocher production might have to be suspended.
The ore-rich water had to be mixed by hand, then
channeled into settling pits dug into the soil.
These V-shaped canals, made of Oppède stones,
followed the natural incline of the land. The
grosser sand particles would deposit themselves at
the bottom of the canals, while ocher ore, a finer
sand, would continue its journey down to the
settling vats, a type of slanted, zigzag obstacle
course lined with stones, which eliminated the last
particles of sand. Finally, the water now contained
pure ocher ores and was directed toward the
tanks. Ocher, however, does not dissolve in water.
At night, an ocher layer one to two inches thick
would settle to the bottom of the tank. In the
morning, the surface water was emptied and the
operation was repeated, until the ocher layer had
reached a suitable thickness. Wind and sun helped
the drying process which lasted several months,
until the end of August. At that point, ocher was
cut with a spade into bricks that would stack up

around the tanks like the walls of a strange,
forgotten city. Later, the bricks would be carried to
the mill, ground, then sifted like flour so as to
obtain a fine powder. There were mills for yellow-
colored ocher and mills for red ocher. The Gargas
ocher yielded an exceptional yellow. However red
ocher, or ruddle, in its natural condition is rarely a
perfect tint, sometimes too purplish, sometimes
too brown. Therefore, yellow ocher had to be
cooked over wood fires in order to get a red ocher.
By varying the temperature and the length of
cooking, different degrees of red were obtained.
Finally, mixing the basic ochers would yield a
large variety of tints.

A stroll through the ancient quarries at
Roussillon or Rustrel is a feast for the eyes, for the
natural color palette of the ocher sands of the land
of Apt is infinite. Although geologists carefully
analyze the composition of these sands and detail
thoroughly the slow, complex changes that
modified the earth's crust for thousands of years,
no one has yet succeeded in explaining by what
mystery nature colored the earth with such a
variety of shades in this corner of the world.

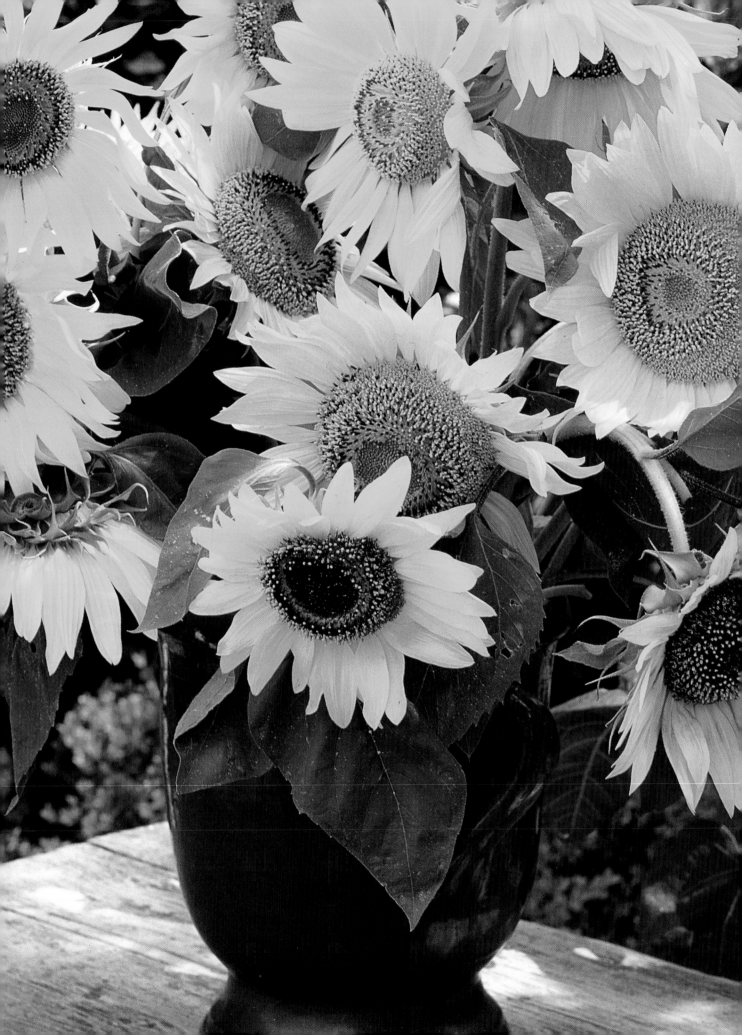

# Yellow

*In the room where you (or Gauguin, if he comes) will sleep,*
*I want to decorate the white walls with big yellow sunflowers, and you*
*will then see these large paintings with bouquets of twelve or*
*fourteen sunflowers filling the small room, along with a pretty bed...*
—Vincent Van Gogh, Lettrès à Théo

In February 1888, Vincent Van Gogh, fleeing Paris, where he felt stifled, discovered Arles and its light. Quickly, more quickly than any other color, yellow filled his canvases. Sunsets, haystacks, wheat fields ruffled like young girls' hair, sunflowers and straw hats, the interiors of cafés, his room's furniture, even his whole house—all vibrated with yellow.

Yellow is the color of the sun and of summer in Provence when the wheat is ripe and the sunflowers converse with deference and joy with the sovereign star. Just a short time ago, before "automatic sprinklers" and green lawns invaded the Alpilles foothills and the hills of Luberon, each year, beginning with the end of June, grass would become blond and adorn itself with the most beautiful yellow until the end of the summer. All of nature was golden, the rhythm broken only by the vertical shadow of cypresses and the gray cloud of olive trees.

Hammered or delicately filigreed gold; harvested wheat; bread slowly kneaded, left to rise, and oven-baked; honey produced jointly by flowers and bees; the willow woven by the hands of Vincent, the basket maker; the twisted straw of chairs and *radassières*, and all the baskets of Vallabrègues make yellow the symbol of wealth achieved through man's labor.

And yet it was very difficult to preserve the yellow of girls' petticoats. Until the advent of modern chemistry, almost all yellow dyes were delicate and faded under the combined action of water, soap, and light. However, this never prevented the women of Provence from loving this color and using it for their dresses or for quilts or bed curtains. Yellow was so loved that it was called *coulour di baiso ma mio*, "the color of a kiss to my beloved."

*Zucchini flowers, delicious stuffed*
*or as fritters* (page 59).
*Straw chair seat. The straw used for*
*chairs and* radassiers *was aufo, a*
*grassy plant that grows along the*
*shores of the Rhône, or* sagno,
*a type of rye straw* (left).
*Wheat, along with the grapevine*
*and the olive tree, is the*
*foundation of Provençal agriculture*
(opposite page).

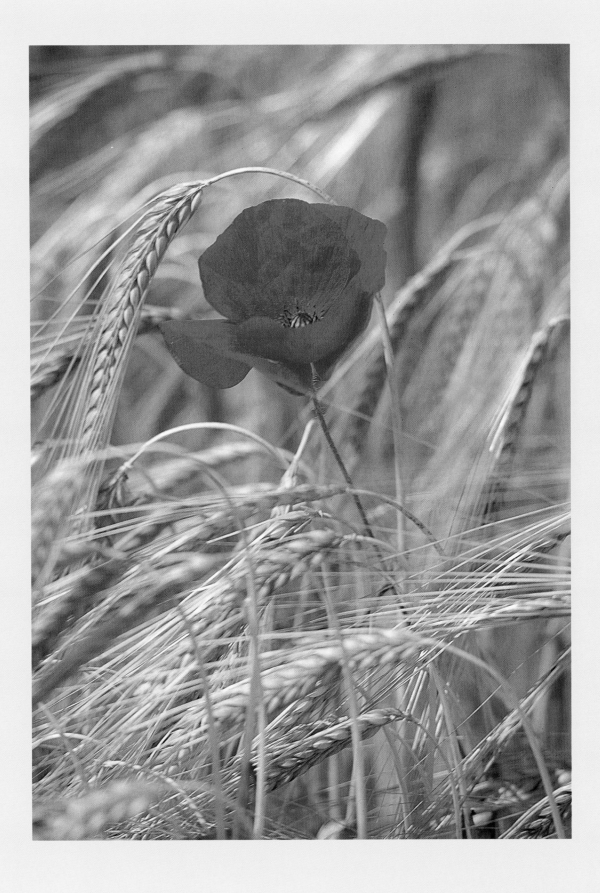

*The enchantment of a sunflower field, rising behind a century-old olive tree, in the Saint-Rémy-de-Provence plain.*

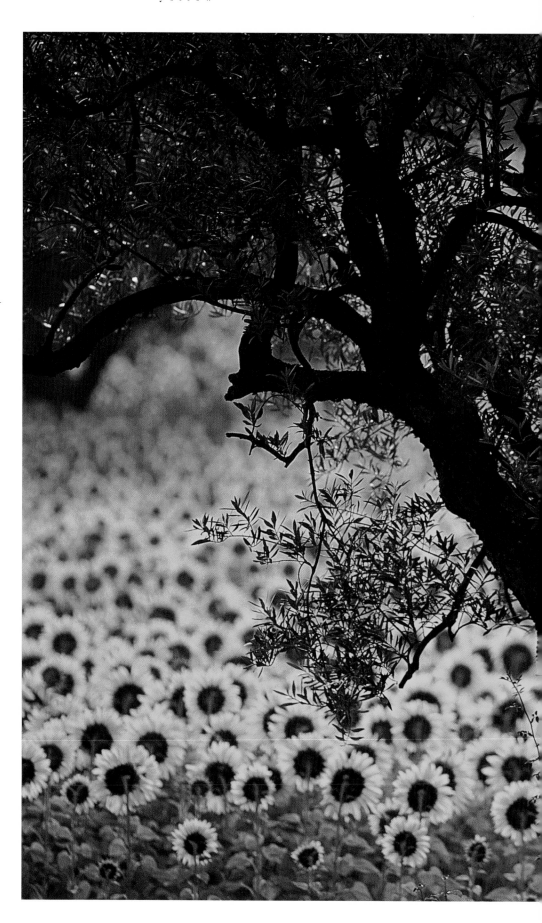

# Saint John's Summer Feast

Saint John's Day, June 24th, is the feast of the summer solstice. The sun is at its zenith, the grass is scorched, and the earth seems dead. This is the right time to gather herbs and plants for dyeing and for healing, as well as for perfuming the kitchen. This gathering follows ancestral laws in terms of the day, the phase of the moon, the maturity of the plants, the weather, even the hour of the day. It is also the time for reaping wheat and spelt, and Saint John's feast celebrates the completion of the harvester's work. This feast is meant to exorcise the "death of the earth" and favor its rebirth. It is the feast of sun and fire and water also, the rains that will replenish the earth. All over Provence, several rituals celebrated Saint John's summer feast. It was the feast of the color yellow, the color of sunburnt herbs, straw, and wheat and spelt berries.

Called *espeute* in Provençal or *petit épeautre*, "small spelt" *(Triticum spelta)* was one of the first varieties of wheat cultivated by man. It belongs to the so-called dressed wheat family because the berries themselves must be husked before they can be used. For centuries this was done by hand, and its difficulty contributed to the near disappearance of this crop, which nevertheless is well suited to the barren, dry lands of upper Provence. Luckily, new techniques have made it possible to farm this cereal again in the Sault country. Spelt flour can be used very well in place of wheat flour for making bread, pastries, and even crèpes. It can also be cooked like rice. Cooking time, in salted and peppered water, is thirty minutes.

One of the oldest recipes is for *petit épeautre* soup. You need a large pot to boil water to which salt and pepper have been added. When the water is boiling, throw in 1 pound of spelt that has been carefully washed, 1 pork hock, 2 sausage links made with pork rind, and a bouquet garni. Let cook slowly for one hour. Now add 8 medium-size, peeled potatoes, 8 carrots, 2 leeks, 1 celery stalk and $1/2$ a pound of white navy beans. Cook for another hour, always on a very low flame. Actually there are two ways of making this soup: the legumes can be cut into small pieces, as if it were a Provençal soup with *pistou*, and this generous, delicious soup is served immediately; or the vegetables can be cooked whole and first one eats the spelt soup, then the vegetables with the meat, as one does a chickpea *baïane* or for *bouillabaisse*.

I cannot resist the pleasure of giving you another spelt recipe, which is extremely popular for summer holiday buffets in the region of Luberon. It's a spelt tabbouleh. Carefully wash 1 pound of this cereal, then cook it for about half an hour in abundant water with salt and a lot of pepper. Turn the heat off and let the spelt swell for about ten minutes before draining; then let it cool. Now transfer it to a large salad bowl to which you will add 5 tomatoes, 1 cucumber, 1 sweet red pepper, and 1 sweet green pepper, all finely diced, the juice of 5 lemons, a generous trickle of olive oil, and a little salt and pepper. Cover the salad bowl and keep for a few hours in the bottom (least cold) section of the refrigerator: the tabbouleh must be served cool. At the last minute, add a fistful of finely shredded mint leaves. Mix one last time and serve.

*Petit épeautre soup is a meal in itself, an archaic joy, flavorful and generous (opposite page).*

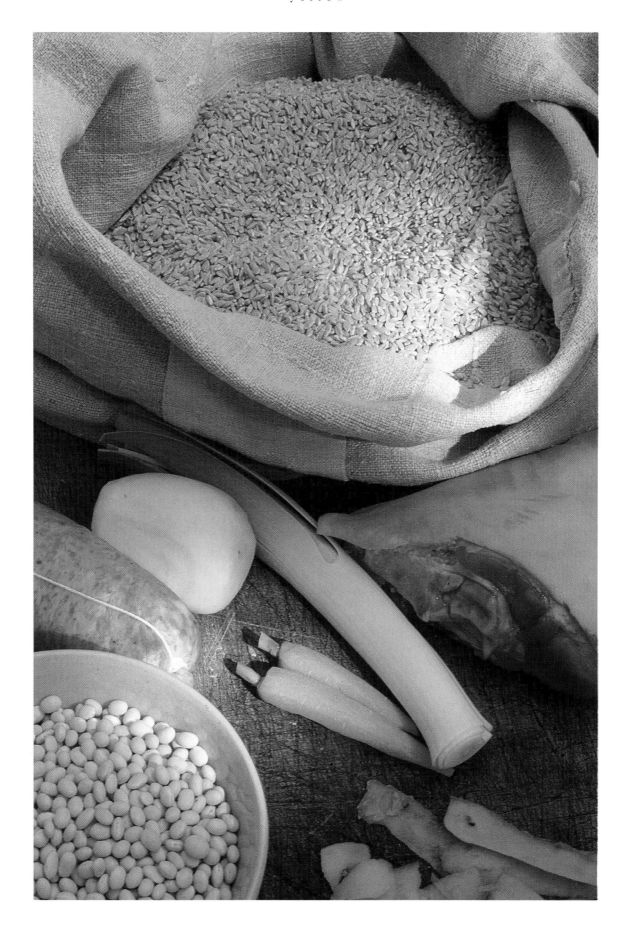

# Wicker Baskets, Rush-bottomed Chairs, and Straw Hats

In 1859, Frédéric Mistral published his first masterpiece, *Mireille.* The lovely music of Charles Gounod celebrates the love between Vincent and Mireille, and the choir of the silkworm breeders and Magali's song will be hummed in the streets for generations to come. But apart from the moving love story, *Mireille* is above all a poem of rural Provence, a magnificent evocation of its landscape, its people, and its legends.

Mistral situates the birthplace of one of the story's heroes in Vallabrègues, since handsome Vincent was a *banastounie,* a basket maker, and Vallabrègues was the capital of that art. A century ago, this municipality boasted no fewer than four hundred fifty basket makers and almost as many rush-chair makers. Vallabrègues is a small, pretty village nestled on a bend of the Rhône River, north of Beaucaire and Tarascon. On these humid, deep lands grew rushes, reeds, and willows. Nevertheless, it was on the islands of the Rhône that the inhabitants of Vallabrègues, from All Saints' Day through the end of May, went to gather most of their harvest. So that several families of men, women, and children would settle for six months in a large reed hut and cut willows the whole day.

*In former times, when people went to buy Carpentras strawberries, they would carry them home in one of these pretty baskets made of woven wicker.*

The *osier,* used for wickerwork, is the young, flexible branch of the willow tree *(Salix viminalis).* There is green willow, also called island willow, that grows in the marshlands; yellow willow, highly prized for fine basket weaving; purple willow, whose branches split easily; and finally black or blue willow, with smooth, slim branches. Of course, these are the colors of the bark. To make a rustic-looking basket, wicker is woven with its bark intact. "Fine" baskets, however, are made with blond wicker: removed of its bark, very pale, almost white at the beginning, with time it takes on a golden patina—a soft yellow color, warmer than the color of straw.

Next to wicker, reeds, called *massetto,* were also used, and *sagno,* a marshland plant with razor-sharp leaves that can cut, called *Typha latifolia* by the botanists. Basket makers would weave all sorts of *banastes,* which are large panniers or hampers; *couffins,* which are soft, large baskets with two handles and a wide top that were often used as portable baby cribs; and *nasses,* fishermen's conical-shaped baskets used to trap

fish. They also made straw mattresses, cushions, and pillows, and even large mats to be used as roof covering.

Today the basket makers are gone from Vallabrègues. At the beginning of August, however, there is a basket fair, when all the village residents hang their panniers and baskets from their window shutters, while basket makers from all of Europe show their wares.

Luckily, in Vallabrègues there are still two famous rush-bottomed chair makers. The straw used then and now for chairs and *radassiers* is called *aufo*. It is a grassy plant that grows in large quantities along the shores of the Rhône. Its uneven color, from soft green to yellow, creates decorative weaving effects. *Sagno*, which is rye straw, was also used. Durable and shiny, it was twisted to cover other less costly filaments such as bulrush, sedge, and even corn leaves.

In hat making, on the other hand, woven rice, rye, and wheat straw were primarily used to make the large, lovely *bérigoules* worn by the peasant women of Provence. Actually, in Provençal *berigoudo* means "mushroom." It was therefore natural to baptize thus this wide-brimmed, small-crowned hat, which in winter was made of black felt decorated with a gold net and in summer of woven straw. It was worn on top of a plain cap, and until the end of the nineteenth century was part of the traditional Provençal women's costume. In the villages around Nice, straw hats had a quite different look. The hat had a very small crown, which gave it the shape of a somewhat flat cone; the straw brim was held straight by hemp straw, and the whole hat was trimmed and decorated with black or colored velvet ribbons. At the end of the nineteenth century, colored wool-yarn embroidery with flower and fruit motifs—mimosas especially—replaced velvet ribbons.

As for the Panama hats worn by César and Monsieur Brun in Marcel Pagnol's films, they were not woven in Panama, as one would think, but in Ecuador. Undoubtedly, there were some Marseilles workers among the workers who had come from Europe to dig the famous canal. When they returned wearing straw hats, these were naturally called Panama hats, the name still used today.

*All the 18th-century*
*Provençal straw hats:*
*A bonnet in rye straw*
*decorated with silk ribbons*
*and paper fruits,*
*a Nice hat with a velvet*
*border, and a large*
*bérigoule from Arles.*

# Yellow Dye

Once upon a time, in very ancient times in faraway China, lived a princess called Si Ling-chi. She took an interest in a small caterpillar that lived on a mulberry tree; she would observe it carefully, learning how to tend it and how to unwind from the mysterious house where it would hide during its metamorphoses the magnificent, glistening thread that would later conquer the world. For centuries, silkworm farming and silk making were secrets jealously guarded by the Chinese. Nevertheless, at the time of the Hang dynasty, word of this luxurious fabric traveled to Rome, thereby opening the legendary "silk routes." Starting in the twelfth century, it was the Venetian and Florentine silk merchants who made their cities rich with their trade.

When, at the end of the thirteenth century, the papacy left Italy and moved to Avignon, it brought with it a brilliant entourage and the expectation of luxury: the satisfaction of these needs wrought important changes in the local customs. Thus it was that mulberry orchards and silkworm farming made their appearance in Comtat Venaissin. The strong silk industry in Provence dates from that time, and still exists despite the emigration of some of the weavers to the Lyon area, which coincided with the pope's return to Rome.

Provence was then blanketed with mulberry-tree fields, from the Var region to the Cévennes Mountains, and several silkworm nurseries raised the precious cocoons. The Lyon silk manufacturers bought the most beautiful to weave sumptuous silks. The second-grade cocoons, those that were pierced or damaged, were unwound, dyed, and woven in Provence, in the small factories of Marseilles, Avignon, and Nîmes. Everywhere, in homes as well as on costumes, Provençal silk added its glittering shimmer to the colored simplicity of printed cotton. Floss-silk and waste-silk fabrics, linens and taffetas, "Avignon sarcenets," and "Marseilles satins" took on all the shades that madder root, woad, indigo, and the gallnut could lend them. One color, however, seemed to be the favorite of Provençal dyers for dyeing silk: yellow.

Several plants were available to dye these fabrics yellow, first of all plants that grew wild and were gathered along the slopes of Mont Ventoux and in the Comtat hills. The stalks of the sumac plant, ground and dried, yielded a fawn color. The leaves of the fustic plant yielded a reddish color; however, the stalk, removed of its bark and broken into small pieces, yielded a yellow that was much loved by the women of Provence, a slightly orange-tinted yellow called *coulour di baiso ma mio*, "the color of a kiss to my beloved." This dye, which was not colorfast, was used primarily to dye wool, animal skins, and leather; the yellow derived from the fustic plant did not take well to alkali or soap, and turned very easily. There was also the fruit of the buckthorn, called "Avignon seed," which was harvested before it was fully ripe and contained a lemon-yellow powder that dyed cotton with another non-colorfast yellow. On Mont Ventoux, *genestrelle* or *petit genèt* was also gathered: it is *Isatis tinctoria*, dyer's greenweed (also known as woadwaxen). From its roots, a yellow dye was extracted that was relatively strong and therefore widely used in Provence.

*Stitched quilts, caracos, and petticoats of block-printed cotton from Provence, from the end of the 18th and beginning of the 19th century, show the whole range of yellows (opposite page).*

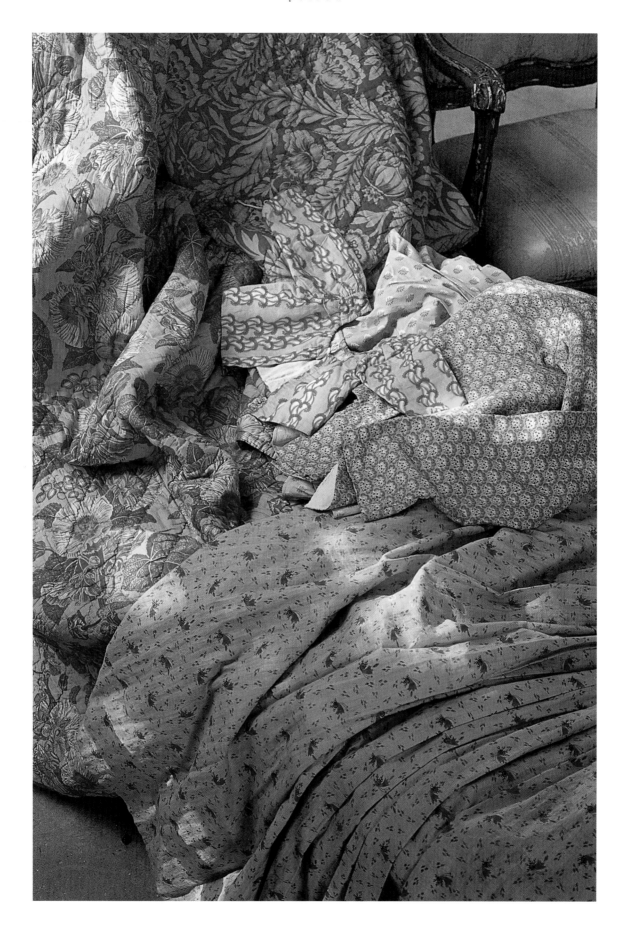

*Silk taffeta petticoat decorated with* boutis *embroidery, worn in the 1780s by elegant Provençal* bastidanes. *This technique was known as "Marseilles stitch."*

However, the loveliest yellow dye was produced by a plant grown for this particular purpose. It was the ultimate "yellowing weed" and it gave a colorfast yellow: it was weld, also known as "dyer's weed" *(Reseda luteola).* The whole shrub was used. Roots, leaves, stalks, even the seeds contained a yellow coloring substance held to be the most colorfast and the most beautiful. It was grown primarily in Comtat Venaissin, sown in the fall, and harvested in the first two weeks in June, when the plant had almost completely lost its young green color and was starting to turn the color of straw. This plant was not cut down; rather it was pulled so that the roots could also be used. It was allowed to dry and then made into bundles to be sold. However, at the end of the eighteenth century a substance called quercitron was discovered, extracted from the bark of a North American oak tree. Upon being introduced to Europe, it met with immediate success and quickly supplanted dyer's weed.

While yellow was a highly prized color in Roman antiquity, strangely, over the centuries its popularity diminished. In the thirteenth century, gold, both light and substance, sparkled in all the domains of art, while yellow was considered the color of Judas the traitor and, by extension, the

Jews. Several laws compelled the Jews of the Comtat and Provence to wear yellow garments or at least a *rouelle,* a round yellow patch to be sewn on their clothing, a distant ancestor of the sinister yellow star of the Third Reich. Dyer's weed, one of the main plants used at the time for yellow dyeing, was called *erbo di judieu,* "the Jew's plant." While these discriminatory measures decreased in intensity, they did not disappear, since a traveler passing through Avignon in 1783 speaks of the beauty of the Jewish women of that town, noting that "during the day they stand out on account of the yellow ribbons they are forced to wear."

Despite this degrading association, in the second half of the eighteenth century and the first half of the nineteenth century, up to the Romantic Age, yellow became a fashionable color, used especially in costumes and in house decorating. The "Avignon sarcenet taffetas" were especially popular in yellow. These fine silk fabrics were

used to make quilts and petticoats in *piqué de Marseille*, a delicate lace embroidery held by a web of parallel stitches inside two fabrics. Most of these magnificent, web-relief embroideries were applied to white cotton, jonquil-yellow or golden-yellow taffetas, or, much more rarely, to green, blue, or pink taffetas.

During the same period, a good number of blankets stitched in "Marseilles satin" or, more modestly, in waste silk, document the taste of the Provençal people for yellow. It was undoubtedly the most frequently used color in dyeing silk in solid colors. However, the cotton dyers and printers made extensive use of yellow as a background color as well. The printed cottons that were used to make stitched petticoats, loose jackets, dresses, and aprons for the women of Marseilles and those who lived by the seashore had tawny, white, or black backgrounds; but very often they had yellow backgrounds, regardless of the color of the patterns such as scrolls with flowers, fruits, and birds, Chinese motifs, bouquets or palm leaves, stylized flowers and fruits in the *batons rompu* style. For printed upholstery fabrics,

yellow backgrounds were also quite popular, except that the patterns were on a larger scale. These Indian-print cottons originated from local workshops in Avignon, Tarascon, Aix, or Marseilles but especially from the Jouy-en-Josas factory. Finally, it is curious to note that the cotton and silk braiding that bordered the hems of the common women's petticoats at the end of the eighteenth and all through the nineteenth century was often yellow, even when the petticoat was red or blue.

From the most ancient times, dyeing was a mysterious art, a science mastered in the darkest secrecy, and its practitioner was a "master dyer." This craft was regulated by Colbert in 1667. In addition to distinguishing between dyers of colorfast dyes and non-colorfast dyes, the regulations gave a very strict definition of the dye's quality, a factor in determining the price of the fabric. But it is in the course of the eighteenth century that the techniques improved considerably, thanks to the cooperation of the best scientists, including members of the Royal Academy of Science who were not reluctant to assist the dyers in solving their problems with colors. Nevertheless, while yellow dyes became really colorfast only with the advent of modern chemistry, yellow seems to have been such a highly prized color in eighteenth-century Provence that apparently the inconvenience of its lack of colorfastness did not discourage the widespread use of all types of textiles dyed in that color.

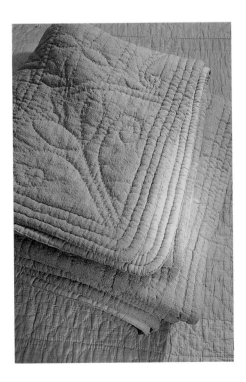

*Late 18th-century stitched coverlet in waste silk. Waste-silk fabrics were mostly dyed yellow at the time.*

# Gold and *Dorures*

*Dorures* were the jewelry young girls received in the form of dowry from their fathers, along with pieces of precious fabrics and lengths of lace.

The history of Provençal jewelry is closely connected to that of its fashion. The prosperity Provence enjoyed in the eighteenth century (with the exception of the terrible plague in 1720, which shook the whole country to its depths), the intense trade at the duty-free port of Marseilles where the most beautiful Oriental fabrics were imported including painted cloth, Indian cottons, and chiffons, and the no less important Beaucaire fair where Flanders lace was found, along with jewelry and precious stones from the jewelers of Amsterdam and Paris—all of this favored the flourishing of a rich and elegant regional costume. Beginning in the eighteenth century, the clothing of Arlesian women stood out. The use of printed cottons, the lovely bonnets in the "wool comber" or "canoness" style, the simple *pletchoun* rolled around the head and the very unusual *droulet*, a type of short gown with long, slim tails in the back, composed an extremely attractive, highly colored costume, so different that travelers were impressed. And what is remarkable is that Arlesian women of all classes adorned themselves with jewels.

The painter Antoine Raspail, who described the small society of Arles at the end of the eighteenth century so well, depicts pretty

craftswomen and shop seamstresses proudly wearing around their neck a Maltese cross and on the right arm a large bracelet, the *coulas*, a gold bangle "thick as a goose feather" that ended in two loops hooked one into the other. From one of these loops dangled another Maltese cross or a heavy medal. This bracelet was worn until the Restoration.

The Maltese crosses, so called because they displayed the mark of the Knights of Malta, were a reminder of the long history that bound Provence to the Order since its foundation by a Provençal man. The crosses were made of gold and were decorated with engraved, enameled patterns, white in front and black on the reverse, suspended at the neck by a black velvet ribbon tied at the nape.

The women of Provence also wore other types of crosses, such as the "cross of the devout woman," made of silver on gold and enclosing, in a tight setting, rose diamonds in sizes that decreased toward the cross' arms. Another cross, the *maintenon,* had six diamonds, plus one for the pendant ring, set inside gold cones. The *capucine* was a cross decorated with five gold cones with diamonds mounted in them, and the pendant ring was shaped like a Saint Andrew's cross and decorated with an additional, identical cone. Finally, the "butterfly" cross was a large cross in

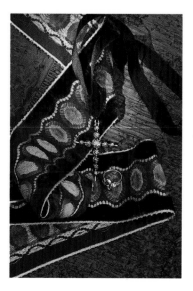

*Jewelry from Arles was often set with rose-cut diamonds, like this "cross of the devout woman" and the ring lying on a cap-trimming ribbon made of Saint-Etienne silk velvet.*

*An 18th-century reliquary, decorated with rolled paper strips gilded along the edges.*

gold and silver, richly shaped and embellished with stones.

When bonnets wrapping the face, such as the "wool comber" or the "canoness" styles in Arles, or the *couqueto* in Marseilles, ceased to be fashionable, Provençal women promptly started wearing pendant earrings in the *poissarde*, a low-class market vendor, and "creole" styles. They also wore rings, embellished with rose diamonds, garnets, coral cameos, and agates, on several fingers.

Finally, in the nineteenth century, the custom of offering a long gold neck chain with finely worked links came to celebrate the birth of each new child. Seven children meant seven gold chains, glittering symbols of the bond of love and slavery.

But in Provence gold shone not only around women's necks. The magnificent baroque chancel of Notre-Dame-des-Anges in L'Isle-sur-la-Sorgue, just like all the gilt-wood frames, panels, and consoles tables decorating the lovely townhouses of Aix-en-Provence or Avignon, testifies to an art that the people of Provence masterfully produced from the sixteenth to the beginning of the nineteenth century. In Provence, the gilt-wood sculptures, furniture, and objects were always carved in linden, a soft wood with no grain, which lent itself beautifully to the carver's tools. The clergy, the aristocracy and the upper middle class gave work to many wood carvers and gilders. Although they always tried to copy Parisian models, these local artists, succeeded, perhaps unwittingly, in creating a unique Provençal style for gilt wood, both in technical—such as the use of local clay to make the *assiette* (the reddish foundation for the setting of the gold leaf) or the custom of making their gilding even brighter by making generous use of the agate stone to polish it—and purely stylistic aspects, since they drew largely from the repertory of decorations that were traditional to the region, sculpting olive branches, laurel leaves, or grape leaves.

The glittering mirrors and the gilded frames played lovingly with the beautiful light of the Provençal sun; however, there was also a more modest use of gold, more intimate, and on a smaller, more personal scale, brightening the edges of paper strips delicately and lovingly cut and rolled by the sisters of the Carmelite convents of Provence.

In the eighteenth century the Carmelite nuns of Aix, Arles, Avignon, Carpentras, and Marseilles would make attractive *paperoles* as offerings to their benefactors. These were cardboard boxes under thin glass that contained scrolls and spirals of gouache-colored paper strips, gilt along the edges, surrounding devout images and saintly relics.

Because of the modesty of the materials, for a long time lovers of religious art and collectors disregarded these marvelous works of art. Nevertheless, the virtuosity and meticulous work the Carmelite nuns dedicated to the service of their faith was certainly equal to that of many wrought-iron workers, lace makers, or goldsmiths. More than talismans intended to protect their owners, and despite being magnificent art objects, although probably this was never the intention of the patient, cloistered nuns who created them, these *paperoles* were first of all an act of faith, true prayers given in thanks. The gold that brightens them is at the same time substance and light rather than color, and holds the same significance of gold in the medieval illuminated manuscripts.

## Pastis, Aniseed, and Absinthe

*Pastis* is drunk while playing *boules*. It brings the sun to the head, and that's why one drinks it in the shade while keeping score. *Pastis* is the key to the Provençal's cheerfulness and conviviality. It is an unavoidable ritual that goes with *tapenade*, olives crushed with capers and anchovies and dressed in oil, vinegar, and herbs, and *poutargue*, mullet fish eggs that are salted and pressed into a sausagelike shape. As a matter of fact, we should say *pastis* in the plural, because although it is alcohol-based and flavored with the essence of aniseed or star anise and different herbs, sugar, or caramel, and each is drunk diluted with iced water, all *pastis* makers jealously protect the secret of their composition and affirm their personality. So that to tell them apart becomes a question of taste.

There are, of course, the more popular kinds, the *pastis* that have been popular for generations such as Ricard and Jeannot, where the flavor of aniseed dominates, or Casanis which has more of a licorice flavor, and 51, which is drier. However, the revival of public interest in regional country products has brought back several "old-style" *pastis*. We will mention Lou Garragaï of the Jeannot distillery, the *grand cru* of a famous *pastis*; the Henri Bardouin, which is flavored with star anise but with nutmeg and cinnamon, pepper and cardamom, clove and wormwood; the Rayon Vert that has a beautiful, clear, strong green color; and finally the Jean Boyer *pastis*, of a color tending to yellow, still produced by traditional methods, with a delicate aroma of aged *Chartreuse*. This last *pastis* contains no sugar, no caramel, and no coloring agents.

*Symbol of Provençal conviviality,*
*pastis served in water with ice cubes*
*is the traditional apéritif*
(opposite page).

All the *pastis* are a lovely amber yellow, the color of liquid honey, before water and ice cloud them, creating that unique color, pale and translucent, midway between yellow and green. Sometimes, on the zinc counters of bars in Provence, this liqueur is mixed with grenadine, thus acquiring a light rose color: it is then called a *tomate*. If, instead of grenadine, mint syrup is added, the color turns pale emerald and the resulting drink is called a *perroquet*. Finally, *pastis* mixed with orgeat syrup takes on the opal color of milk and is called *mauresque*.

The anise is an annual umbelliferous plant of the Mediterranean regions (*Pimpinella anisum*) that is grown for its seeds. Because of their subtle and aromatic taste, aniseeds are used as flavoring for some cakes and, of course, to make *pastis*. Sometimes fennel seed is used instead, called, quite strangely, Paris aniseed. Star anise, also called Chinese anise, is the fruit of the aniseed tree (*Illicium verum*), a shrub of the magnolia family originally from China and India. It is star-shaped and consists of six to twelve follicles, each one containing a seed. Its aroma and flavor are very close to that of aniseed.

As for wormwood, it is a perennial plant, a type of artemisia with a strong, penetrating odor and bitter flavor. A liquor of a beautiful green color and bittersweet aroma used to be made with this plant. However, it played such havoc in drinking establishments toward the end of the nineteenth century that in 1915 the French government outlawed its manufacture and sale.

A final word about anisette, a homemade liqueur somewhat forgotten today, for which my grandmother gave me a wonderful recipe, which I am passing on to you. In 2 quarts of brandy soak 3 ½ ounces of crushed aniseed with a pinch of coriander, a pinch of cinnamon, 2 cloves, the dried zest of 1 orange and ½ a split vanilla bean. After fifteen days, filter it and add 2 quarts of water in which you will have dissolved 6 pounds of sugar. Anisette may be drunk straight as a liqueur or, like *pastis*, as a pre-dinner drink with ice water.

# Green

*We had a plunging view over a vast stretch of parks and green pastures.*
*The water ran into streams out of springs that were sheltered by giant plane trees.*
*Castles sitting in the middle of beautiful round lawns reflected their powdered faces into*
*oddly shaped ponds. Fancy: under the shady trees, idle women sat on armchairs!*
*—Jean Giono, Les Deux Cavaliers de l'orage*

In this land that basks in the sun's light and warmth, yellow and red are symbolic colors. Blue is omnipresent in the sky, especially when the mistral chases fog and clouds away. And yet Provence has a short season in which to be green: it is springtime. The young shoots appearing on cypresses and olive trees make these trees share in the feast of greenery like everything else around them. Later, in the dry season, the olive trees will turn gray again, and the cypresses black. But for now, life infuses itself everywhere, on trees, slopes, hills, on plains and fields, down to the rivers overflowing with living water that allows the fluvial banks also to turn green. Soon kitchen gardens will overflow with splendid vegetables and orchards will be filled with juicy, sweet fruits. But none of this comes without labor; the fields must be sheltered from the strong winds which sweep down from the Rhône Valley. Hence the need to interpose between the wind and farmland those high cypress-tree walls that give shape to the plain. Come summer, grasses and wheat will turn from green to yellow; strawberries and Spanish pimentos, cherries and tomatoes, peppers and apples will turn from green to red; and later figs, mulberries, and olives, will shade from green to black. But before this happens, perfectly green nature bedecks itself with a multicolored explosion of a thousand springtime flowers, narcissus, irises, poppies, and wild orchids.

The new bride would be given this advice:

*Se la verduro duro gaire,*
*sares la noro de moun paire,*
*e aures li clau de pertout,*
*meme aquelo dou cagadou*

"If green-time lasts only a short time, you will be my father's daughter-in-law, and you will have the keys to everything, toilet included." Green-time was the time of engagement, innocence, the happiness of young lovers' paradise. But that time is short-lived. With marriage, the bride gets the keys to the whole house, symbolizing knowledge and power, including the key to the toilet, because responsibility carries with it some awareness of impurity.

This example is a good illustration of the philosophy that fills the everyday language of Provence as well as its proverbs. On her wedding day, the Provençal bride's gown or at least some part of her costume, the apron or even just a ribbon was green. In any case, the bride's attire had to include something green as a symbol of hope and fertility, just as the dish of sprouted wheat on the Christmas was meant to encourage a rich harvest.

There aren't many green stones in Provence; our stones are white, golden, or gray, sometimes rose, very rarely mauve. There is, however, a place where stone has made green its color, setting it for all time in marble: the green marble of the Alps, from the Maurin Valley up to Barcelonnette. Sometimes we find beautiful examples of it used as mantelpieces or flagstones in townhouses and country villas.

And yet some greens in Provence have a hard life: the dark green of evergreen plants for example, such as the pine, the cypress, or the cedar tree; or the green tending to gray, sometimes almost to blue, of the olive tree, the oak, the juniper bush or the plants of the *garrigue*. Apart from the short-lived springtime, they preserve only a token memory of green in their foliage. This is why this color is worshipped throughout the year in Provence on every suitable occasion. Hence the feast of green olives in the month of September, announcing *olivade* time; or Saint Barbara's feast that ushers in the calends festivities.

In fact, the worship of green includes water as sacred. For centuries, from the time when the Romans built the first aqueducts, some of which still stand proudly today, the people of Provence have tried everything, dared everything to seize springs, to sink wells, to channel, irrigate water, and replenish the earth. Little by little, this search and its victory changed the very nature of this country. Today, the green lawns of gardens and golf courses, the successful work of landscape architects, nursery designers, and swimming pool builders, and the harnessing of the Durance and Ouveze Rivers make it difficult to understand how only a short time ago water was considered precious and rare.

# Glazed Clay

We live in strange times, when gardeners have all become "landscape architects," building painters are now "wall artists" or "decorators," and craftspeople "creative artists." And yet we are not far from the times when potters were simply pot makers, fashioning everyday objects with their own hands and reproduced the same items for centuries. Their ancestors had achieved perfect forms, simple and functional, that barely evolved from one generation to the other. Each craftsman nevertheless would add his own imprint, a bit of his personality. Since baked clay is porous and had to be made waterproof for the storage of water, olive oil, and wine, a clay glaze was invented that gave it a yellow color—all the shades of yellow, pale or intense green, red, or brown.

How lovely were these earthenwares of Provence and Languedoc: dishes and plates, soup tureens and stewing pots, bowls and *tians*, coffee pots, jars for preserves and fat, flour containers, snail pots, crayfish pots sold to the fishermen of L'Isle-sur-la-Sorgue, jugs that poured water and wine easily and goglets for pouring a thin trickle, *toupins*, saucepans and casserole dishes, colanders and omelet turners, even chamber pots.

Pottery workshops were everywhere—well, everywhere there was clay. Many were isolated. More often than not they were small, modest shops that manufactured wares for sale in the immediate neighborhood. Since these glazed clay objects only rarely bore trademarks or signatures, and some shops had only a short life while others extended their activity over several generations, it is very difficult to study their output. However there were several production centers where several craftsmen were active, quite often producing comparable objects, and for this reason it is easier to identify the features of the pottery made in Biot or Vallauris, Aubagne or Dieulefit.

*The water of the Sorgue River is clear and cool all year round, a heaven for trout and wild ducks (page 76). Jar from Anduze, formerly used for the cellar storage of olive oil or olives in brine (page 77). These late-18th-century vases from Pichon, ceramist in Uzès, were made of a mass containing clays of different color, worked together (right).*

Biot specialized in large, potbellied jars with yellow-glazed necks. Equipped with a wooden cover, they were used for storing water and oil; sometimes they were placed in the cellar even before building the house walls, since they were too large to fit through the door. Biot, located next to the port of Antibes, exported large quantities of these jars. Today, they have become emblematic of French Riviera gardens, their massive shapes punctuating terrace railings and overflowing with geranium and ivy.

Vallauris manufactured dishes and plates, cooking pots, *toupins,* and *tians* that were sold along the seashore, and Dieulefit made pale yellow and green earthenware for the Rhône Valley. In Aubagne, in addition to plates and dishes often colored in a dark yellow, almost caramellike color, potters manufactured a small watering can, the *arrosoir d'Aubagne,* with its perforated rose attached to the bucket. In Aubagne all kinds of children's toys as well as miniature objects, were produced, including water whistles and trumpets called *tarraillettes.*

The inhabitants of Arles country purchased large quantities of glazed earthenware from the Languedoc region, where several potters were active. These wares from Uzès, Saint-Quentin-la-Poterie, Anduze, Vauvert, and Meynes were all finished with a glaze containing a lead oxide base bearing the charming name of *alquifoux,* which yielded either a strong yellow or an intense green.

*The orange-tree vases from Anduze owed their hues to lead, copper, and manganese oxides. They were so heavy, especially when planted with an orange tree, that a special wood cart was built to move them easily between greenhouse and garden (opposite page).*

In the country around Apt there were many potters also, as evidenced by the yellow-glazed earthenwares that were excavated from digs. It seems that Apt and Le Castellet were probably among the very first ceramic centers to produce fine faïence crockery. The soil's exceptional quality, rich in sand, and the talent of the craftsmen who were able to master the high-temperature baking required for these faïence wares, combined to give rise to a production that was remarkable at once for its elegance and its rustic simplicity. The main feature of Apt glazed pottery is the lack of colored designs on a white background, unlike the white dinnerware from Moustiers or Varages decorated with a yellow border, flowers, Chinese-style patterns, and fanciful embellishments, or the richly polychromed, beautiful faïence from Marseilles. In Apt, as in Castellet, decoration was often expressed with reliefs made use of the interplay of light and shadow, on a solid, pale yellow color, more rarely ocher, brown, or green. These tints came from the natural color of the clay.

As far back as the end of the eighteenth century, Apt potters became leaders in the mixed-earth technique, using a paste of several colors, either marbled or mottled, sometimes called *à la brocatelle.* On most objects, this paste was highlighted by borders or by relief decorations in pale yellow enamel. This technique was revived and interpreted in the nineteenth century by the faïence makers of Uzès.

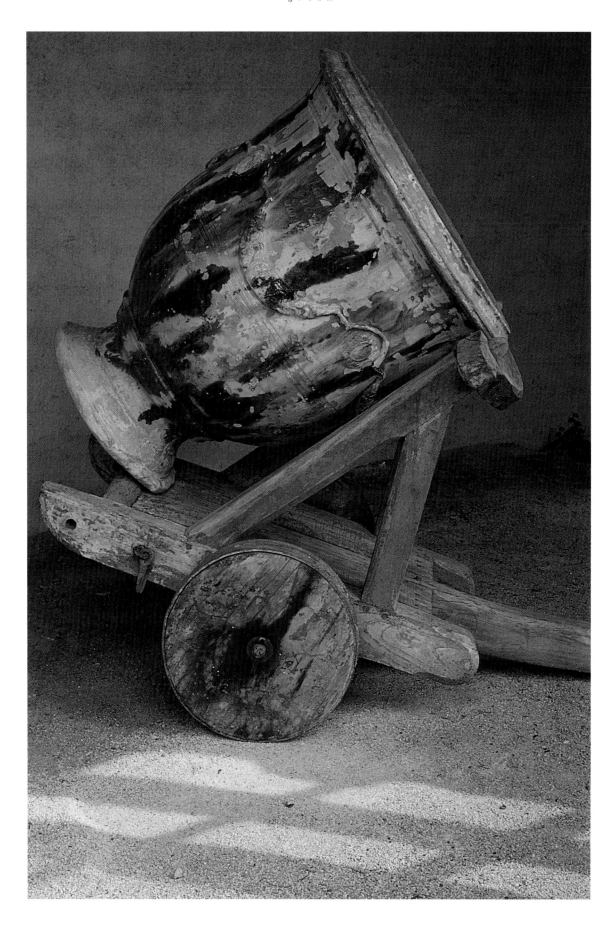

## Green Wheat, Saint Barbara's Wheat

Every December 4th, Saint Barbara's Day, a few wheat berries are put to sprout on a bed of absorbent cotton or moss gathered in the hills and heavily soaked with water in a small dish. Some families also sprout lentils, chickpeas, or a whole garlic head placed like a hyacinth bulb atop a water-filled pitcher. This tiny garden suggests a bit of spring on the Christmas table; in the middle of the dead, cold season, it symbolizes the hope that soon the land will again produce crops.

According to the legend, Saint Barbara was born in Nicomedia (now Izmit), on the shores of the Sea of Marmara, in the third century. Her father, a satrap named Dioscurus, imprisoned her in a tall tower to shield her both from men's eyes and from the new religion that was beginning to spread. One day Dioscurus had to leave. When he came back, his daughter had converted to Christianity. In a rage, he ordered that she be put to death, but she was nevertheless able to escape. A search throughout the country was begun, and as she was on the point of being caught, a rock

*Young wheat
fields bordering Goult,
a Luberon village.*

*Saint Barbara's sprouted wheat dish, the table centerpiece for the Christmas Eve supper, augurs a beautiful, rich harvest.*

miraculously opened before her to shelter her. In the end, she was betrayed by a shepherd, captured and thrown in jail. She was then subjected to several terrible tortures: she was tied to the rack, lashed with switches, her flesh rent by iron combs, burned by blades heated over a fire, and exhibited naked and quivering through the town. At this point, an angel came to her rescue and covered her body with a veil. But her father dragged her to the top of a mountain to behead her. As soon as the deed was done, he was struck by lighting and perished instantly.

Saint Barbara is represented standing next to a tower, holding the martyr's palm frond in her hand. She is the patron saint of firework makers, artillery men, and masons. One prays to her for protection from lightning, fire, and sudden death. What connects her directly to our sprouted wheat? It takes twenty-one days, from Saint Barbara's Day to Christmas, for the wheat to grow bright green and straight.

Nowadays homes are more heated than they were in the past, and wheat has a tendency to grow a little too fast. So after a week, I place Saint Barbara's wheat dishes out on a window sill to slow their growth and strengthen them. For like all other crops, wheat requires care, attention, and love. The soil must be kept at a constant moisture level, not too damp or the wheat will rot. A mild temperature is required: if it's hot, the wheat

grows too quickly and turns sickly, and if it's cold it won't grow at all. Every day the dish must be turned a bit to allow daylight to reach all its sides. If you follow these guidelines, your wheat will be magnificent. And the new year will bring wealth and happiness, because the beauty of Saint Barbara's wheat foretells what is to come. Unhappy the wretched creature whose wheat is thin, yellowish, and dull!

# Cooking with Greens

When tradition was still part of Provence's simple, day-to-day life, it was possible to find in the hills all kinds of good things simply for the taking. Hunting, fishing, poaching (the distinction was clear only to the *gendarme*), and herb and plant gathering contributed at least half, if not more, of the quality and variety of home cooking. So one would gather snails, mushrooms, truffles, thyme and savory, wild asparagus, mulberries, and rose hips. People never went for a walk without taking along a basket and a knife, and never returned home with an empty basket. Between this gathering and the vegetable garden, between spinach and chard leaves, turnip greens, radish leaves, wild leeks growing in vineyards between plants, purslane, young poppy shoots, rocket, dandelion, chicory, and all types of wild salads, the people of Provence ate greens throughout the year. That's why people here talk about the "green" *tian*, the "green" pie, the "green" omelet.

I think I sensed raised eyebrows from some of you when I mentioned young poppies. And it also seems to me that, fascinated by the violent, fiery red of this plant's delicate petals, you never bothered to observe what its leaves resemble. This is where the plot thickens, because poppies must be picked just before the first flowers make their appearance. At the most, we might tolerate one or two buds, as this might help you recognize the plant. Otherwise, come springtime, you will have to carefully observe the poppies as soon as the flowers bloom, so as to be able to identify them the

following year. Actually, once the flowers have made their appearance, the plant is too tough and can no longer be used. Therefore, equipped with a large basket on your arm and an old garden knife in hand, walk along the sides of the road on a beautiful day in May and fill your basket with very tender, young poppy shoots. They are covered with a delicate green velvet, slightly more intense than the green of fresh almonds.

The whole outside part of the plant is edible. First, the shoots have to be blanched by throwing them in a pot of salted, boiling water. Three minutes will suffice: they will turn a lovely emerald color. Cooking them longer will strip them of their delicate flavor. Drain them thoroughly. Now they can be used as you would use spinach, for example, to make small green *caillettes*. *Caillettes*, literally, "small quails," are small patties, round and plump as quails, to be eaten still warm, just out of the oven, along with some good mashed potatoes. If any are left over, they can be served cold the following day. There is even a legend about *caillettes*: they say that one unhappy day when some peasants from Flayosc wanted to stone to death their own Saint

*Chards can be used for delicious gratins. The green part goes beautifully with sardines, and the white rib part is served with anchovies (right). Small green* caillettes *may be made with poppy leaves or any other green such as spinach, or chard leaves. (opposite page).*

84

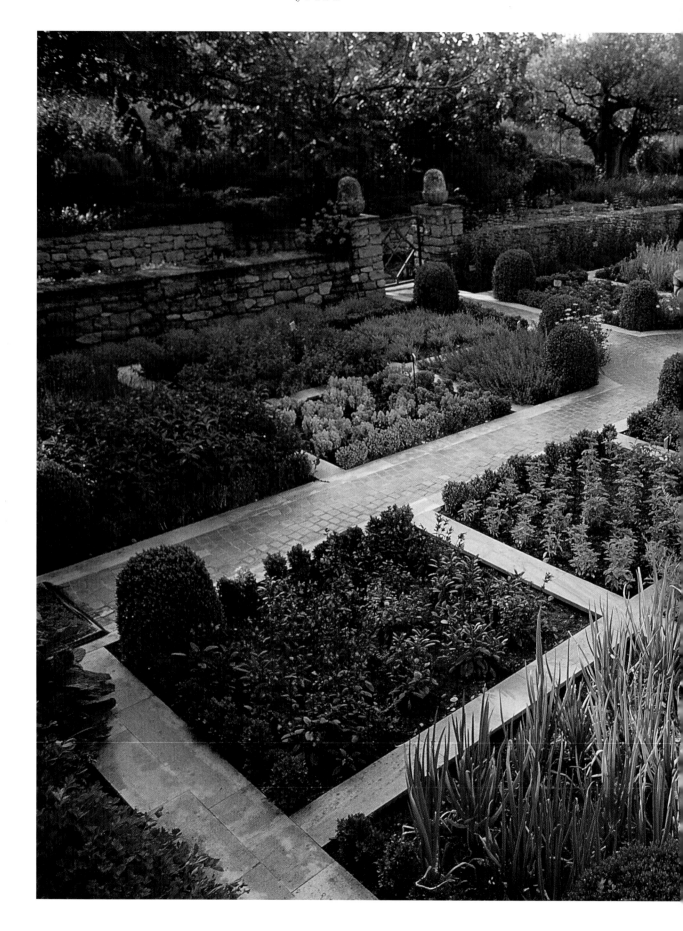

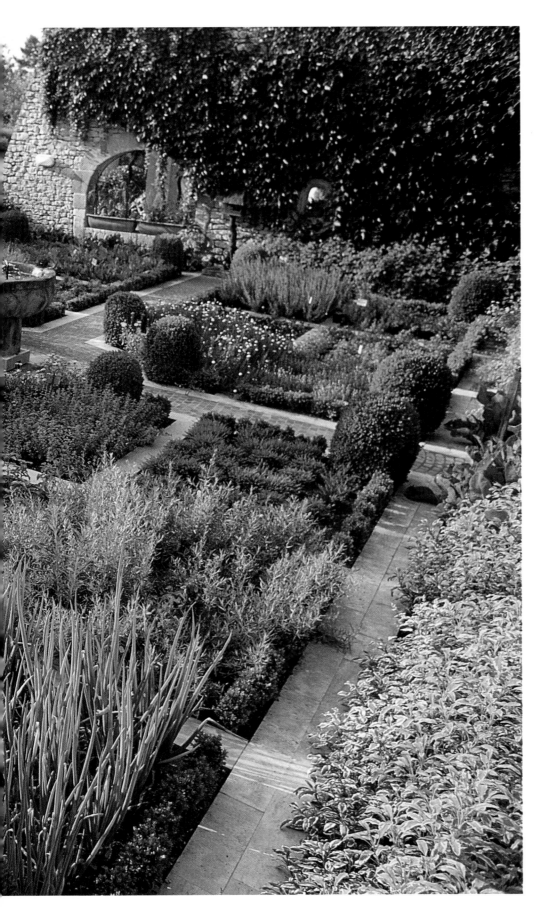

*This herb garden in the Luberon region grows thyme and oregano, basil and scallion, chamomile and verbena, wild thyme, wormwood, and hyssop.*

Sebastian, each stone they touched would turn into a roasted *caillette*.

Several recipes for *caillettes* from the country around Var, the upper Provence Alps and the Luberon use pork liver. I prefer the following recipe, which uses only lean pork and greens such as spinach, chard leaves, or young poppy shoots. Take 1 pound of lean pork from the neck and the belly, and grind it. Chop 3 pounds of washed, blanched and well-drained greens, and mince 6 garlic cloves. In a large bowl, mix all the ingredients, add salt and a generous amount of pepper and let rest for about two hours in a cool place. In the meantime, take ½ a pound of pork *crépine* (caul) and soak it in warm water. Caul is a transparent membrane, lightly covered with a net of white fat, that you will use to wrap around the *caillettes*. Drain and dry the caul on a dishtowel. Cut it into twelve pieces of about 6 inches square. Grease a baking dish with a bit of lard, form about a dozen small balls with the chopped ingredients, and wrap a caul square around each of them. Place them in the dish close to one another. On each ball place a small square of bacon and 1 or 2 sage leaves. Then bake for about an hour in a very hot oven.

*Renowned cracked olives from the Baux Valley. They are prepared in a brine scented with fennel and orange zest (opposite page).*

# The Olivades

Olive green! Green olives still on the tree are of an intense, fresh green, but they turn slightly yellow once they are put in brine. The leaves of the olive tree are pale green in the spring before turning silvery at the first heat. As for olive oil, its color ranges from golden yellow to amber green, and sometimes the color of the new oil coming out of the press is so strong that you could call it emerald green.

Recent work by scholars of prehistory indicates that the wild olive tree, or oleaster, and probably the cultivated species as well as, grew in Provence well before the advent of the Greeks. Undoubtedly, however, the Phocaean settlers encouraged its growth, which has only intensified since then. With grapevine and wheat, the olive tree has been a staple of traditional agriculture. And like the cypress, the pine and the fig tree, it is also a symbolic element of the Provençal landscape. Starting at the age of four years, the olive tree bears fruit every two years. It can live for several centuries and grow to a height of about thirty feet. It is pruned at the end of winter. The leaves and young branches shoot out in March. Its flowers bloom between April and June. The *olivades*, or olive-gathering days, begin each year in September with the gathering of green olives, the ones that go cracked into apéritifs. In its natural state, the olive is completely inedible, being dreadfully bitter. It must therefore go through several processes to remove the bitterness, each depending on whether the olive is picked green or ripe.

Actually, all olives are green before changing to purple, and they are purple before turning black. However, some varieties lend themselves better to certain preparations. Some olives are perfect for cracking, such as the *salonenque, grossanne,* and *picholine* varieties. First, the olives are lightly crushed; this used to be done with a wooden mallet. Then they are soaked for several days in clear water. Finally, they are stored in a fennel-scented brine. Cracked olives are a specialty of the Baux Valley. Each year, in September, the pretty village of Mouriès celebrates the green olive feast when, at high mass, the village children, dressed in their most attractive traditional costumes, offer at the altar a large basketful of olives in thanks for the harvest. There follows a magnificent procession throughout the village, followed by a picnic under the trees and, later, the bull races at the arena. Other types of olives are ideal for pricking and salting—*grossanne,* for example. This olive must be harvested when it is perfectly ripe and must be pricked as was done in old times, with a fork or a piece of cork studded with several pins; today, however, there are tools that make this work easier. The olives are then salted in wooden cases that are left outdoors to the double action of the salt and the cold, which will give them their flavor. The olive from Nice, or *niçoise,* very small and flavorful, is harvested when black and stored in brine for six months before it is ready for consumption. And the Nyons olive, harvested when it is even riper and starts to wrinkle, is immersed in a solution that contains some brine from the previous year.

*When very new, just pressed, virgin olive oil sometimes is of an intensely green color, like the bottle in the center of the photograph (opposite page). The color will slowly mellow over time.*

Once they are cured, olives can be eaten as they are, or used in preparing rabbit, duck, or *sarcelle,* a small freshwater duck, or superb *tapenades* made with olives, capers, and anchovies reduced to a paste. However, olives are also used to make an exceptional oil, light and fruity, which is equally well suited for consumption at the table or for use in cooking given its very high smoking point (410°F). Some varieties of olives, such as *grossanne, salonenque, belgentiéroise,* and *cailletier* are grown both for eating and for their oil. Other varieties, such as the *verdale,* the *aglandau* and the *bouteillan* are destined only for the oil press.

Beginning with Saint Catherine's Day, November 25th, the harvest of olives destined for the press begins. The olive pickers climb on three-footed wooden ladders called *chevalets* or *escalassouns* and pick the olives, either by hand, letting them fall in a basket, called a *corbelette,* attached to their waist, or by sliding a small rake, the "comb," along the branches. In the latter case, large nets are stretched under the trees to catch the olives. In olden times, instead of nets, large hemp sheets would be spread under the trees; the sheets were striped white and blue and were woven with an indigo-dyed thread alternating with a non-dyed thread. In the region around Nice, where olive trees are rather tall, olives are not "combed" but rather knocked down with a long pole.

As with the grape harvest, in the past the olive harvest was the occasion for great merrymaking. At the end of the harvest, the master of the olive grove would serve to the workers, relatives, and friends who had helped in the gathering a sumptuous *aïoli* that was eaten under the trees.

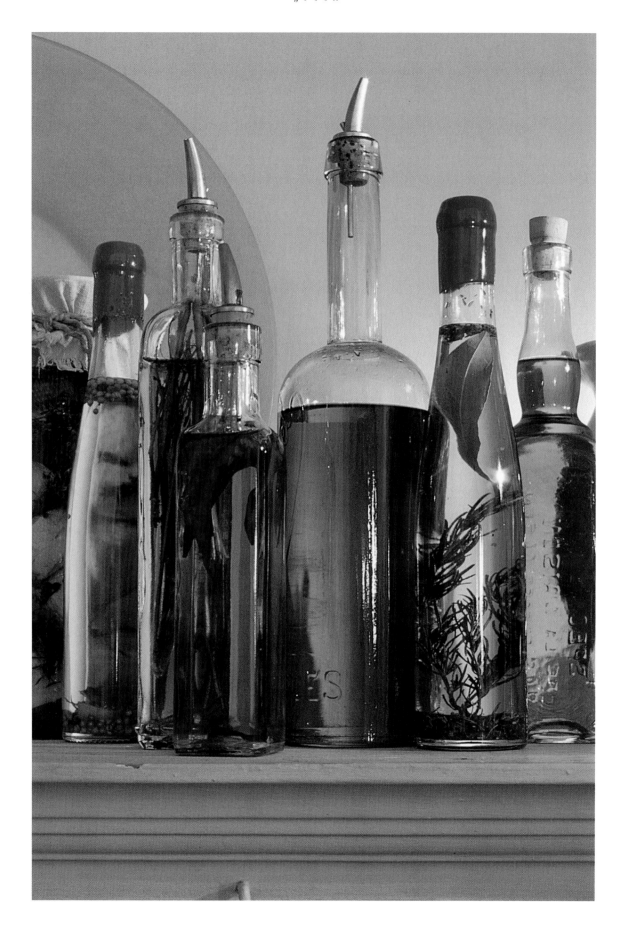

*Nets are spread underneath olive trees to catch the olives raked from the branches.*

Once gathered, the olives can be stored up to one week before going to the press but no longer; otherwise the quality of the oil could suffer. First the olives are washed under cold water, then they are crushed, with their pits, under a granite millstone, until a rich paste is formed. The paste is then spread in one-inch-thick layers on round filtering mats that in olden times were made with natural fibers and today are made of nylon, called *scourtins*. These mats are piled one on top of the other and placed under a press. This "cold press" procedure yields a juice containing olive oil and water that is collected in vats called *espérances*. The water must then be eliminated, either by decanting it or by centrifugation. Now the new oil can be tasted, and this is the occasion for another celebration, called *roustido dou moulin*. Large, thick slices of bread would be toasted, virgin olive oil would be poured on them, and they would be rubbed with garlic or crushed fillets of anchovies. These magnificent *tartines* were enjoyed with *grenache* wine, and happy songs were sung.

In times gone by, the oil would be stored in a cellar or storeroom in large, glazed clay jars. The jars were green in Anduze and yellow in Biot, and all had a wooden cover. Today, the oil is bottled in glass. However, it is better to use dark green bottles because olive oil stores better and longer when shielded from light.

*A banaste, a large basket full of the new olive crop.*

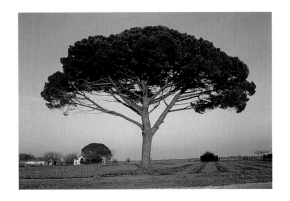

# Forest, *Garrigue*, and *Maquis*

The Aleppo pine is a conqueror. It grows very fast and equally well in sandy soil and chalky land, it spreads over *garrigues*, which are expanses of calcareous scrubland, and *maquis*, which is moorland or heath, shrubby wasteland; it rises again after fires, and settles in fallow land and abandoned fields. Not even the formidable caterpillars can slow down its invasion; and yet, when they finally leave the large white-thread cocoons they set up here and there on the pine branches, these insects can completely destroy the needles of all the pines in the vicinity. So that while from year to year, pine groves gain land, no Provençal will complain. There is something truly extraordinary in strolling in this universe of light vibrations. The air is imperceptibly shaken by the constant hammering of the cicadas and the cheerful, muted play of shadow and light. Even the ground, padded by thick needle carpeting, gives the walker a floating sensation, and the ethereal scent of the resin heightens the feeling of inebriation.

Today, the Aleppo pine occupies ten times more space than it did one hundred years ago. And yet, it was always there. One of its distant ancestors grew in Provence 25 million years ago. In addition to Aleppo pines, other types of pine also thrive. There are Scotch pine groves: these trees have a red, almost orange bark, and start growing at an altitude of one thousand feet while they thrive at an altitude of about a mile. Hook pines have darker needles and a gray bark. They don't like company and prefer to grow in solitude. The little hooks on its cones give the tree its

name. Finally, along the seashore grows the parasol pine, also called stone or piñon pine. Its large cones contain a delicious seed, the pine nut, used in the sea-bordering regions of Provence in several desserts, such as the *pignoulats* which are small, pine-nut croissants.

Similar to the Aleppo pine, the holm oak grows equally well in chalky or sandy soil. Its evergreen leaves love sunlit slopes. It grows everywhere, in the forest and in the *garrigue*. On the other hand, the white oak, also called pubescent oak, with deciduous leaves, tall and imposing, prefers deep, chalky soil, and the shade of mountain hollows. When young, this tree hosts the delicious truffle between its roots. Smaller, scraggly, and almost indestructible, given its resistance to drought and fire, is the kermes oak. It clings to even the most arid soil. This is the tree whose branches women and children used to scratch with their nails in olden times to remove the small insects full of red-dye capsules. When they are still young, the kermes oak and the

*A lonely hook pine on the Crau plain* (top).

holm oak can often be confused for each other, but when fully grown they look quite different. The holm oak has a vigorous look and is completely covered with very small green acorns that seem to hide in their gray pods. The kermes oak is sickly and stunted, as if exhausted from having to hold its heavy brown acorns. Finally, in the Maures mountain range grows the cork oak, whose bark supplies cork, removed in large slabs approximately every ten years, and the chestnut tree. These chestnuts are small, smaller than those of Ardéche or Piedmont, but their reputation throughout the centuries has been just as high, and would be still if one took the trouble of picking them up from the ground.

Not far from the oak trees grows the box tree. This shrubby tree grows to no more than six feet in height yet can have a life span of up to five hundred years. Its extremely hard wood was traditionally used to make a variety of hand-turned objects. Its thick evergreen foliage explains why it was used as sculpted hedges in the gardens of the *bastides*.

Beyond the pine and oak forests, the *garrigues* and the *maquis* spread out. Under the unforgiving sun, all is fragrance, scent, and perfume. Each step, each passing contact releases a new smell while at the same time causing the nervous scattering of thousands of insects. The scrubs and bushes of the *garrigue* cover chalky, arid soil. This is the domain of wild lavender and rosemary, thyme and the rockrose, the juniper and cade tree and the furze plant. As for the *maquis*, moorland,

*This lovely pine tree lane leads
to the town of Caromb in Vaucluse
(opposite page).
Before humans tamed them to grow
in fields and gardens, the lavender and
the olive tree grew wild all over the
Provençal scrubland.*

it prefers siliceous soil, such as that of the Maures range. This is the land of the strawberry tree, of heather, myrtle, and the mastic tree.

In Provence, forest, scrubland, and moor have a common ruthless enemy: fire. Each year, especially in the regions of Var and Bouches-du-Rhône, many fires break out, destroying thousands of acres. In certain places where the sun is harshest and trees such as the Aleppo pine grow rapidly, the landscape soon repairs itself. However, frequently recurring fires destroy all life. In the long run, rocks reappear. The desert settles in. The infinite palette of greens—dark green, soft green, gray green, blue green—lightened by the flowers' small touches of color, forever surrenders its place to gray stone.

# *Bastide* Gardens

Among the many pleasures that for a long time have marked life in Provence, there is one that gives meaning all by itself to the expression "the art of Provençal living" that seems to attract and fascinate the whole world. In fact, everyone on the social ladder, from the lowest rung to the highest, has built for himself or herself a country haven made of old boards or cut stones for pleasure, for entertaining, or just for resting in the fair season. People used to spend summer in their *bastides*, Provençal country villas of old, in the same way people still spend weekends in their country houses. And, since there is no pleasure without coolness, people tried to create whatever coolness they could within their means. The cottages that did not sit by the water of creeks or coves were shielded by the shade of pine trees. The cottages sitting in the middle of vineyards or fields where flanked by a vine trellis and one or two fig trees. The larger mansions enjoyed the shade of two plane trees, carefully positioned in front of the house. But the loveliest *bastides* of Aix-en-Provence and Marseilles were shielded by sumptuous gardens and surrounded by tall trees that reflected themselves in stone water pools. At the beginning of summer, I am sure, you have seen broad, yellow plains blanketed with ripe wheat, with something that resembles from afar a slice in the forest cut by a giant with a taste for vegetation. Sometimes, all the way on top, between the silhouette of a century-old pine tree and the leafy mass of a chestnut tree, set in the corner of a pink roof with perfect rows of tiles, sits an ocher-yellow chimney decorated with a stone flame.

These villas were built in the seventeenth and eighteenth centuries in the vicinity of Aix-en-Provence and Marseilles. The upper middle class and the rich merchants of Marseilles, the members of Parliament and those of the Audit Office of Aix-en-Provence, the sword-and-robe aristocracy, all carried on a brilliant life in the city. They built luxury townhouses, richly decorated with works of art, elegant furniture, china and silverware. They gave parties, carnival balls, concerts, and large dinners. Yet they were seized by the same instinct: as soon as the first heat was felt, they all wanted to repair to their country homes, which were clearly a symbol of success, and everyone, from the nobleman to the plain shopkeeper, dreamed of owning one. However, there was also a genuine desire to return, for a limited time, to a simple, wholesome life, to the happiness of a meal without ceremony or a game of *boules*. The neighboring farm always provided eggs, milk, poultry, fruits, and vegetables, and the garden surrounding the summer house offered coolness and the sweet life. So then, with the coming of good weather, a procession of hitched-up carriages, overflowing with trunks, small furniture, and boards, would set out for the bastide. And nothing could postpone this trip.

"They are so besotted with their *bastides*, cheap little places they have in the countryside, that they leave the best business in the world rather than lose entertainment in their cottages" wrote Arnoul, the commissioner of prisons, to Minister Colbert in 1668. In fact, it was a major phenomenon, since in the eighteenth century one counted about five thousand of these summer residences around Marseilles and over fifteen hundred around Aix.

If on the face of it, pleasure was the main reason for these sojourns in the country, and people settled in their villas as soon as they could to flee the town's boredom, the *bastides* were also a haven from more serious dangers. During the most threatening days of the Reign of Terror, life went on peacefully inside many of these homes as people patiently waited out the storm.

At the beginning of the seventeenth century, as the *bastide* started to appear in the Provençal countryside, a theory of the garden slowly developed at the court of Louis XIII. At the end of the seventeenth century, Le Nôtre codified the definitive arrangement of the ideal French garden, and the gardens of Versailles became the perfect model of this landscape organized in a rigorous yet elegant fashion. Italy, however, was very near by,

and the fashions of the people on the other side of the Alps have forever seduced the Provençal people. So it was that between the beautiful symmetry of a French garden and the terraced arrangement of an Italian garden, with its steps and its waterfalls, the Provençal garden found it own personality.

However, it would not have been possible for such gardens to bloom in a country where water is rare each summer, unless a true science of hydraulics had not been mastered: wells, irrigation canals, superimposed pools, and cisterns that stored rainwater played a fundamental role. Also, many of these country houses were built alongside a river, or at least on land were water sources could be found. In addition, the water had to be "tamed" and channeled, and to do that, complex networks of underground conduits and tunnels were built, made of brick and surfaced with glazed clay tiles; these works sometimes extended over a radius of several miles. I will never forget my astonishment when I visited the attractive *bastide* at Gaude, near Aix-en-Provence: behind the house, in the outbuildings I discovered a huge hydraulic room equipped with complicated machinery that made me think of the *Nautilus* machine room in Jules Verne's *Twenty Thousand*

*Leagues Under the Sea* and which regulated all the water circulating on the property.

The greatest charm of these gardens was that they offered shade to their guests. The shade unfurled all along the walk, flanked by plane trees or chestnut trees, sometimes scented linden trees, that led to the house. The shade stretched out from the forest of large pine trees and cedars that leaned up against the house. Shade lurked in the groves of spindle trees, laurustinus, strawberry trees, and fig trees, in the green lawns decorated like rooms, with statues and stone benches, in the *téses* where sometimes one would stretch large nets to catch small birds. All this was enclosed on both sides by box-tree parterres running along the base of the terrace. Strangely, the terrace was usually wide open in front of the house and stood in full light, no doubt to set off the harmony of the architecture. Some glazed clay pots planted with orange trees would decorate the terrace, and these would be taken inside during winter.

Past the garden was the kitchen garden and the orchard. Everything here was laid out to provide pleasure as well as display abundance. In the orchard, the trees were planted in alternating species, following a design that recalled the garden's arrangement. Several varieties were planted for each species, with varying degrees of blossom time, from the earliest to the latest. The vegetable garden also was chock-full of a great variety of vegetables. In fact, the whole Provençal garden was experimental soil, because the owners prided themselves on their botanical knowledge, they dabbled in medicinal herbs, and they would exchange seeds and cuttings and correspond with other horticulturists. They tried to grow exotic plants that sometimes adapted themselves so well to the local climate that they are now considered to be native to Provence. The plane tree, for example, was introduced only in 1754 and the Judas tree, the magnolia, the geranium, and the wisteria later than that.

*The castle of Roussan, a lovely bastide in the countryside of Saint-Rémy-de-Provence, is currently a charming hotel.*

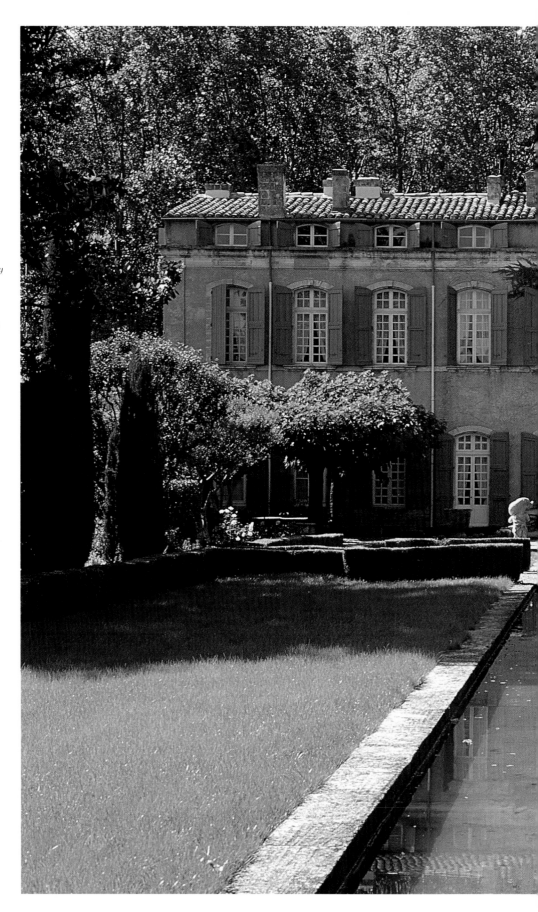

*The symmetrical beauty of the façade of this castle, a bastide in Brantes, is reflected in the pool.*

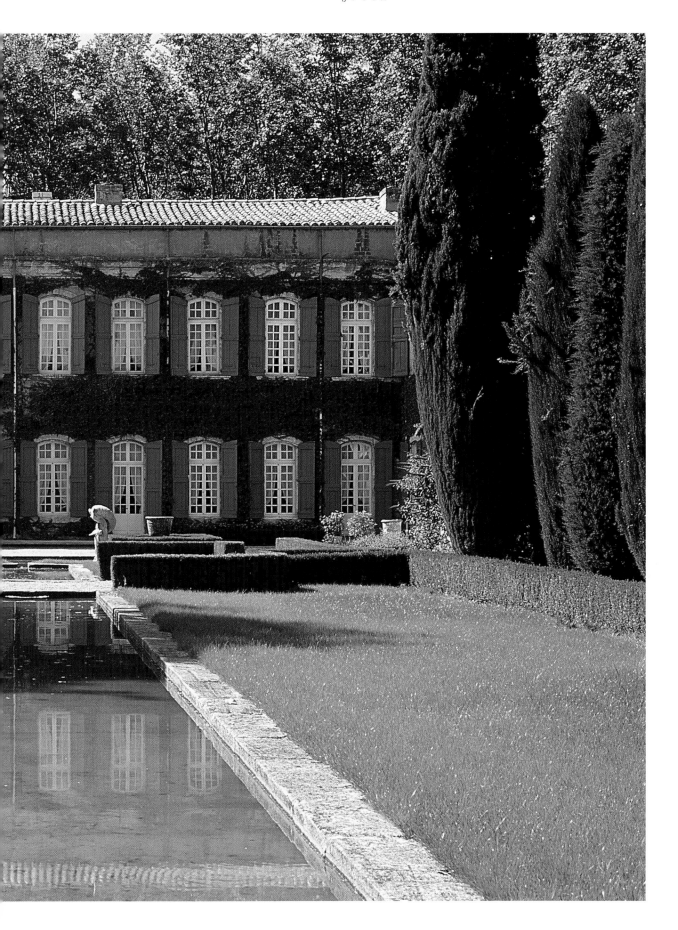

# Blue

*The Mediterranean has a color like mackerel, I mean a changing color, one never knows whether it's green or bluish purple, one never knows whether it's blue because one second later the changing reflection has taken on a rose or gray tint.*
—Vincent Van Gogh, Lettres à Théo

The Mediterranean Sea, the "Great Blue," has an ungraspable, deep, immaterial color, just like the atmosphere's blue that changes from the lightest of skies to the bluest of nights. But when the mistral has been blowing three, six, nine, sometimes twenty one days, dissolving mist and haze and scattering the clouds from the horizon, then the sky and the sea are both truly blue, of a rare, intense, luminous blue as majestic as the radiating magnificence of the sun. The paradox can then be noted of this ungraspable, transparent blue, symbol of faith, ruling side by side with the sun, symbol of pure reason. It is perhaps one of the secrets, one of the mysteries of Provençal light.

Blue has an infinite number of shades. Nevertheless, the indigo dyers, complying with an order of Minister Colbert, who wanted to regulate their craft, used to count thirteen shades of blue, beginning with the lightest, white-blue, then emerging blue, pale blue, dying blue, light bluish claret, sky blue, queen blue, turquoise blue, royal blue, woad blue, Persian blue, aldégo blue, and finally the darkest, hellish blue. They could not, however, pinpoint the exact point of passage from one hue to the other. Nevertheless, from the vats of Languedoc woad and West Indies indigo issued an abundance of blue fabrics, woolen broadcloth, silk taffetas, cotton cloth printed "à la réserve" and, of course, serge from Nîmes, the direct ascendant of American blue-jean cloth. Except for the blue of the sky and the sea, this color is quite rare in Provence, and it is always startling, almost incongruous, to spot, as one turns a corner, a cart painted blue, loaded with a just-harvested crop.

What about lavender fields, you ask? Those blue fields of flowering lavender that appear on the cover of all the books on Provence and are the subject of so many postcards? Well, first of all you should know that they are quite recent. Not too long ago, the Valensole tableland, the subject of so many photographs today, was all blanketed with almond trees. And if you lived next to a lavender field, you would know it turns blue for only a few days—even so, it is more purplish than blue—in the short time when the tiny flowers open, just the time it takes to be visited by the bees. For the rest of the year, however, lavender fields are gray, and their color dissolves in the light.

As far as purple is concerned, we eat it. First of all there is violet, the sea fig, a strange, wrinkled potato like limpet that concentrates in itself all the fragrance of the sea; for the people of Marseilles, it is the necessary accompaniment to sea urchins, oysters, and mussels. Then we have the small artichoke from Villelaure, the asparagus from Lauris, and especially the eggplant, round or elongated, light or dark skinned, but always purple. And what about a few Caromb figs for dessert? They are called black figs, but if you look carefully...

There is, however, one place, one moment that is simultaneously blue, mauve, and purple, beautiful and somewhat mysterious, something like an instant of eternity: it's the garden of the parish priest at Easter time. There is one, sometimes two or more, in almost all the villages of Provence. Behind their painted iron gates, these charming gardens suddenly become magical, bursting with irises, lilacs, and wisteria.

*Sometimes paint left over from painting a cart was used for shutters (page 100). In the coves of Cassis, Redonne, or Ensues, summer bungalows were often furnished with plain boards salvaged from shutters or fences and nailed together (opposite page).*

# Fishing with the *Palangrotte*

*Palangrotte* fishing should not be confused with *palangre* (trawl-line) fishing, for they are two widely different forms of fishing. A trawl line is a very long rope held aloft by cork floats and carrying a large number of vertical lines each placed six feet apart, which the fishermen lay down at night. They leave the trawl line out the whole night and gather it in the morning. With the trawl line fishermen catch eels, *pageots* (also known as "beautiful eyes") and *pagres*—a type of snapper—*fiélas*, whiting, and all kinds of good-sized fish. The very word *palangre* means "catch-all." By contrast, the *palangrotte* is one plain ground line that technically has just one fishhook. Sometimes however, our skilled coast fishermen attach several hooks to their line at spaced intervals.

I will now tell you about an unforgettable *palangrotte* fishing expedition. I was seven or eight years old, and I was spending the summer vacation as I did ever year in a large family house my uncle owned in Carry-le-Rouet. Up to that time, I had always been forbidden to tag along with the adults when they went fishing, under the pretext that I was too young. That day I had finally secured both

*The prow of a pointu boat was always embellished by an engraved totem, symbol of the fruitful meeting of fisherman and sea.*

my uncle's grumbling assent and my mother's resigned permission, and I was reeling with happiness as I left for the hills to fill a can with *limaçon* snails.

These are tiny snails that in the summer clamber up fennel leaves and are sometimes eaten "*à la suçarello.*" They are an excellent bait for the brightly colored *girelles*. The *girelles* seem to prefer this bait to a even piece of mussel or sardine. I had eaten my vegetable soup as if it were a real treat and had gone to bed very early. The following morning, I had even consented to wearing a heavy, rough woolen sweater that I usually detested. The three of us—my uncle Victor, my cousin Marcel, and I—met on the dock with a snack basket, a box containing the can full of snails, a few *palangrotte* lines, spare weights and hooks, and a big jute sack with two blocks of ice inside for storing the fish we would catch. We went on board. The boat was a "*pointu*" boat, one of those small, wooden boats sporting a strange phallic totem at the prow and a kind of small shed where the diesel engine is kept; it smelled of diesel fuel and paint and was all spruced up in its two shades of blue. I think the lighter blue was leftover paint from painting the cottage, and the darker blue was that of the garage door. The boat was called *Georgette.* It was the first time I was going aboard this boat. We started the engine in a cloud of smoke. It was still night.

The sea was perfectly still, almost flat; the only noises were the rhythmic chugging of the engine and the boat parting the water. We did not speak.

My uncle had explained to me that we had to reach the site where we would be fishing and prepare everything before sunrise. Apparently, the *girelles* waited until then to start hunting for their breakfast. We did not venture far, maybe half a mile beyond the port and about a hundred yards from the coast. My uncle stopped the motor, then threw a floating anchor to prevent our being dragged by the currents. We prepared our lines. I knew what they were because I had often played with them in the garage. Once I had even been severely scolded because I had tangled them up. A good fifty yards of fishing line was rolled around a cork rectangle. A large weight, shaped like a pyramid was solidly attached to one end; a little above that, a piece of string hung from the line with a hook attached to it. First we crushed a snail with a pebble we had brought just for that purpose, then we hung the snail on the hook without bothering to remove the shell pieces. The sea water would take care of that. The three of us threw our lines at the same time, at the exact moment that the sun's first rays were making their appearance.

Everything was bathed as if in green gold. We unwounded our line little by little until we heard the weight touch the sea floor. Then we gave it a little slack and waited for the *girelles'* good will. *Girelles* are small rock fish, among the most beautiful in the Mediterranean. The males have a blackish-green back and their sides are dressed in all the different colors of the rainbow. The female are white underneath and orange red on top. These fish live between algae in schools, with one male surrounded by many females. My uncle Victor would tell us that if a male died, one of the females would turn into a male and take its place.

*The ports along the Var coast, like the coves of Cassis and Marseilles, are home for many pointus, the traditional fishing boats.*

This story made me laugh a lot, but I never found out whether I should believe it or not.

The first one to feel his line "pull" under his fingers was my cousin Marcel, who pulled up three nice fish; my uncle followed, and then me. I had caught a *royal girelle* at least five inches long! From then on, things picked up speed. We could not stop. As soon as the line was in the water, it pulled again. The jute sack was filling up: mostly *girelles* but also a few *rouquiers*, two or three "blue" fish and a big, very ugly *sarran* with a throat as big as the fish itself. Now the sun was higher. The universe had turned blue. The sky, the rocks, the water, now rippled by a few waves caused by the boats that were leaving the port—everything was the same smoky blue. It was hot. I was so busy, so excited by my fishing that I was wet with sweat, and kept laughing without stopping. I had not even taken the time to take off my sweater. And then, all of a sudden, I heard a slightly stronger "tug" than usual. I tried to pull, but the line was heavy, really heavy. The line was so taut that it was going to cut my fingers. I called for my uncle

*Girelles are rolled in flour and fried in a large pan; all the other fish are destined for rockfish soup.*

to come to the rescue and he told me I had probably caught some trash. When the thing was no more than six feet from the water surface, I saw it moving, and my uncle shouted to Marcel: "The landing net, give me the landing net, it's an *octopus!*" And so it was, an enormous octopus, a monster, with tentacles at least sixteen inches long. It had decided to eat a *girelle* that had been caught in the trap and had also gotten hooked. We were finally able to hoist it in the landing net; very quickly, my uncle turned its cap over. But I was the one who had caught it! No one ever felt as proud as I did at that moment. We sailed back to the port around one o'clock. My aunts and my mother were waiting on the dock to take our catch and prepare the *girelles* for frying, while we rearranged and cleaned the boat. As far as the monster was concerned, we ate it the following day, in a stew.

*Light and shadow on the port of Martigues*

# Woad and Indigo

When Nicholas Ray filmed James Dean in his blue jeans, he wanted to depict the behavior and conflicts of American youth in those years. But when the young people of the Old World discovered the "rage of living," they in turn adopted American blue jeans and made them an international symbol, signifying that they, too, belonged to the same tormented generation. Later, blue jeans conquered the world, and whether new or faded, torn or patched, stone-washed or re-dyed, with holes or embroidered, extra tight-fitting or extra large, worn with a military-surplus, khaki-colored parka or with Céline moccasins and a wild-mink coat, a studded leather jacket, or a Canadian lumberjack shirt, a plain T-shirt, or a vest and tie, they possess the uncanny ability to clothe almost the whole population of the Earth.

In 1850, the conquest of the American West began. Gold diggers, miners, and adventurers, as well as traders and farmers, piled into covered wagons and set out full of hope toward the unknown, in the direction of California. Among them was a young merchant from Bavaria by the name of Levi Strauss, who was carrying a few rolls of coarse brown cloth to be used in manufacturing tents and wagon tarpaulins. Very soon, however, he had the idea of also using it to make sturdy work clothes for the pioneers. The first Levi's pants were so successful that the brown hemp-cloth stock was exhausted and Levi Strauss had to replace it with another, very strong fabric in an indigo-blue color his brother had sent him from New York: it was *denim*. There is no longer any doubt that the fabric originated in the faraway city of Nîmes, in the South of France. In any case, this etymology is just as plausible as the one the *Oxford English Dictionary* attributes to the word "blue jean" as deriving from "Genoa blue," thus bestowing on the Italian port city the parentage of the famous blue pants. Here then are two theories on the origin of the cotton serge fabric woven with one thread dyed with indigo alternating with a non-dyed thread, and both are legitimate. Very similar cloth and a good number of comparable blue fabrics were produced in Genoa as well as in Nîmes starting in the eighteenth century, and they were used for making boat sails as well as tarpaulin for wagons and work clothes for Ligurian, Provençal, and Languedoc peasants. Alas, only very few samples of these humble blue fabrics survive, as they are the kinds of fabric that were worn, re-worn, mended and patched, used down to the last thread, and finally discarded. Also, no museum would have thought of preserving ordinary objects, traces of everyday life, modest testimonials to a people's labors and customs. The first museums that give an account of popular culture date only from the beginning of the twentieth century, and then only for the purpose of preserving regional identity and traditions. Ethnology is a recent discipline. When it was finally decided to establish collections of popular objects and costumes, it was already quite late. The Old Nîmes museum, however, does have a few, rare examples of ancient blue-jean cloth.

*18th-century man's jacket, pockets, and work skirt, woven with alternating indigo-dye threads and non-dyed threads* (opposite page).

There are two plants that in succession supplied indigo blue to European dyers. The first was *Isatis tinctoria*, called *guède* or *vouède* (woad), cultivated in Europe since the Middle Ages. A plant of the cruciferous family, it is covered with clusters of bright yellow flowers. Woad farming required constant effort and a large labor force. The leaves of the plant had to be gathered, and the plant produced up to four harvests a year. The leaves would then be taken to the mill where they were crushed with a stone mill that turned around a perpendicular axle that was moved by a horse. The resulting product was a paste that gave its name to the plant. The paste was left to rest for about fifteen days, then pressed into increasingly smaller wooden molds to obtain small round balls called *coques* or *coquaignes*, shells. From this word comes the expression *pays de cocagne*, land of plenty. The shells were then spread out on screens, where they would dry for two weeks. Not all of these shells could be used, however, and only those that were purple inside and of an agreeable smell were used to make woad powder. The shells had to be pulverized, then the powder had to be moistened with water to allow the woad to ferment. The fermentation process heated the paste, producing a thick smoke and a remarkable stench. This operation was repeated every two days. Finally, the powder was left to dry, and only then was it ready to be sold to the dyers. The considerable amount of labor required is undoubtedly one of the main reasons for the decline of woad farming.

*Indigo gave a blue color to all kinds of everyday fabrics for household use, even the thread for knitting peasant socks (opposite page).*

The other blue plant is the exotic *Indigofera tinctoria*, or indigo, of the papilionaceous family, a plant native to India and grown in China, India, Indonesia, Syria, Egypt, Africa, and the Americas. Making indigo was no less difficult and laborious than making woad, but as it came from faraway places, no one was concerned about the indigenous labor force, often constituted by slaves. The seeds were sown in rich, well-tilled soil, and the plantation's growth was carefully monitored, eliminating weeds as well as caterpillars which are fond of this plant. After two months, the plant was cut using a sickle or large shears. Every six weeks for the next two years, the plant was harvested until it decayed. The crop was then taken in barrels to tanks, where it was immersed in large quantities of water and left to ferment. The water would turn a lovely dark blue. The blue water was then poured out into a *batterie*, a sort of beater where, after a little fish oil was added, it was violently shaken until the indigo particles precipitated and separated from the liquid. The water was left to decant and the useless liquid was discarded. All these operations took place amid dreadful and sickening vapors. The resulting paste was set to drain in cloth sacks, then laid out to dry on sieve screens. Finally, the dry indigo was broken into pieces. By the time it reached Europe, it was in the shape of solid, dark blue, almost purple bricks.

Indigo and woad contain the same blue coloring agent, indigotin; however, indigo contains thirty percent more indigotin. At the close of the Middle Ages, the Languedoc region became the most important woad production center, while indigo was making a tentative appearance on the docks of the port of Marseilles. However, thanks to its exceptional coloring power, indigo was soon adopted by the dyers, thus endangering woad culture. In 1609, Henry IV tried to restrict this competition with an edict that applied the death penalty to anyone using indigo.

But it did not work; in the eighteenth century, woad farming declined and was almost completely abandoned. In 1737, the use of indigo was officially authorized. At the time of the Empire, when the continental embargo prevented the importation of indigo, woad farming was revived; however the advances made in the chemistry of dyes soon struck the final blow against it.

Together with Avignon and Marseilles, Nîmes produced large quantities of blue fabrics. Some were of good quality, such as woollens or silk taffetas. The majority, however, despite the high cost of indigo and woad, were "common" fabrics for daily use—for work clothes and heavy-duty canvas. This was possible because the dyers organized their baths, the "blue vats," so that the better fabrics would be dyed first; the same bath solution was then used again and again (after being "revived") for inexpensive cloth. Hence, the same tubful of indigo solution could be used for fifteen days at a stretch. All kinds of solid-color fabrics were dyed "in the tub." However, since indigo was not water soluble, plunging a piece of fabric in a solution of water and indigo did not dye the fabric. First, blue indigo had to be altered with the help of ferrous salts. The result was white indigo, which was soluble in an alkaline wash. The white cloth was soaked in a white-indigo vat heated to 122°F. Then the cloth was left to dry outdoors and the natural oxidation process gradually changed the color from yellow to green and then to blue.

This was an excellent procedure for dyeing white cotton, linen, or hemp to a solid blue color, and also for woollens, waste silks, and *bourrates*. On the contrary, the "hot vat" was not required for printing "*à la réserve*." In the latter case, when some patterns were to be left white during the dyeing process by protecting them with a light wax layer, the fabric was dyed in the "cold vat." In this case, white indigo was dissolved at cold temperature in an alkaline wash to which iron

Stitched bed covers from the 18th century, made with cotton fabric printed à la réserve (opposite page).

sulfate was added. This method prevented the wax from melting and gave excellent results. Blue dyeing "*à la réserve*" was done on cotton fabrics, more rarely on linen. More often than not, the large-pattern "reserve" blue fabrics were stitched into bedspreads or bed curtains. Small-patterned blue "reserve" fabrics were used to make gorgeous short gowns, petticoats, and aprons for women's costumes.

However, most of the "common" fabrics dyed blue in the 18th century in southern France were woven with an indigo-dyed thread, sometimes alternating it with a thread that was not dyed or was partially dyed, as in the case of speckled cloth. The fabrics used to achieve this result were of cotton, wool, silk, or hemp fibers; often, mixed-fiber fabrics were used. There were white-and-blue windowpaned fabrics that were used for the most part to make straw mattresses; the same treatment used speckled fabrics. There were fabrics with plain white and blue stripes: these cloths were thicker and stronger and were usually spread out under olive trees to collect the olives when they were not used to make peasant women's petticoats. There were also serge fabrics with a bias cross-weave and either left or right ribbing and "small Venice" fabrics whose weave was even more complex, with diamond-shaped double patterns. These fabrics were used to make petticoats and women's work jackets, vests, and breeches for men.

# The Blue Cart

The wheelwright used to make carts, and the wagoner used to drive them. So that when the automobile revolution came, the village wheelwrights very naturally became auto-body men and mechanics, and the wagoners truck or cab drivers. The wheelwrights were part blacksmiths, part carpenters, and part painters. However, strangely enough, they painted only one color, "wheelwright blue," a dense, saturated ultramarine, blue that softened only slightly with time. Why were all the carts in Provence painted blue? No one really knows, except that it is believed blue repels flies and stinging insects. This is undoubtedly the reason why the ancient Greeks chose this color to paint their doors and shutters, and the Sardinians and Sicilians used it to whitewash the interior of their homes. Even the Provençal people often gave a light blue tint to the lime water they applied to the interior walls of their homes and their stables and to door and window frames.

*It was believed that cartblue*
*kept away the flies; this is undoubtedly*
*why its use was so pervasive on the*
*farms of Provence.*

In a country colored in an infinity of gray and yellow shades, with only a few touches of green, bathed in a white light that Giono calls "a boiling plaster," where the blue of the sky is totally ethereal, all infinite depth and transparency, the sturdy blue cart stood out as a surprise. We are so used today to seeing nature crowded by all the colors of the advertising billboards, subdivisions, industrial parks and commercial malls, thousands of cars crossing it incessantly, that our eyes wear out from having to select among all this confusion, and we can no longer enjoy the beauty of an almond field in bloom or of a vineyard painted in autumn-red colors. How difficult is it then for us to imagine the visual shock, still not too long ago, of a plain blue cart crossing the countryside? In fact, after Van Gogh painted a blue cart in the center of the Crau plain, several Provençal painters, from Louis Audibert to Pierre Ambrogiani, became fascinated with this subject.

But the surprise is even greater when the cart—piled high with an enormous bundle of tall green elm and willow branches, behind which a drummer is hidden, decorated with flowers and streamers and pulled by no fewer than twenty draft horses, all richly harnessed in the Saracen fashion, crossing village streets at full gallop and led by as many wagoners in white shirt and blue pants—rolls in through a town gate and, like a moving forest or a frigate in a storm, among the clamor, the cries, the lashing of whips, and the rolling of drums, crosses a crowd suddenly frozen by the haunting vision. It's the *carreto ramado,* the "cart with branches."

Legend tells us that a long time ago, a mysterious illness suddenly struck the horses of the Maillane farms at the onset of summer.

The poor animals were dying one after the other. Everything was tried, but nothing could be done to stop this calamity. In a few days it would be harvest time and the horses would be needed to cart the wheat, but they were dropping like flies. Despairing of finding the cause of the epidemic, the peasants turned to good Saint Eloy, protector of horses and patron of wagoners. And a miracle happened. Immediately, the horses stopped dying. Since then, every year on June 25th, traditionally Saint Eloy's feast day, the *carreto ramado* celebrates the event in most of the villages sitting between the Alpilles and the Durance River. Currently, these celebrations take place on Sundays throughout all summer in Barbentane, Rognonas, Châteaurenard and Mollégès, Maussane, Graveson, Saint-Etienne-du-Grès, Boulbon, Eyragues, Saint-Rémy, Paluds-de-Noves, and of course in Maillane. It is a magnificent pageant, but undoubtedly the original meaning of these processions has been lost. In fact, it is an agrarian fertility ritual. The cart filled with leafy branches, hitched to many horses, would go through the village so as to enclose it within a magical protective circle. This was done on Saint Eloy's Day, which is the day following Saint John's Day, which celebrates the death of the earth.

*During the week, the cart was used for farm work: on Sundays it drove everyone to mass when no more elegant vehicle was available.*

# Lavender and Hybrid Lavender

Certainly there is no more mythical blue than lavender blue. There are about twenty species of lavender, their color ranging from light blue to purple. The intensity of the blue varies from day to day and also changes according to the degree of ripeness of the flower. Therefore, everyone can have his or her interpretation of lavender blue. Wild lavender grows at an altitude of two thousand to five thousand feet and is not easily tamed. The essence of fine lavender, the best and most fragrant lavender oil, is extracted from this plant. Lavender grows all over the *garrigue* and only rarely does it give a true blue note, since its

flowers are very small and it grows scattered. The wide, blue fields of the Albion plateau are planted with officinal lavender and especially with hybrid lavender, which is a hybrid of officinal lavender and spike lavender. Hybrid lavender yields a lower-quality essence, but is easy to grow in the foothills, from a thousand to two thousand foot altitudes. It is generally used to manufacture tourist products.

Lavender essence accumulates in the epidermic hair scattered over all the annual parts of the plant, on the flower but also on the leaves and part of the stem. The essence rises into the flower at the hottest time of summer. It is at this time that harvesting takes place. The upper part of the plant is cut, taking care not to damage the bottom tuft that will continue to produce for several years. The lavender is then taken to the distillery to extract its oil.

For me, lavender is tied to two childhood memories. The first memory is rather

*A bag full of lavender "seeds." Actually, they are flowers, but in Provence the word graine, "seed," was used to denote anything that was harvested; therefore, people called the silkworm eggs silkworm "seeds," and they called the red dye capsules gathered from the oak trees, kermes "seeds" (top). Lavender and olive trees have of late become the symbols of Provence.*

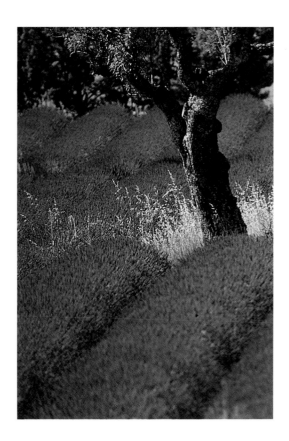

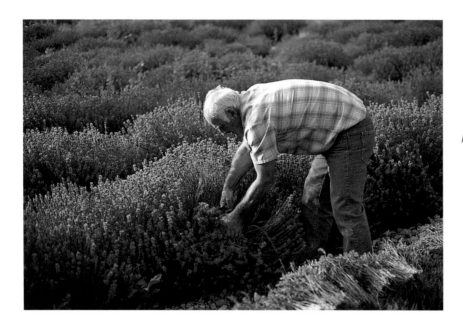

*Today, lavender and hybrid lavender are grown primarily for the tourist market.*

disagreeable; it is the lavender vinegar my mother would make by simply steeping lavender flowers in a bottle filled with wine vinegar that she would draw from the cellar, from the enormous demijohn where it slept for centuries. She would use it anytime we were stung by a wasp or a bee. Frankly, it stank and, as far as I can remember, did not really relieve the sting.

The other memory is much sweeter and happier. Every summer in July, when our garden's lavender was in bloom, my friend Aline and I would sit under the arbor, on a large blanket spread out on the ground. With freshly gathered lavender we would make very pretty spindles braided with colored satin ribbons that we hurried to sell for a few coins to family members and to neighbors, for scenting sheets and linens at the bottom of armoires. Aline had truly mastered this craft, and would patiently explain to me with unquestioned authority the operation's secrets. I

was the eternal apprentice, not very skilled. But since Aline was in charge of finishing the spindles, the results were pretty impressive. First we had to make a small bouquet with the lavender flowers, tied together at the top near the flower heads, with a bit of raffia or string. Then we would wind the stems around the flowers and start braiding the satin ribbon by interweaving it with the stems, top, bottom, top... A rather simple concept, but the difficulty consisted in giving the spindle an agreeable shape and volume. And this was really complicated. I must confess that all the money I earned from this activity was immediately spent on huge, delicious *"chichi frégi,"* those big, golden, crunchy fritters, scented with orange-flower water and rolled in sugar when still hot, that we went to buy from the stand at the port.

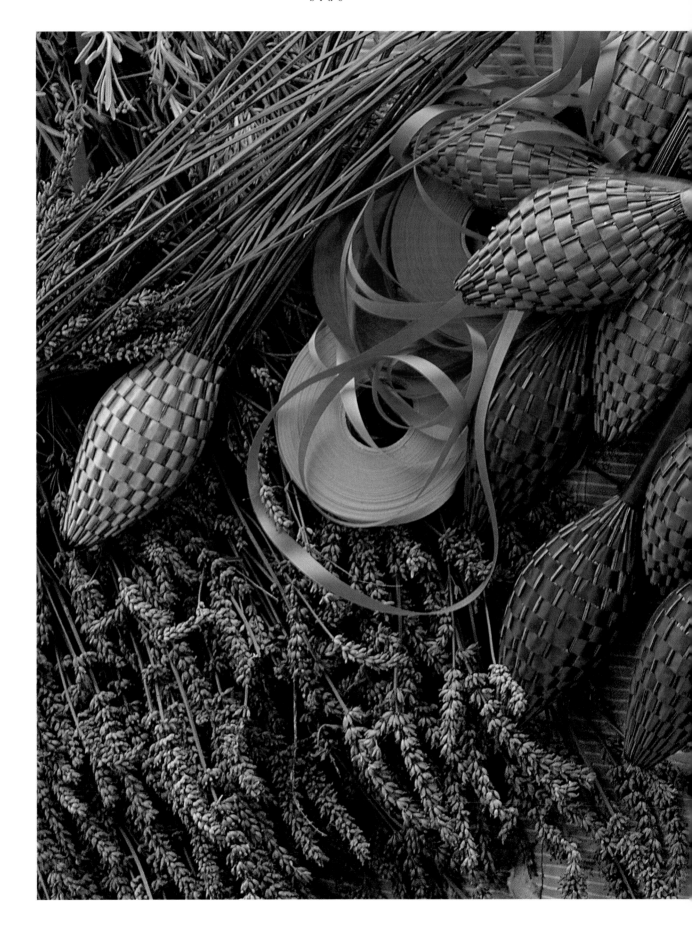

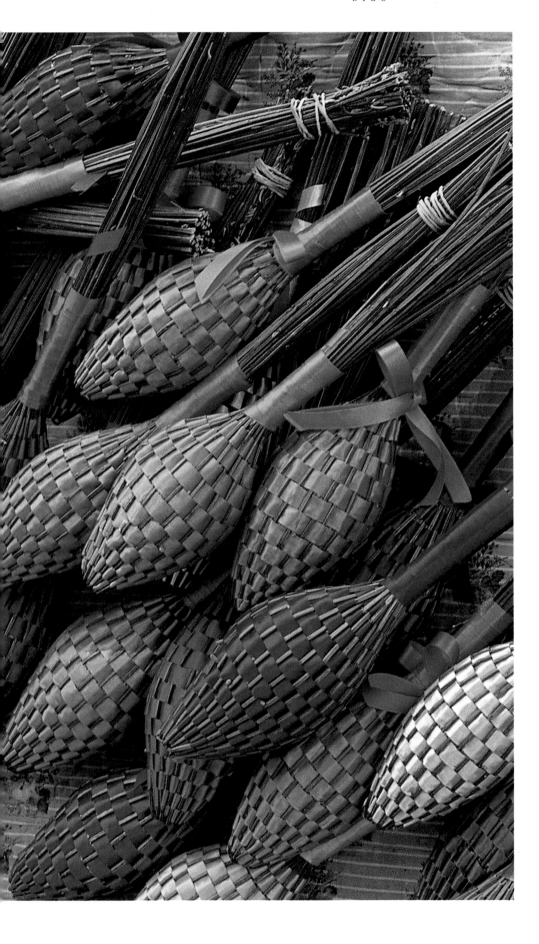

For generations,
these lavender
spindles braided with
colored ribbons
were used to scent
linens in the recesses
of large Provençal
armoires.

# The Easter Garden

In almost all our villages you will find at least one of these modest gardens that seem to be dedicated to the happiness of shade, where the ivy's waxy leaves rule supreme all throughout the year. Suddenly in the month of April, they dress themselves in delicate flowers ranging from pale mauve to intense purple. A lovely wisteria completely overpowers the iron entrance gate, runs along the surrounding wall and assaults the trelliswork, twisting itself around everything, sometimes even misshaping the hard work of the village blacksmith. The wisteria covers everything with its light, mauve-colored flower clusters that move at the slightest breeze. Tall bushes of Indian lilacs blossom on each side of the house. Often these dark purple flowers become pink with time, while the pale mauve wisteria flowers turn even paler. At their feet, on each side of the gravel walk leading to the house, contained by intersecting cast-iron arches, two rich borders of Dutch irises, their flowers an inklike, almost blue-purple, are in bloom. The low wall next to the arbor is half-hidden by another border of large mauve irises. Finally, right behind the lilacs is a splendid Judaea tree that has been in the garden forever, its old branches, including the venerable trunk, all covered with flower clusters of a strangely cold cyclamen pink. Next to the Judaea tree, a perfectly round bush is bursting with milky green flower balls: they are Guelder roses that will later turn white, then pink. Next to the trees, strewn on the ivy-covered ground, clumps of violets show their faces. This garden exudes an undefinable charm, radiant and a little sad, cheerful yet melancholy at the same time. This is undoubtedly due to the lead-gray window shutters and the net-lace curtains that create behind the windowpanes a white screen to the interior darkness of the house.

It is also undoubtedly due to the fact that purple is the symbol of piety. As Johannes Itten wrote: "Dark or dull, it is the color of superstition. Catastrophes are predicted with a dark purple background. When lighter, when light and intelligence illuminate piety, it shows marvelously tender hues. Darkness, death, and nobility are purple; solitude and devotion are purplish blue, divine love and the dominance of the spirit are purplish red."

Throughout the period of Lent, starting with Ash Wednesday, the vestments worn by the parish priest in church are purple. On Maundy Thursday, they are white. On Good Friday, they are both purple and black, before becoming white once more for Easter week. I have always been troubled in realizing that the garden, waking up after a winter-long sleep, decks itself in the colors of Lent and that for a while its colors are exclusively mauve and purple. Because after the lilacs, the irises, and the wisteria have blossomed, it is the turn of the white syringas, the multicolored roses, and Saint John's lilies.

*Heavy lilac bunches scent the*
*Easter garden (top).*
*The purple iris stands*
*simultaneously arrogant and fragile*
*(opposite page).*

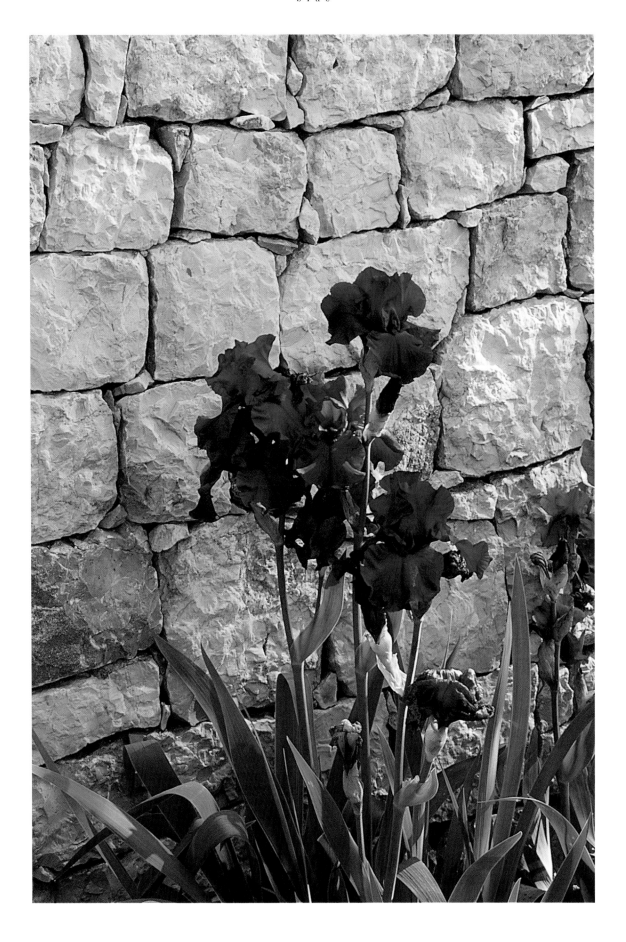

*A lovely wisteria
assaults the trellis
and scrolls up
everywhere, even to
the point of
bending out of shape
the village
blacksmith's work.*

# Purple Cuisine

In Marseilles, people eat *violet*: it's the sea fig, a type of limpet that resembles an old, shriveled potato more than a fig. It belongs on all seafood platters because its interior edible part, which is not purple but a bursting yellow, has a remarkable, very strong iodine flavor. *Violet* fishing is done by divers, because the mollusk attaches itself to rocks and lives at a depth of up to six hundred feet. It is quite difficult to spot because its shell, supple and leatherlike, is covered with algae and tiny marine animals. You must be equipped with a screwdriver and remove it with a sharp stroke. Otherwise, as soon as it perceives movement, the mollusk will contract and make itself almost impossible to dislodge. Like the sea urchin, it is savored alive and plain.

But the color purple is also present in the kitchen gardens of Provence. You see it on artichokes as well as asparagus, it colors eggplants and figs. The *violet de Provence*, "Provence purple," is a small-sized artichoke, native to Italy and grown in Provence since the sixteenth century. The village of Villelaure in Vaucluse is famous for its production. There are spring artichokes beginning in March and fall artichokes beginning at the end of August. The Provence artichoke is the best kind for eating raw, sliced thinly and seasoned with a little salt and just a trickle of olive oil, or for preparing stuffed artichokes *à la barigoule*. You need very small artichokes, picked

before they have grown a choke, the variety called *mourre de cats* in Provençal, or "cat's face." Stuffed artichokes are stewed in a covered pot for about two hours with a bit of diced salt pork, a few garlic cloves, some sliced onion, very little salt, pepper, and a trickle of olive oil.

The color of asparagus depends solely on how they see the light. As long as they are underground, shielded from light, asparagus are white; later, as they grow closer to the surface, they gradually acquire color: first purple, then green as chlorophyll is produced. The people of Provence like their asparagus either green or purple, and let the white ones depart for northern France. Since the end of the nineteenth century, the village of Lauris, also in Vaucluse, has acquired a far-flung reputation for the quality of its asparagus which it ships to Belgium, Switzerland, England, and Germany.

*Most eggplants are a dark purple tending to red; some varieties however, like the one at right, are a lighter purple.*

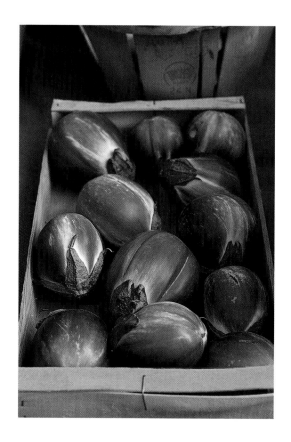

When figs are not "gray" or "white" they are called "black," although their skin is actually a dark, velvety purple with a blue shimmer. A dessert to crown this kitchen-garden lunch would be figs *à la Carlton*. A creation of master chef Auguste Escoffier, it is extremely simple yet sublime. Prepare a raspberry purée by putting 1 pound of raspberries through a food mill. Add 3 or 4 tablespoons of powdered sugar, then fold the fruit into 1 ½ pints of whipped cream. Pour some of this rose-colored cream on a few well-ripened figs that were cut in half and chilled for an hour in the refrigerator.

Like the tomato, the eggplant did not really become a staple vegetable of Provençal cuisine until the early part of the nineteenth century. Among the several varieties of eggplant, some of which are white, some pale purple or dark purple, and some almost black, those with the best reputation are the "Avignon long," the "Avignon purple," and the "Barbentane purple" eggplants. Provençal eggplant recipes are plentiful. One of the more refined and excellent preparations is the *papeton* which is a small tart made with eggplant pulp and eggs, cooked in a mold and served lukewarm with a well-seasoned tomato purée. It is so called because in olden times, the molds used for baking these tarts were shaped like a papal crown.

*The violets de Provence are small artichokes. delicious when eaten raw with just a trickle of olive oil or stewed* à la barigoule (below).

*Asparagus from Lauris are known throughout Europe* (top). *They are called "pink." Even garlic takes on a purplish tinge* (right).

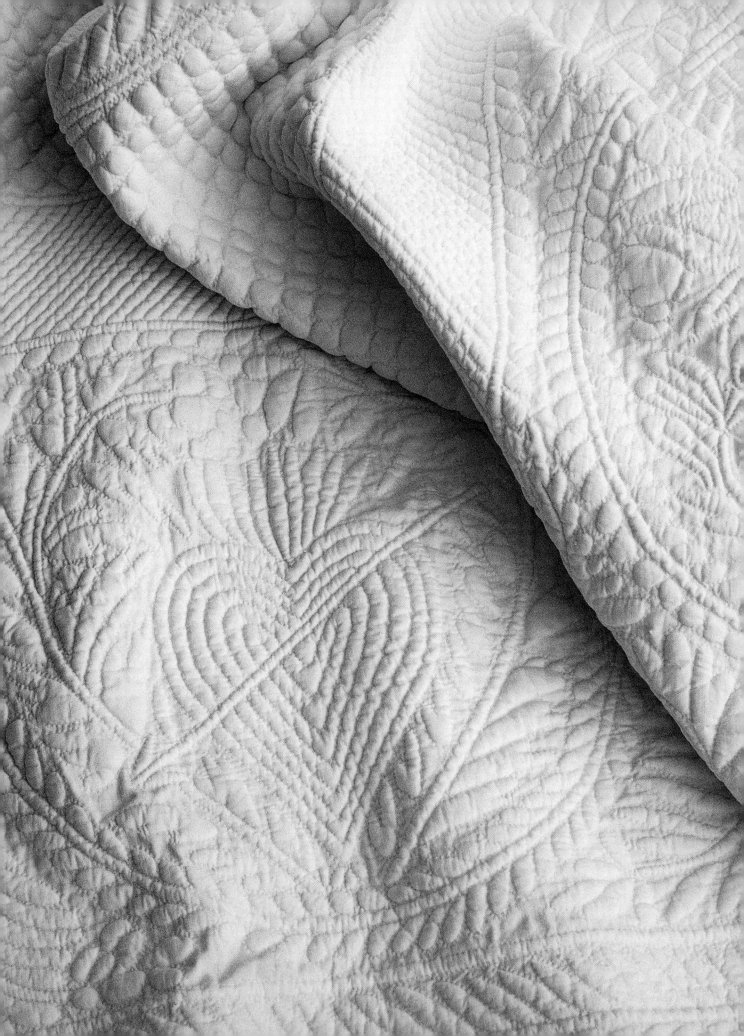

# White, Black & Gray

*I finally have an Arlésienne, it is a figure I fired off in an hour, on a pale lemon
background, with a gray face and a black, black, black dress of a harsh Prussian blue.*
—Vincent Van Gogh, Lettres à Théo

*I also painted a café which Vincent liked very much, and that I did not like as much....
In the foreground is a face painted in the Arlesian manner,
with a black shawl and a white veil in front.*
—Paul Gauguin

White and black, shadow and light, the finished and the unfinished seem inseparable. Thus horses and wild bulls run together along the shores of the Vaccarès wetlands, and in the racing arenas of the Camargue the immaculate costumes of the *raseteurs* dance with the beast's black mantle. Also, the *bugada*, the great washing, a domestic ritual for bleaching linens and underwear, could take place only in the dark secrecy of night.

Black and white are not colors but different kinds of lighting. Black is night, shadow, the moment when color seems to be absent from all things. However, when the sun rises, color is made visible again. Also, black in Provence is never completely black. It can be Prussian blue like the black dress of Van Gogh's *Arlésienne*, or intense purple like grapes on the vine trellis or figs from Caromb; brown like the mantle of the bulls of the Camargue or of honey-and-almond nougat candy; dark like the background of grayish fabrics, dyed with gallnut, and like the truffle that secretly ripens underground.

For its part, white is celestial light. The least alteration clouds and alters it. The least stain tarnishes it. Although our brides wore a green or flowered gown, they tucked it up so as to show their wonderful petticoats in white *boutis* embroidered with hearts, doves, temples, and heavens, just like the bedspread on their nuptial bed. And just as the *bugada* was done twice a year, similarly all the house walls were periodically given a coat of whitewash, a purifying ritual that eliminated vermin, but also and especially dressed the house for a time in an impeccable whiteness. White is also the color of salt, a crystal revealing the flavor of things, that used to be extracted from the numerous salt marshes that dotted the Mediterranean coast. Finally, white is

*Wedding* boutis *were often decorated with an arrow-pierced heart* (page 126).
*Until a short time ago, in Provence doors and shutters were painted gray, in an infinity of shades* (page 127).
*Tellines, tiny, delicious clams found on the Camargue beaches* (above).
*A mortar made with Cassis stone, used to make* tapenade *(right).*

the sky when the mistral is not blowing. Actually, upon reflection, and at the risk of sounding paradoxical, Provence is a land that more often than not is bathed in a gray monochrome, submerged in a pale silvery light. When I was a child in the 1950s, long before American fashion pushed our villages to make themselves up in colors from Italy, and with some rare exceptions, all the walls of all the houses were daubed with the natural colors of local sands, and all the window shutters of the village houses, the farmhouses, and the summer villas were painted in an infinite variety of grays that contrasted in a delicate play of colors with the gray of the sky and the soft, silvery palette of the

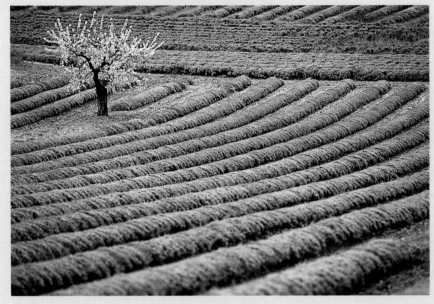

*Stone and shutter patinas blend in a gray monochrome (top).*
*Flowering cherry trees and lavender fields shiver under a late frost (left).*

the color of all of Provence when it drowns in the noon sunlight that Jean Giono speaks of as "a boiling plaster."

Gray is essentially the color of time's passing. Old women's hair, stone walls, farmhouse shutters—all become gray with time. It is also the color of the hills, of thyme and santonica, the color of lavender fields when they are not blue, which is to say eleven months out of twelve—the color of

surrounding landscape. So that when a color appeared, whether it was a blue cart loaded with bales of straw, or a druggist's shop window decorated with all the brooms of Lapalud or again, fruit and vegetable stalls at the Saturday morning market, it burst out, sovereign, in the light of the Provençal sun.

# The Camargue Race

The Camargue is first of all cattle-raising land, inhabited by wild horses and bulls that live in separate herds, the *manades*. The Camargue cowherds are horsemen guarding the herds. They spend the whole day on horseback in this immense landscape, wet with water and sparkling with salt. Camargue horses are born with a black, bay, or gray coat that will turn white as they reach adult age. The coat of the Camargue-bred bulls is black, sometimes with fawn highlights. Their horns are lyre-shaped. They are lighter and more nervous than the Spanish-bred *toros*.

In the country around Arles, every instant revolves around the bulls and the people's passion for everything that has to do with bulls; the *bouvine*, as they call it here, is so great that it is also called the "faith." Man's struggle against the bull is an ancient tradition. The first bull games were undoubtedly played in farmhouse yards, enclosed by carts. At first, it was simple family merrymaking meant to amuse servants and cowherds. Later, the races would be held in the village squares. The town of Arles, when it wanted to honor special visitors, would close the square facing the town hall and, from the enclosed balcony, the guests would watch the white-and-black show of races and games. In 1826, clearing of the Roman arenas began. After the collapse of the Roman Empire, the amphitheaters had slowly become true fortified towns sheltering about three hundred houses, small squares, and chapels. All these additions were demolished and the arenas could then be reconnected to their distant past and returned to the public. The custom arose of using the arenas for two very different kinds of show: the Spanish races and the Camargue races "with the cockade."

The Second Empire had made the Spanish corridas fashionable. This popular show borrowed the strict rules of the Spanish *cuadrillas*. The Spanish corrida is a blood drama which unfolds as a tragic dance leading to the bull being put to death. It is a richly colored ritual, with costumes bedecked with embroidery and enriched with gold relief, where the bull's black coat is stained with blood and dances with the pinks and reds of capes and *muletas*. On the other hand, the Camargue race is a game in which the bull is not killed, and the *raseteurs*, all dressed in white and equipped with a hook, try, with a movement called *raset*, to remove a cockade held by strings between the bull's horns. In this game, man is set against animal, intelligence against instinct, agility against force. There are many *raseteurs*, but each one of them faces those formidable horns alone.

These cockard races came under supervision around 1900 and at the beginning of the nineteen fifties the rules and regulations that are still followed today were put in place. There are approximately sixty bull herds in the Camargue, but only a few herds "race" in the large arenas and participate in the races almost every week during the season that begins in March and officially ends in October. The racing bulls are of pure Camargue breed. Unlike the corrida, where the real star is the man, the hero of the Camargue race is the bull. Some even become real stars, moving the crowd and causing memorable riots at the arena gates. Goya, for example, a member of the Laurent herd, had an exceptional career. While alive, he even had a statue erected in his honor. Like all the great bulls of the Laurent herd, he died of old age. He was twenty-three years old.

On the day of the races, things start very early in the morning, at the break of dawn. The herd leader starts out on horseback with his retinue of cowherds to choose the bulls for the "triage." A subtle dance then takes place between the cowherds on horseback and the bull that has been

*The raseteurs,
all dressed in white,
tensely watch every
bull's movement.*

picked, to distance it from the herd. As soon as the bull has been isolated, it is surrounded by horses and brought to the bull pen. There, the cowherds make it climb onto the "carriage" and, standing above the animal, attach the "glands" (white woolen pompoms) to its horns, one on each side; the *"frontal"* (a string going from one horn to the other), the red cockade, and the strings that are wound around the horns. Picked one by one and decorated with ribbons for the race, the bulls are brought on a truck to the bull ring. Six bulls are needed for each race, and they may be chosen from among different herds, at the organizers' option.

In the ring, anticipation has reached a climax. The seats are packed. The spectators have their eyes fixed on the door of the bullpen. The *raseteurs,* dressed in white, are in their places. Suddenly, the trumpet blares high and loud and the door opens, revealing the bull, magnificent in its power and bearing. The bull stops at the center of the arena, shocked for an instant, and takes in the scene. Then, very fast, it charges into anything that moves. In an amazing choreography, the *raseteurs* run across the arena in an oblique trajectory, with outstretched arms, trying to pass

in front of the beast and reach its horns. But the bull pursues them with all its might and forces them to leap into the air to escape. The animal jumps over the railings, sometimes knocking them down in its rage. It creates panic in the ring, stamps the ground, throws the foolhardy unrelentingly in the air, to the audience's great delight. Nevertheless, from time to time a skilled *raseteur* succeeds in unhooking the cockade or the glands and the crowd cheers him triumphantly. But the bull charges again. And the *raseteurs* again fly onto the arena's steps.

The bulls of Camargue are artists and athletes, the only show animals to have a career without training or coercion. A race lasts fifteen minutes for each bull, which runs only once a month. The rest of the time, the bulls roam freely over the vast pasture lands of the Camargue.

*Bull and raseteur caught in a virile, aerial ballet, the Camargue race.*

# The *Bugadières*

*Bugada* was the name given to the great clothes washing that was done twice a year, with the onset of the first fair spring days and in the fall, after the work in the fields was done. Of course, clothes were washed every day: children's underwear, bonnets and shawls of embroidered chiffon and tulle, lovely laces from Malines or Valenciennes. All these garments were washed gently with Marseilles soap; this washing was called a *bugadon.* Printed cottons, *indienne* prints, and all colored fabrics were washed in a solution of soapwort root, a plant that grows all over the hills of Provence. To wash black fabrics for mourning clothes, ivy and walnut leaves were added to the soapwort.

But the rough day and night shirts, the handkerchiefs, the sheets and table linens, all the linen, hemp, and cotton whites that were not changed as often as they are nowadays, were the occasion for an immutable ritual that always took place in the secrecy of night. The day before the washing, the clothes were left to soak one whole day and night in clear, cold water to which a few soda crystals were added. Then they were rinsed. As evening approached, the *tinéu* was prepared: it was a huge, wooden washtub ringed with iron hoops and placed on a tripod. At the bottom of the tub a hole allowed for water drainage. So that the clothes would not stop up the hole, a bouquet of thyme was placed in the hole, protected by a small rag. To make sure the tub's wood would not stain the clothes, a large, rough gray sheet called a *florier* was used to line the inside of the tub. Then the clothes were piled in, starting with the dirtiest. A second *florier*, smaller and not as rough, topped the clothes, on which a layer of sifted wood ashes was spread. Now the women of the house had to wait until night, as if darkness were necessary to guard the mystery of this magic activity. All the women would gather and "pour the lye water." They had heated gallons of water which they poured on the ashes, first lukewarm, then increasingly hotter. The water carried the potassium contained in the ashes, thus forming the *léissiu*, which drained into a bucket placed underneath the tub. This water was reheated and poured again. And again and again. Thus one poured the lye water on the wash the whole night. The grandmother started and was relieved by the daughter. When the latter, exhausted, would leave to get some rest in the morning, the grandmother picked up the task again. The ladies who could afford it did not do this job themselves. They had the washing done by a professional washerwoman, a *bugadière*, who performed the task all by herself the whole night. Finally, the *léissiu* would take on the color of coffee with milk, and the wash was done. Now the clothes were loaded on a wheelbarrow and taken to the washhouse or the river for rinsing.

The washhouse was a special place where all the women met to comment on village life. Kneeling on a straw-padded board and armed with a bar of soap, a scrub brush, and a walnut washing beetle—the same one their fiancé had given them on the eve of their wedding—the washerwomen persisted on the last stains and rinsed the clothes in running water. All of this was done amid laughter and shouts. In the summer, the women wore a wide, trimmed rustic bonnet to protect them from the sun; but in the fall sometimes it was very cold when, with their sleeves rolled up, they plunged their arms in the water up to their elbows. Finally, two by two they would wring out the laundry and hang or spread it in the meadows, on top of bushes or on laundry lines that went from tree to tree on the village squares.

*As in past times, at the wash house in Ménerbes, large cube-shaped cakes of Marseilles soap are still used (opposite page). These sheets were made with hemp that was handspun and handwoven on old looms (left).*

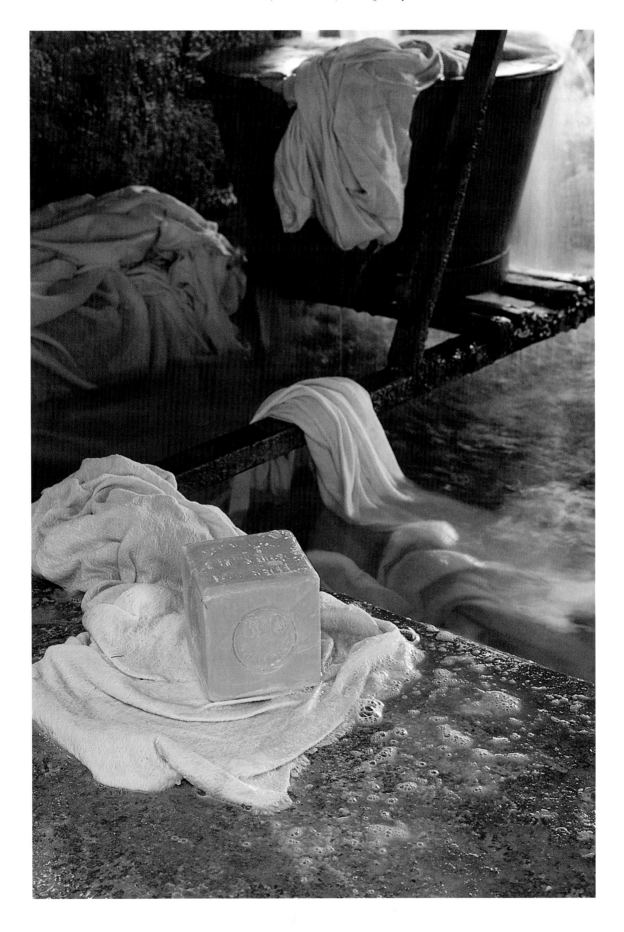

# Stone and Lime

Provence is subdivided into two vast regions. In the first, which extends from Hyères to Cannes and includes the Maures, Esterel, and Tanneron domains, rock crystal is predominant. The other region, calcareous Provence, where sedimentary rock prevails, is more to the west and includes Bouches-du-Rhône and Vaucluse.

In the secondary era, the crystal block in Provence was covered over by the sea and sediment settled on it. Today this gives us a hard, chalky stone, colored white, rose, or gray. It is Cassis stone, which forms the carved rocks of the coves between Cassis and Marseilles. Cassis stone is very hard and used for doorsteps of houses, staircases, sidewalk borders, *piles* (stone sinks), and the mortars in which *aïoli* is pounded. In the lower Cretaceous period, the continent emerged under a tropical climate. At that time, phenomena related to changes in materials contributed to form ocher and bauxite sands, which created the ocher cliffs of the Apt basin and the red soil of Tholonet. During the upper Cretaceous period, the sea submerged Provence once more and deposited a layer of sediment rich in shells, which went to form white Midi stone. This generic term includes several kinds of soft, calcareous limestone, with a more or less fine grain, mostly white, sometimes of a golden color, that were used in construction everywhere in Provence.

*White, chalky stone from Provence was used for most of the region's monuments, like these statues on the church of Sainte-Trophime in Arles, a Romanesque art jewel (above). The white stone quarries of Ménerbes and Oppède are still active today (right).*

*The dry-stone walls of*
*ancient* bories *were white;*
*time overlaid them with*
*moss and lichen.*

La Couronne stone is of a soft color halfway between yellow and rose, and forms the sloping cliffs between Marseilles and Carry-le-Rouet. Bibemus stone is golden, has a fine grain, and was used in the seventeenth and eighteenth centuries to build all the townhouses of the Mazarin district in Aix-en-Provence. The Bibemus quarries are no longer active today, and to restore these houses the stone from Pont-du-Gard or Rognes is used. The latter, however, contains a lot of shells; it is coarser and more fragile.

The stone from Arles, Baux, Calissane, Eguilles, Oppède, and Ménerbes is white. It was used to build most of the ancient monuments in the area. These quarries were used from the beginning of time, and their stone has always been used to frame doors and windows as well as the corner beams of country houses. Sometimes if one built next to a quarry, the front of the building would be all in freestone. Several quarries are still active today in Fontvieille and Baux, Rognes, Ménerbes, Lacoste, Saint-Pantaléon, Estaillades, Espeil and Crillon, Mane, and Mont Ventoux.

Freestone was expensive and had to be carried a long distance for important monuments only. For this reason, the stone from ruined buildings was always reused for new construction. Sometimes the stones were cut again; other times they were used as they were found. There are some *mas* in the Arles countryside that have lovely Gallo-Roman sculptures built into their façades. However, most house walls were built with fieldstone. Before starting a new crop, the Provençal farmers had to clear their fields of stones, and this entailed removing all the stones that were level with the soil. These stones were used to build houses, either by arranging them one next to the other as squarely as possible—these are dry-stone walls in which no mortar is used— or by stacking them and binding them with lime mortar, sometimes even soil mortar. The latter are roughstone walls, and were always given a coat of whitewash.

Lime is the product of calcinating and then dissolving in water a calcareous stone known as limestone. White lime is mostly employed for mortar and plaster. In Provence, lime used to be made in wood-fired ovens. There were many of these ovens, and for comfort's sake they were often set up in the middle of forests, which exasperated the local lord who thus saw his woodlands destroyed. Once out of the oven, the lime was transported to the construction site. It had to be used right away so it could dissolve easily in water. To do this, it was placed in a tub lined with tiles, and water was poured on it. Lime would immediately start boiling and had to be stirred until the boiling stopped. Then it was completely covered with water. The following day, a paste had

formed. These were all delicate operations: for example, if one poured too much water on the lime to slake it, the lime would "drown" and lose its properties; if insufficient water was used, the lime would burn and refuse to bind with the sand.

On the contrary, to make limewash, also called whitewash, the lime had to be slaked with a great quantity of water; a white liquid would form, which could be applied on the walls with a brush or a paintbrush. Once it was dry, limewash gave the walls an impeccable, velvety white, the impression of total purity. Once a year therefore, in a purifying ritual, just like the great washing, the whole interior of the house would be whitewashed, including door and window frames, the interior of stables, sometimes even the outside walls up to a man's height with outstretched arms.

Michel de Truchet and later Frédéric Mistral tell the story of a woman from Arles who was told her husband had died. Without a word, she went back home and, in a sudden frenzy, emptied the house of all furniture and objects, prepared a limewash, and whitened the walls, washed the windows, floor tiles, and kitchenware, waxed all the furniture, and polished all the copper pans. Everything sparkled in the new white. At that point, she went up to her room, put on her mourning clothes, sat down on a chair and began to cry.

*Salted, dried cod must be soaked twenty-four hours in clear water, changed several times, before it can be cooked* (opposite page).

# Salt and Codfish

The salt marshes along the Provençal coast—at Hyères, around the Berre wetlands, and in the Camargue—have been exploited since antiquity. And the salt they produce has not lost its reputation for whiteness and flavor. For centuries, the salt worker's work was a tiring one because there are no tides in the Mediterranean to feed the basins. Therefore, saltwater had to be brought to the first basins, called "heaters," and then spread over the large, flat expanses called "tables," thus allowing the water to evaporate and salt to crystallize. This was done by manual labor, with scoops. In the fifth century, large hoisting paddle wheels were invented to lighten the workers' burden. However, the work of salt collecting was still particularly laborious. Fernand Benoit tells how this "gathering" of the salt, directly tied, like the harvest of the fruits of the land, to the weather, had borrowed its language from agriculture. The "table" on which the salt worker had to break the salt crust with a pickax was called, in Provençal, *iero*, or "threshing floor." The town of Hyères owes its name to the saltwork tables. The salt worker, with the help of a rake, collected the salt in small heaps called "sheaves" before carrying them in a wheelbarrow on large, flat boats called "carts." These boats carted the salt to an elevated "threshing floor," shielded from flooding, where a large heap was built, the salt "haystack."

Camargue salt went upstream to be sold in the Comtat and upper Provence areas. The salt from the Berre wetlands served the Durance Valley, and the salt from the Hyères saltworks was sold even in Italy.

Today, although the principle is still the same, fortunately the methods have evolved considerably. And the market has grown. The quantity of salt used for industry and removing snow from the roads is three times greater than that used in the food business. However, as in the past, salt continues to be used for seasoning and preserving food like olives, cold cuts, and fish.

It is no surprise that salted, dried codfish is so popular in Provence and the ingredient of so many famous dishes such as *aïoli* or *brandade*, although it has always been fished, salted, and placed in barrels or cases still on the boat in the faraway northern seas by the cod fishermen of Paimpol, Lorient, and Saint-Malo. These fishermen came to the Mediterranean to stock up on the salt their industry required, and often they would barter it for salted codfish, whose type of preservation was perfectly suited to the hot, dry climate of our region. Hence they found a very important market in Provence. And the town of Nîmes, which lies very close to the Aigues-Mortes saltworks, became the capital of codfish *brandade*.

*Brandade* is the recipe of a perfect match between salt codfish—whose salt has been removed after several rinses in clear water and then poached—and olive oil. In principle, the dish contains nothing else. The codfish must be finely pounded in a marble mortar with a wooden pestle and the oil added drop by drop, in the same way in which *aïoli* is made. In any case, a touch of garlic or, even better, a few thin slices of fresh truffle are anything but detrimental.

Cod fishing is a great adventure. At the time of sailboats, three-masters, brigs, and schooners

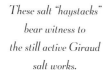

*These salt "haystacks" bear witness to the still active Giraud salt works.*

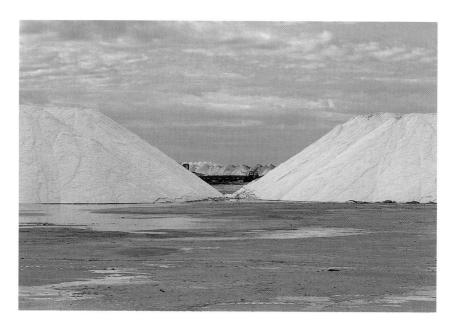

*A salt boat made by a Camargue salt worker in the 18th century.*

would depart each year in the spring from the port cities of the English Channel and the Atlantic, their holds filled with salt, headed for Newfoundland and Iceland. In fact, the cod is an arctic fish that lives at a depth of more than four thousand feet in winter, in the neighborhood of warm lower currents; however, starting in the month of May it rises to the surface in schools. It swims in a southwestern direction down to Newfoundland and in a southeasterly direction down to Iceland and the North Sea. So each year, fish and fishermen meet halfway, as if in a rendezvous. Once on site in their fishing area, these ships detach small boats and set their lines in the evening. The lines are picked up the following morning and the captured fish are taken to the ships, beheaded, emptied, slit open, spread out, salted, and finally stored in the hold.

However, in the Camargue salt was also used for a highly unusual decorative purpose. During the low season, the salt workers amused themselves by sculpting in wood all kinds of perforated objects such as huts, castles, windmills, or superb sailers that they placed along the borders of the salt tables. Slowly, the objects would become covered with a layer of white, translucent crystals, like petrified dreams.

# Wedding Petticoats and *Boutis*

The Empress Josephine was the first to marry in a white gown, since the fashion at the time was to marry in white cotton muslin draped the Roman way, and since white went beautifully with the color of her skin, tanned by the Caribbean sun. She was soon imitated, first by the court ladies, then by the brides from wealthy city families. It would take another sixty years or so before country brides also began to marry in white. It is true that white, as a symbol of immaculate purity, had found an echo in right-thinking nineteenth-century society. So white replaced green, which for a long time had been used for bridal attire in Provence.

As long as Provençal women remained faithful to their traditional costume, on their wedding day they wore a pretty dress in the latest fashion, often cut in a printed cotton, sometimes in a taffeta or ottoman fabric. Over this gown, they would tie a silk apron and fold a white embroidered muslin shawl, "neatly fastened with four pins," over their prettiest cap; at the waist they would wear a key ring, a silver clasp from which the keys of their new home would soon hang. But when the bride's small feet, sheathed in beautiful knit stockings and wearing *mouro de tenco*—black silk, square-toed ballerina slippers—climbed the stone steps leading to the church, she would lightly raise her gown's hem which, like a theater curtain needed some assistance, revealed the most beautiful decoration of her wedding costume: a white *boutis* petticoat.

A few hours later, on their nuptial bed, another wonder awaited the young couple: a quilt, also in white boutis, undoubtedly the masterpiece of the young bride's trousseau. The *boutis* embroidery was of exquisite quality, and its relief work was so refined that often a solid white fabric was used to enhance its beauty. The lining fabric was stretched over a wood frame, and the fabric that was to be the right side of the quilt was simply laid on top of it. The meticulous decorations were painstakingly transferred to it using perforated tracing paper, then the pattern was covered with fine front stitching and sometimes, on the loveliest of works, also with backstitching.

This done, the relief was created but only where the embroideress thought it necessary. In older quilted work, the decoration always consisted in a network of parallel stitching between which strings made of cotton yarn would be threaded. In Provence, this work is called *vermicelli boutis*. The yarn would be threaded with the help of a *boutis*, a special needle used for this purpose that, in turn gave the name to this type of embroidery. The work was always done on the reverse side of the quilted work by separating the threads of the lining fabric. During the eighteenth century, this cotton-yarn relief was applied to the whole work in an extremely delicate honeycomb pattern. Thus *boutis* embroidery was used to create sumptuous coverlets, elegant petticoats, supple corsets, and the loose jackets known as *caracos*, as well as many layette, or baby garments.

In the nineteenth century, the use of this technique for popular costume was highlighted by all the naïve inventiveness of the embroidering women. Cotton yarn was discarded in favor of cotton wadding, resulting in more volume and a rounder shape. This is undoubtedly the most original contribution Provençal women made to the *matelassé* technique. Thus they created real textile sculptures where the use of white cotton fabric and the depth of the relief decorations allowed the light to play out its role fully.

Although conceivably most quilted articles were made at home by young girls, they were undoubtedly helped in their work by mothers, aunts, and girlfriends, as these masterpieces required considerable labor. However, the nuns of some convents also manufactured very beautiful custom-ordered quilted pieces for wealthy families. It was also possible to purchase custom-made *boutis* petticoats from these convents. This explains why three completely identical wedding petticoats were found in three houses in Saint-Maximin, obviously embroidered by the same hand. These sublime works were reserved for the sacred time of marriage. As an aside, it is amusing to note that the usage of the Provençal word *vano* which means "quilt," has kept its connection to marriage, as evidenced by these two popular expressions: *I' an fa lou lié' mé la vano,* which, alluding to the bride and groom, means "they made a decorated bed for them" and *faire vano* or *se faire vano* which means "to leave the parents' home."

The decorations on these quilt pieces are a true repertory of popular art. The wedding *boutis,* the quilts and petticoats, in most cases made of white percale, were embellished with scrolls, flowers, birds, and familiar symbols patiently embroidered by the young girls. Some works

included intertwined hearts, sometimes pierced by an arrow, two doves symbolizing love, or bowls and vases overflowing with fruits and flowers, symbols of affluence and fertility. Other decorative patterns were the lyre, fountains, windmills, a hunter and his dog, and a shepherdess and her sheep. Sometimes, a monogram or a date would be included in the embroidery.

We could say that *boutis* decorative designs evolved with fashion, following the same trends as other embroidery work: in the eighteenth century, scroll patterns with flowers and birds became popular; during the Empire, laurel garlands made their appearance; at the time of the Restoration it was baskets of flowers, and during the Second Empire, very ornate fruit and flower designs flourished. In this last period, the relief work on the *boutis* became extraordinary. On some works dating to the Second Empire we can see apples and pomegranates wadded with cotton giving them almost the size of a fist, and vine grapes that can only be described as life-size.

With end of the nineteenth century, these techniques went into decline. The introduction of the sewing machine and expanding industrialization, would gradually cause these magnificent works to disappear. At the beginning of the twentieth century there were still some rare quilt makers active in a few villages in Provence, though their work was mediocre. On the beds, the feather duvet replaced the stitched quilt. And since women no longer wore costumes, the stitched petticoats were used as padding for ironing boards or to cover precious tractor engines. Luckily for us, some of these works, some of them the most beautiful of all, were devoutly and miraculously preserved in the deep, dark recesses of large armoires.

*19th-century wedding bedspread, embroidered with* boutis *work.*

## Truffles and Almonds

Have you ever tasted *caillé du berger*—shepherd's curdled milk? Very simply, it is a bowl of lightly salted, curdled sheep's milk into which are dipped pieces of good black bread. The shepherds of the Vaucluse Mountains had a trick for curdling milk: with a knife, they would finely shave a truffle into it. This alone would cause the milk to coagulate. I am persuaded that, even more than the taste, it is the smell of the truffle that bewitches. At first it is disconcerting, then it sets in, and finally it asserts itself and you are lost. Because you will never forget its perfume. You will recognize it among thousands of other scents, wafting from an open window or from the splinters of a wicker basket. Immediately you will be moved, happy, your mouth watering, your eyes sparkling.

It seems there are about thirty varieties of truffle, all of them edible but not all truly delicious. With the exception of the white truffle from Piedmont, exquisite when finely shaved over a dish of pasta, an entirely different experience, I know of only one, the *rabasse* or black truffle, *Tuber melanosporum*, the black pearl of Luberon. It is very black, sometimes very large, with an uneven surface. It has a finely marbled, white and black flesh and gives off an incomparable perfume. Botanists call it the "Périgord truffle," but that label is grossly unfair because this truffle is found just about everywhere, in Spain, the Pyrénées, as well as the Périgord region, Provence, and even Savoy and Italy. However, it seems to be especially plentiful in Provence. It is said that truffles from the Périgord region are the best. So, because Périgord truffles were the most famous, each winter large quantities of truffles would leave Apt or Carpentras to be resold in the Cahors or Périgueux markets under the name of Périgord truffles, sometimes to gastronomists from Marseilles who had had them shipped at great expense!

Truffles grow underground, often at the feet of oak trees, holm oak as well as white oak, and very rarely near other trees. I cannot resist telling you about the prodigious sexual life of the truffle. This unhappy tuber, imprisoned an inch or two beneath the earth's surface, is totally unable to scatter around by herself all her spores, which would allow her to reproduce. She therefore gives off a heavy, heady scent to try to seduce the first wild boar that passes by. And it works. The boar has a highly developed sense of smell and loves truffles. It scrapes the soil and devours the lovely truffle raw, then immediately forgets about her and continues on its path. Later, when the boar relieves itself of its meal, the truffle's tiny spores, carried by rainwater or coprophagous insects, will find a new home. Now the waiting period begins, because for our story to continue, a young oak acorn must fall and sprout next to the truffle's spores. Now the wedding can take place in the secret recesses of the earth. And while the new tree is growing, the mycorrhiza multiply underground, invading its roots and giving rise to strange changes in the surface soil. All plants and herbs that covered the ground waste away and wither. Soon, soil and pebbles appear. The people of Provence say that the tree has a "mark," the sign of its puberty, just like the mark on a girl's trousseau.

*A truffle brouillade is
served in an old Aubagne glazed-clay
salad bowl.*

145

If it rains abundantly in the spring, if a storm rages punctually on August 15th, if the autumn is not unduly dry, there will certainly be truffles in winter. They are gathered in winter, come the first frosts. But, until January 15th, their smell is not especially compelling, they are somewhat light-colored, with white and gray marbling, and most importantly, they do not keep very well. The best truffles are picked between January 15th and February 15th. This is also the time when they are the least expensive.

There are truffles from truffle farms, "cultivated" truffles, and wild truffles that, theoretically, anyone can gather. I say theoretically because it is not that simple. The *rabassiers*, the true connoisseurs, train dogs and pigs for this purpose. This is probably why Saint Anthony the Great, often depicted with a pig at his feet, is the patron saint of truffle seekers. Other seekers use the "fly" method. Armed with a pine branch with only a small clump of needles at its tip, they sweep the bald, burnt spot that signals the presence of truffles under the oak tree, with a slow and gentle motion. In doing so, they upset all the small flies that were peacefully laying eggs. They take flight and land a little farther away. In principle, you will find a truffle underneath the ground where the *rabassière* flies were. You must dig carefully in order to dislodge the black marvel.

There is another beautiful lady that has been ruling Provençal tables from time immemorial: it is all white, once the rich, soft green velvet cloak, then its hard, honey-colored shell, and finally its dusky fustian dress have been removed: it is the almond.

*Calissons, black nougat, white nougat, and orgeat syrup, are some of the marvels indicating the importance of almonds in Provençal sweets* (opposite page).

The almond is white like the cope of the unshod Carmelite nuns it represents on the thirteen-dessert Christmas table. There are sweet almonds and bitter almonds. The sweet almond, of course, is the more widely used, and the best variety is the princess almond. The bitter almond is used in small doses or to extract its essence. However, both kinds are mixed in the thirteen desserts, as if to stress that life is sweet and bitter at the same time. We no longer remember when or how the almond tree, native to the Orient, was introduced to Provence. It is as if it were always here, like the olive tree. It grows everywhere, among the stones of the Crau plain, on the hills of the Alpilles, even on the mountains of upper Provence. At the end of winter, it is the first tree to dress itself in a snow of delicate white and pink flowers.

Aix-en-Provence had become the center of the almond trade by the Middle Ages. The best almonds came from Aix even if they were gathered a bit farther away, all around the Berre wetlands. Aix confectioners were undoubtedly the first to ennoble this fruit by mixing it with candied fruit and making it the basic ingredient of the famous *calissons*, small glazed, oval-shaped, almond-paste sweets made with unleavened bread. Almonds are combined with honey to make black nougat and white nougat. They are mixed with olive oil and anchovies to make an exquisite sauce to spread over grilled bread slices. Pounded and cooked with flour, sugar, and orange water, they become croquants, crunchy almond taffy. Finely crushed with confectioner's sugar and a little egg white, they become almond paste that is colored green, yellow or pink for stuffing walnuts, dates, and prunes.

Finally, almonds have been used since antiquity all around the Mediterranean rim to prepare a delicious syrup, orgeat. It is made with sugar and mostly sweet almonds with a few bitter ones. It was given this name by mistake, because it was confused with another syrup, prepared more to the north with barley, which, like orgeat syrup, clouds the water with a lovely white opallike color.

# Provence, Land of Harmony

*Olive trees are very distinctive, and I am struggling to grasp their uniqueness.*
*They are silver, sometimes more blue, sometimes turning to green, to bronze, to*
*white, on a soil which is in turn yellow, purplish pink or tending to orange, even to a*
*dull, red ocher. But I like it, I like to work with gold and silver...*
—Vincent Van Gogh, Lettrès â Théo

If we look at a Provençal village from afar, it almost seems a monochrome, blending perfectly with the surrounding nature in a soft array of beiges, natural tints, and grays. What a surprise then, in entering the landscape, to discover the varied palette of recent plaster on walls and the fresh paint on shutters and doors! Of course time will leave its mark, shrouding the walls with a soft lichen veil, the rain will wear the painted surfaces down, and the sun will fade them. But as if by magic, daylight is already taming, subduing this violence of color, transfiguring it. Here light, which changes so much according to the season or the time of day, is of such quality that clearly it is the principal artificer of the beauty and harmony that suffuses Provence. How can one therefore be shocked if so many painters have attempted to capture the mysterious alchemy of this light?

In Provence, nature possesses its own colors, which change from month to month according to the seasons, in a succession of small, joyous bands, like so many guests at a feast. Spring is green and pink, with a few touches of white, vermilion, mauve, and purple; summer is white and gold, highlighted by yellow and blue and striped with black; autumn

is red and yellow, again with some traces of green; winter is brown, gray, and blue. How can one escape dreaming of the time when nature, a faultless queen, ruled and humans contented themselves with combing the fields and brightening up the roads with peasant women's petticoats? How can one not dream about those market squares saturated with the colors of a modest people dressed in their Sunday best, like the pretty *santons* of the Christmas crèche? How can one not be moved by the veiled virgins and the bearded saints in their orange, yellow, or green robes, with a halo made of golden paper, safely shielded by their glass enclosure, confidants of a people's sorrows and hopes?

The Greeks came to this land a long time ago, and were the first to bring civilization. Later, the Romans traced the roads, laid down the bridges, dug the canals and built the aqueducts. In the ninth century, the Saracens invaded Provence and settled in the Maures mountains, leaving a few towers and very few relics. However, it is from the end of the Middle Ages, first with the Crusades, later simply in a spirit of adventure and commerce, that Provence opened itself to other cultures, setting up exchanges with the farthest Orient through the Levant seaports, and soon after with the New World as well. Thus indigo and geraniums, cotton fabrics and plane trees, orange and mulberry trees, tomato and madder, and so many other exotic treasures found here a place they would no longer leave. The Provençal people have always possessed the talent of acclimatizing new species, appropriating techniques, integrating new fashions without losing their character, or rather, creating and enriching their own culture with each new encounter.

*The Sault plateau displays*
*all the colors of Provence (page 148).*
*A mas, a traditional farmhouse in*
*upper Provence (left).*
*Gordes, a hilltop town,*
*blends perfectly with the surrounding*
*nature (opposite page).*

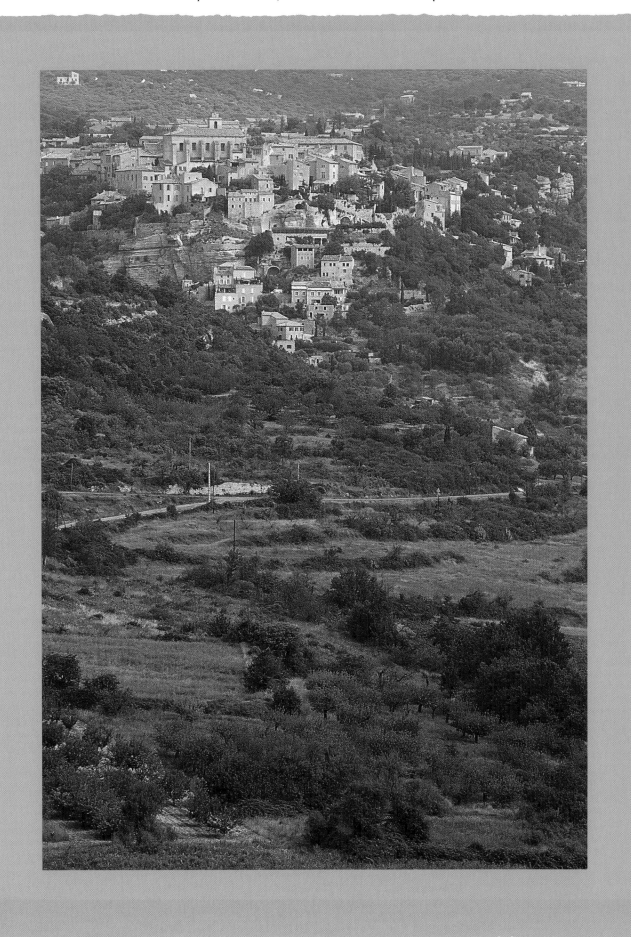

# The Seasons' Colors

Frédéric Mistral, in describing the *mas* in Juge, not far from Saint-Rémy, where he was born, gives a beautiful description of passing time and of eternity: "My parents were *meinagiers*, families that lived off their property, off the labor of their land, from generation to generation! The *meinagiers* in Arles country form a distinct class, a kind of aristocracy that constitutes a transition between peasant and bourgeois and that, like any other class, has its caste pride, for if the peasant who lives in the village farms his small plots of land with his arms, a spade and a hoe, the *meinagier* of the Camargue or Crau farm domains, a large-scale farmer, works while standing and singing a song, with his hand to the plow.... How

blissful was this rustic work! Each season renewed a series of tasks. There was plowing, sowing, sheep shearing, hay mowing, silkworm breeding, wheat harvesting, threshing, grape picking, olive gathering: each of these activities, in my view, expressed the majesty of the farmer's life, forever hard but forever independent and calm. Day after day, all of nature attests to this state of calm. In spite of the wind, sometimes so violent and cold, or the horrible storms that cause river flooding, and in spite of drought that sets in so suddenly, an exceptional sweetness of life, a daily feast, its decorations unceasingly renewed, does pervade Provence.

Winter colors are all porcelain monochromes, in infinite gradations. Light is slanted and pale, lightly dimmed. Bark and stone, normally hidden, display their grays. Pubescent oaks are still covered with dead, almost fossilized leaves, the color of dust. Cypresses and holm oaks are neither green nor black: they are dark, and the olive trees

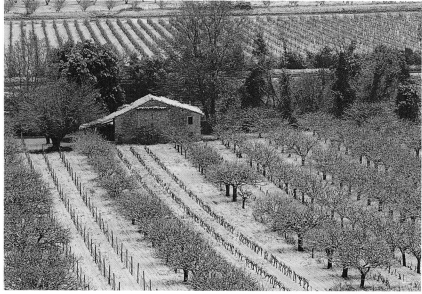

*Plowed land in the Apt plain* (top). *The shape of the houses and the trees, the divisions into fields and orchards are an instantly recognizable Provençal landscape, though it is unusual to see them blanketed with snow* (right).

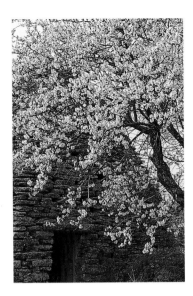

*Delicate almond flowers*
*soften the rough severity of a borie*
*dry-stone wall (left).*
*Fall turns the vineyards in the*
*Luberon hills crimson.*

are grayer than ever. The sky is blue gray, very
clear, the hills only slightly less so. Only the young
tree shoots sometimes punctuate the plain with
their yellow-brown or red-brown colors. Then,
from one day to the next, the plowed land turns
green, a startling, intense green, when the sun
pierces through the young wheat shoots. It's a
green that overtakes all other colors, and all the
surroundings seem bathed in smoke.

One fine morning, the almond trees herald the
arrival of spring, often well ahead of spring itself.
They dress themselves in fragile white or pink
flowers, astonishing in the winter landscape. Some
time later, the slopes dress themselves in purple
irises. The wisteria hangs its blue flower clusters
over iron grills and trellises even before framing it
with leaves. Then everything starts to turn green,
an infinity of fresh, tender, inviting greens.
Springtime has come and the grass is growing fast.
Now is the cherry trees' turn to bloom and their
delicate white is set off by the trunks, sprayed blue
with sulfate. A little farther down, a poppy field is
an explosion of red. A thousand flowers, pink,
mauve, white, blue, yellow, crop up here and there
in almost regular beds, like the printed cottons of
so long ago.

Amid the tall grass, wild oats are the first to
turn yellow, soon followed by wheat and spelt
fields, lakes of liquid gold. The sunflower fields
are bright with a bolder, harsher yellow, and
lavender fields are mad with blue. As harvesting
time ushers in, the light becomes blinding white.
It is summer. Everything is dry and scorched.
Dust thickens the air. The cypresses are tall, erect
rods, black as their shadow. The olive trees quiver
in the wind with all their silvery scales. And the
leaves of the peach tree are already turning yellow,
exhausted by their heavy, golden fruit.

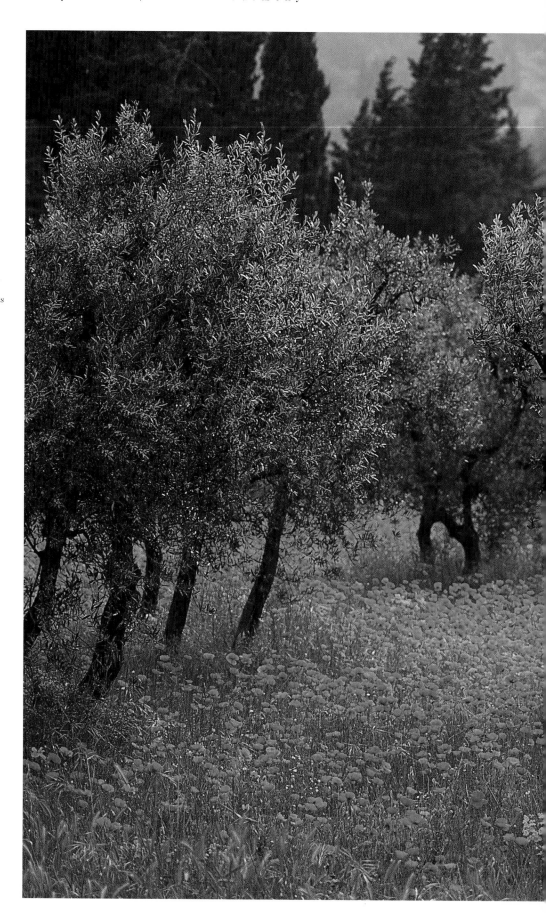

*Poppies bring cheerfulness to the dramatic landscapes of the Alpilles.*

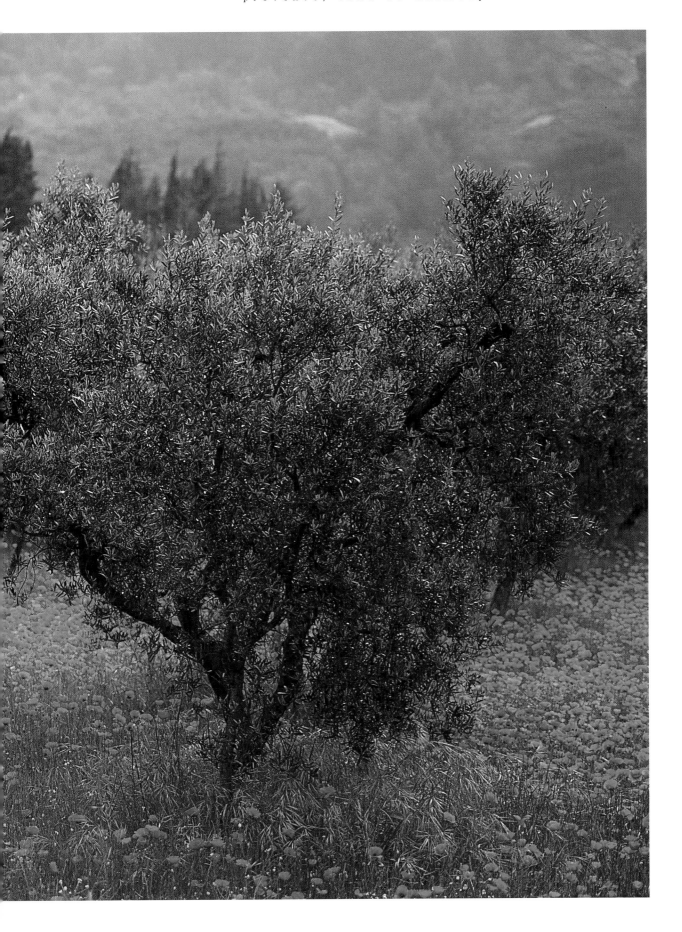

And then fall sets in. The air is limpid again. The rains have washed and refreshed everything. The grass turns somewhat green again at the foot of the trees that turn crimson. All of nature becomes red, almost orange. In the hills, the rose hips hang their red lanterns on the branches for one last party before the long sleep.

Just before falling, the leaves of the linden tree take on for an instant a sublime yellow color, forceful and delicate at the same time. The persimmon trees proudly bear their heavy, golden fruit. And the leaves of the plane tree pile up in heaps, pushed by the wind. The Sorgues smoke, and everything is bathed in mist. In the fields, the big pumpkins seem to have been placed there, in the midst of the shreds of their vegetation. The oak trees, covered with fine down, suddenly dry up and turn beige, after illuminating the forest with their yellow and red leaves. Only the red vineyard leaves will continue for a long time to give some warmth to the landscape before being blown away by the mistral.

## Woven Stripes and Printed Flowers

Having securely mastered techniques that sometimes came from afar, the dyers, weavers, and fabric printers concentrated their craft on the Provençal costumes of all stations. Striped petticoats were worn with loose jackets, and *siamoise* prints were mixed with *indienne* prints. The very names of these types of printed fabrics suggested their faraway origins, the *siamoises* from Siam (now Thailand), the *indiennes* from India, the muslin from Mosul. These exchanges between Europe, Africa, and Asia have always taken place in the Mediterranean. And from the sixteenth century onward, Marseilles had asserted itself as an open port city between France and the Orient. There existed solid commercial ties with the seaports of the Levant and especially Aleppo. Aleppo was a gigantic bazaar at the crossroads of all routes, the largest market in the Ottoman Empire. There, merchants from India, Persia, Armenia, and Tartary met shopkeepers from Venice, Holland, England, and Marseilles. For almost three centuries, the latter would buy or barter French bonnets, paper stock, woollens and hardware in exchange for an incredible variety of white or colored cotton fabrics from India or the East.

Michel Pastoreau, in *L'Etoffe du diable*, recounts that in the Middle Ages stripes symbolized impiety and dishonor. A striped

*This 18th-century block-printed cotton fabric was brush-painted: it was undoubtedly the apron of an Arlesian woman (left).*

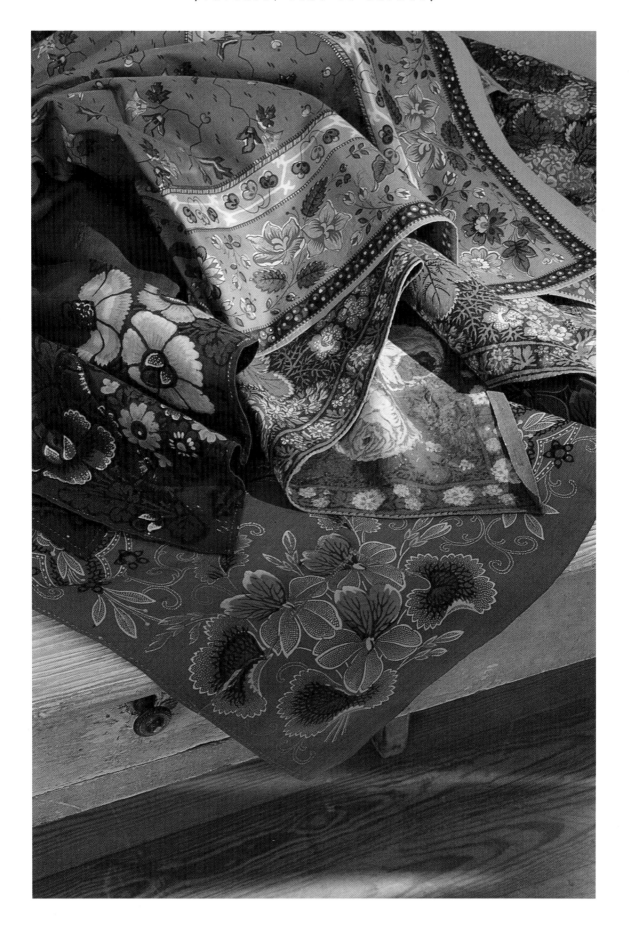

garment identified all those who were deemed to be outside the social order: counterfeiters and criminals, lepers and madmen, knaves, prostitutes, and hangmen, blacksmiths who were thought to be magicians, bloodstained butchers, millers who starved the population, Moslems, Jews, and heretics.

This pejorative connotation given to stripes lasted until about the seventeenth century. At that time, hardwood from West Indies, coffee, tobacco, sugar, and an abundance of fabrics with new patterns and colors would be unloaded almost daily on the docks of the port of Marseilles. In Paris, the fashionable loved Turkish-style objects, and striped textiles were popular because of their exoticism. In 1684, the ambassadors of the king of Siam, traveling to the French court, passed through Marseilles and their striped garments seduced everyone. Thus were Siamese textiles born. At first these materials were woven with a silk warp and a dyed cotton weft, but as they were not very strong, the silk warp was replaced by a warp of non-dyed cotton. At the end of the eigheenth century, France enthusiastically embraced America and its young revolution: "The flag with thirteen red-and-white stripes representing the thirteen American colonies rising against the British Crown appeared as the image of Freedom and the symbol of new ideas.... From then on, everywhere in the Old Continent there was an unfurling of stripes... at the court as well as in the villages, most garment pieces are striped or could be so." Siamese fabrics—linens and dimities striped red and white, blue and white, blue and red, sometimes with three colors, sometimes even in red and yellow or blue and yellow—would henceforth become part of the traditional Provençal peasant costume and would be mostly

*18th-century Provence:*
*a harmonious marriage of indigo*
*and madder root.*

used for work petticoats, which were worn every day until the close of the nineteenth century.

Beginning in the sixteenth century, or about one hundred years before this fashion took the rest of Europe by storm, we find the first traces of multicolored, printed fabrics originating from the Levant and India. These flowered, colored cottons were blue mixed with indigo, colored with all the shades of purple, red, and rose yielded by madder root; the blacks and browns produced by the gallnut; and the yellows obtained from turmeric. They would become so characteristic of Provence that centuries later they would be called exclusively Provençal fabrics—yet they required techniques that were much more advanced than the skills of the Marseilles dyers of the time. Nevertheless, some Marseilles manufacturers had developed a profitable playing card industry. To print the cards on paper, engraved wood blocks or "molds" were used very similar to the blocks used in the East for textile printing. It therefore seemed obvious that similar wood blocks, more adequate for fabric patterns, could be engraved and applied

These stitched bedcovers
illustrate the vast palette of
18th- and 19th-century
Provençal printed cottons.

to the textiles. The real problem consisted in mastering the color dyes.

Seeing the success Oriental textiles met with in Provence, and presaging a new market, master card makers, engravers, and dyers pooled their knowledge and talent to manufacture good-quality printed fabric that would be resistant to water and light. It was in this period that the dyers' daughters were marrying the card makers...but it took more than a century to wrest successfully the secret of colorfastness from the Levantine and Armenian textile manufacturers who traveled to Marseilles, thus allowing Provençal artisans to achieve acceptable results.

During this time, all of Europe became infatuated with lightweight cottons printed in pretty patterns of flowers, fruits, and exotic birds that the Portuguese and Dutch merchants were bringing back from India and the surrounding islands through new sea routes and the Cape of Good Hope. The nobility and the bourgeoisie wore these fabrics and used them to cover their walls and make curtains for their beds and furniture, so much so that the traditional wool and silk industries were endangered. Minister Louvois tried to put a stop to this fashion and in 1686 issued a prohibition against Indian prints and painted textiles. However, Marseilles, a duty-free port since 1669, was able to continue

its production of Indian prints destined partly for local consumption and partly for the colonies. The prohibition, which continued until 1759, failed to discourage the lovers of these fabrics who would obtain them by subterfuge and smuggling, in defiance of the very strict laws. Starting in 1759, however, it was possible to officially set up new factories like the factory at Jouy-en-Josas, which at the end of the eighteenth and the beginning of the nineteenth century was the main supplier to Provence, together with a few Alsatian manufacturers. Every year, therefore, the Beaucaire fair carried enormous quantities of printed cottons, especially intended for the Provençal market: the *indiennes pises* with natural flowers inspired by Indian motifs strewn on a white, yellow or gosling-green background; the *bonnes herbes* with field flowers printed in a busy combination of leaves and grasses on a bronze background; the *ramoneurs* with an even darker background, and the *bâtons rompus* with stylized geometric flowers. Sometimes feathers, monkeys, birds, vases, temples, fountains, or Chinese-style motifs were added to these blooming gardens.

Did the pretty bastidane know, as she went to the market with a large wicker basket under her arm, that her striped Siamese petticoat and her stitched under-petticoat were lined with *chafarcani* from Constantinople, that her loose jacket was of Jouy printed cotton, that the shawl she was wearing pleated on her shoulders had been printed in Mulhouse, and that her bonnet trimmed with Valenciennes lace was covered by a *pletchoun* of muslin from India?

# The Nativity Scene
## Santons

All the colors, the flowery prints on shawls and vests, the striped fabrics of the peasants' skirts, the fruits and vegetables overflowing from wicker baskets carried on the arm or by donkeys on each side; all the flavors, the hunter's game, the baker's hot bread, the *escargots* from the snail seller, the codfish and garlic for *pistachié;* all the costumes from the seashore villages, from Arles and Comtat country; all the trades, the knife grinder and the fishmonger's wife, the mayor and the parish priest, the miller and the country warden, all of society, the country villa residents and the farm servants, the craftsmen and the gypsies, the tambourin players and the *ravi*—in short, all the people that make up traditional Provence are represented, modeled in clay and painted with gouache, around the Holy Family in the Christmas crèche.

The beautiful Provençal harmony is very naturally translated by the skilled paintbrush of the *santonnier:* all that is needed is gouache and a few basic colors. The identical red on the umbrella of Grasset and Grasseto, this couple of country villa residents, all spic-and-span in their Sunday costumes, is found on the miller's *taïolo,* on Margarido's lips, on the fisherman's cap and the mayor's wide bow tie. The same blue is used for the sailor's breeches, the pumpkin seller's tunic, and the country warden's jacket. The miller's smock frock, like his breeches and cap, is white, all powdered with flour. White are the sheep grazing the crèche's moss, and white is the lamb carried on the shepherd's shoulders.

Also white is the *ravi's* shirt, for the enraptured man had no time to dress and raises his arms to the heavens, ecstatic with joy and wonder. Of course, the cassock of the parish priest is black. And black are the large *bérigoule* felt hats worn by some women. Black are the mustache and beards of the chief of the *boumians,* the gypsies.

The other colors, yellow, orange, green, and purple, are distributed in small touches on petticoats, women's jackets, coats, and shawls. However, the rough, merino-wool homespun cape of the Arles shepherd is always brown, and the crib's donkey is always gray.

In the eighteenth century, many churches displayed these Nativity scenes. They represented sacred history characters such as Mary and Joseph, Baby Jesus, the ox and the donkey, the Magi kings, and also the shepherds and their flocks that had followed the star. These statues were always large. They were made of carved wood or of a metal frame with the head and hands in wood. These figures were arrayed in rich garments prepared by the nuns of a nearby convent. Later, the large Nativity scene statues were made with cardboard. There were also extraordinary crèches in spun glass to be displayed in homes where, inside a glass box, all around the crib, a marvelous world of flowers, animals, and waterfalls grew. The Arlaten Museum of Frédéric Mistral has on display a few beautiful examples of this art.

Nevertheless, we had to wait until the Revolution before the people of Provence, now self-conscious, allowed their likenesses to be represented around Baby Jesus, with no exception. Furthermore, the sense of respect and symbolism in the early Provençal crèches was so strong that more often than not, Baby Jesus and the *Boufareu* Angel—the angel that blows, both cheeks puffed, into the trumpet to announce the Good News— were fashioned as divine beings in wax rather than clay like the rest of the characters.

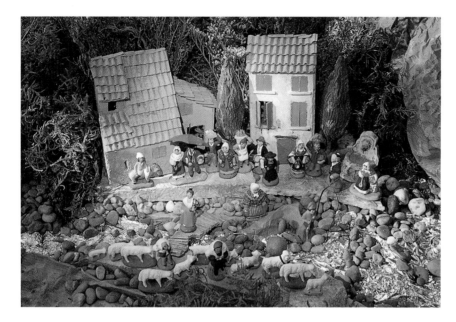

*Two or three painted cardboard houses, a silver paper stream, a bridge made with matches, paper rocks, a few thyme branches, and painted clay figurines constitute the crèche.*

The first *santonnier* to fashion clay figurines in plaster casts was Jean-Louis Lagnel (1764–1822). He was from Marseilles and was first a painter and a faïence maker before becoming an amateur painter, sculptor, and finally a figurine maker. These craftsmen made crèche figurines as well as *santibelli*. First they would model a clay figure, then take a plaster cast of it. The casts would then be used to reproduce countless figurines. For this type of work, a certain type of clay was required, "very pliable (either red or gray, of the kind used for floor tiles, not roof tiles) with enough body so as not to break or adhere too strongly to the worker's hands or to the cast, and sufficiently soft so as to obey the fingers' pressure and penetrate into all the grooves and hollows of the cast." The figures were left to dry before they could be painted. As they were made with unbaked clay, they were fragile. Today's figurines are made of baked clay.

Jean-Louis Lagnel met with immediate success, and many other artists followed in his footsteps, first in Marseilles, later and more modestly in Aix, Aubagne, and Toulon. In any case, Jean-Louis Lagnel's genius is extraordinary because he set down once and for all the rules of this craft, and all that his successors have done is reproduce his first figurines, giving them, of course, their own interpretation. The weaver with the sleeves of her *listo* blouse turned back on her printed *caraco* and a long distaff set into her apron belt; the washerwoman with her basket full of linens; the peasant woman carrying vegetables and protected by a large black felt hat; or a lower middle class couple kneeling in workship, the wife offering a beautiful *pompe à l'huile*—a large Christmas Eve cake shaped like a crown, made with brown sugar and olive oil and flavored with lemon and orange zest—and the husband with two hens in a wicker basket were all created by Lagnel and have been reinterpreted many times, up to our day.

Numerous craftspeople followed in Lagnel's footsteps. Each one depicted with precision and tenderness the Provençal society of his or her time, bearing witness to its evolution by creating new figurines and thus keeping this tradition alive. Although most of these statuettes soon became immutable guardians of this tradition, like Joseph, Mary, and the Magi, the *ravis*, the blind man, the child, the servants, the elderly, the hunter, or the fish vendor, others were forgotten, like Jean-Louis Lagnel's pretty marmot trainer. Dressed in woollen gaiters tied under the knee with a red ribbon, with brown wool breeches, a red vest, and a short, green serge jacket, he carried the small wooden cage in which the animals were kept on his back and had a marmot climb along a stick that he held in front of him. It is a mountain man from Savoy who came down with his friends to hire themselves out for the wheat harvest, grape picking, and olive gathering.

New trades, new costumes, new characters appeared over time. Some are "types" like the tambourin player created by Guichard or the knife grinder created by Simon, or the characters wearing Arlesian costumes that were added to the crèche at the time of Frédéric Mistral. Other characters recall men and women met by the artist one day and immortalized in clay, like the pretty Virginie of Garlaban created by Thérèse Neveu, a bit stooped, grasping in one hand her large blue umbrella and holding two pretty gray rabbits with the other, smiling in her fluted bonnet tied under her chin with a large yellow ribbon.

Since December 4, 1803, every year on the same day, the *santon* fair takes place in Marseilles, not far from the Old Port. Since 1883, it has been held outdoors on the avenues of Meilhan, on top of Canebière. The figurine makers of Provence settled in those streets from the beginning, displaying in their stalls hundreds of small characters in colored clay to astonished eyes.

# The *Santibelli* of Marseilles and Aubagne

I will never forget the image of Saint Blandine in the large catechism book of my childhood. Strapped to a wooden stake, her hands behind her, her blond hair cascading down a long, pale blue tunic, Saint Blandine turns her face to heaven, smiling, her eyes wide open. Lying at her feet, a majestic male lion, dark-maned, looks with tenderness at two sleeping lionesses. A little farther away, strewn in the arena's sand, are arms, legs, and bloody shreds of fabric attesting to the slaughter. An oblique ray of light, piercing the clouds, lights up the scene. On almost all the fireplace mantels in the rooms of the large family houses, there were pairs of oval glass bell jars resting on blackened pearwood stands: they encased curious statuettes of baked clay painted in lively colors, dressed in long, gouache-colored paper cloaks with halos of cutout paper, decorated with garlands and bouquets of small fabric roses, goffered and gilded paper sheets, and fluffy white chicken feathers. Some of these costumes were also flecked with small, scattered mounds of golden sequins. They all had the same smiling face, the same ecstatic eyes. The men were bearded and wise-looking; most of the women were veiled and some were wearing crowns, while others had their long hair loose on their shoulders like the image of Saint Blandine. They would carry in their hands

*Saint Anne and Napoleon,*
*a sultan and his wife, Saint Magdalene,*
*her hair undone, and Saint Michael*
*the Archangel with outstretched wings*
*were all represented as* santibelli
*(opposite page).*

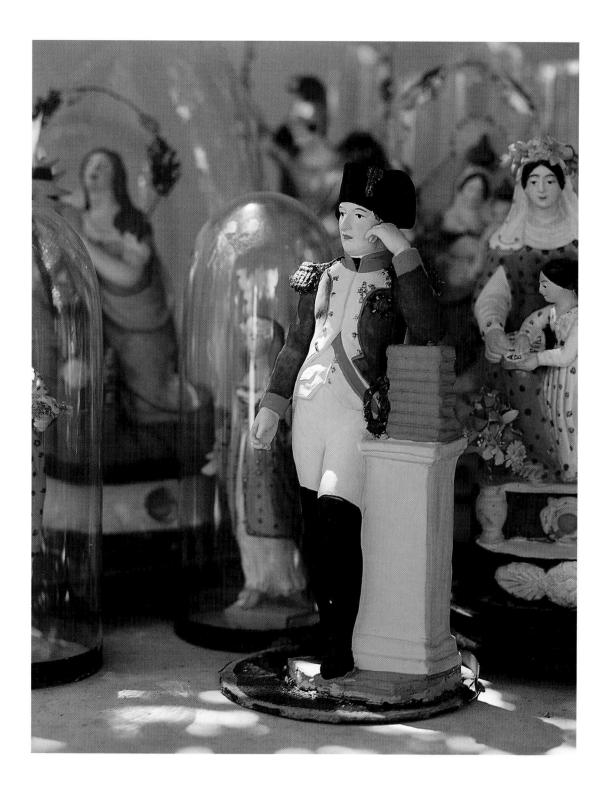

a large palm branch or a cardboard cross. At their feet stood an angel, a rooster, or a pig, sometimes even a strange green dragon with a gaping mouth and what seemed to be the small legs of a child inside. And we were surprised, even a little frightened, when Tante Claire would tell us the ghastly and edifying stories of these unhappy martyrs of the early Christian era. Their shared symbol was the green paper palm branch.

There was Saint Catherine of Alexandria, represented next to a half-wheel, wounded by spears. This unhappy virgin had pledged herself to Christ and refused to marry the Emperor Maximinus. After she sustained and won a disputation with fifty Alexandrine philosophers appointed by the emperor to prove the futility of the Christian faith, she was sentenced to be broken on the wheel. But by a miracle, it was the wheel that broke. So the emperor had the fifty philosophers burned alive and Catherine beheaded. She is the patron saint of young girls, wheelwrights, and of philosophers.

There was Saint Christine of Bolsena, who held the palm in one hand and a gilded arrow in the other. Having refused to sacrifice to Apollo and having shattered the gold and silver idols and offered the pieces to the poor, she was delivered to the executioner. She was whipped, imprisoned, drowned, burned in boiling oil, thrown to snakes, and finally offered to the archers' arrows. The executioner's ax brought an end to this long series of torments. She is the patron saint of archers, millers, and Italian sailors.

There was Saint Marguerite of Antioch, who refused to marry the Roman governor Olibrius because she had taken a vow of chastity. Olibrius had her thrown in jail, where she was set upon by the devil. He transformed himself into a monstrous dragon and devoured her whole. But Marguerite, holding in her hands a small cross, pierced through the dragon's belly and miraculously came out of the beast's entrails unharmed. Olibrius, exasperated by this miracle, then subjected her to so many atrocious tortures that he could not bear to look and shielded his eyes. Finally, Marguerite was beheaded. The saint's painted, baked-clay statuette depicts her holding a cross in her hand, with a rather good-natured dragon lying at her feet.

When, many years later, I combed the flea markets and secondhand stores of Provence, I was delighted to find statuettes enclosed in a globe, similar to those I have described above, and decided to collect them. But it was very difficult to find any kind of documentation on these objects, however plentiful they might be. Ignored, forgotten, despised by the lovers of religious art who undoubtedly found them too kitsch, these objects have not yet received a serious study, although this charming, popular art bears witness to the naïve piety of an entire people. It is mentioned only infrequently in works related to the *santons*, because it seems established by now that it was the same figurine makers from Marseilles and Aubagne who created both *santons* and *santibelli* beginning at the end of the eighteenth century. However, while the *santons*, which are smaller in size (from two-fifths of an inch to about six inches) were generally made of unbaked clay, the *santibelli*, in larger sizes (often one foot high), were usually fashioned with baked clay, which is stronger, although the same casting method was used. And contrary to the *santons* that usually bore marks or signatures identifying their authors, the *santibelli* have no such marks.

Only the shape of the stands, flanked by vases or consoles, and the general features of these statuettes allow us to differentiate them into groups according to different workshops.

From the eighteenth century onward, itinerant sellers from Italy would travel through Provence to sell plaster statuettes depicting various saints, objects of popular devotion. When, in turn, the craftsmen from Marseilles and Aubagne began manufacturing their own saints, made with baked clay instead of plaster, they kept the Italian term of *santibelli*, or beautiful saints. In addition to the unhappy virgin martyrs, these statues represented all the saints worshipped in Provence. The figure most frequently represented was the Virgin Mary —surrounded by angels, carrying Baby Jesus in her arms, or a younger Mary—learning to read next to her mother, Saint Anne. Her husband, Saint Joseph, was also depicted in various fashions. Other saints represented by these statuettes were Saint George, Saint Peter, Saint Paul, Saint Sebastian, Saint John the Baptist, Saint Louis, Saint Theresa, Saint Mary Magdalene, and so many more. They are recognizable only by the symbols that are attributed to them, so that Saint Peter is flanked by a rooster and holds a golden key in his hand. Saint Martha of the *tarasque*, often confused with Saint Margaret of Antioch, holds no cross in her hands; however, the medieval monster *tarasque* is devouring a child at her feet.

Undoubtedly because they were the objects of the same type of worship, some historic lay figures such as Voltaire and Diderot or General Bonaparte, who later became Emperor Napoleon I, his arm resting on the volumes of his Civil Code, were also inducted into the large *santibelli* family. There were also other statuettes made with an identical technique but for decorative purposes only, that represented shepherds and shepherdesses, a turbaned Turk smoking a pipe, and even Diana the huntress dressed in a Greco-Roman tunic.

Finally, some individuals from the more modest classes of Provençal society, who were included in the Nativity scene as *santons*, were also represented in a *santibelli* version: hunters, gardeners, and apple vendors wearing late-eighteenth-century Provençal costumes are fashioned in great detail thanks to the larger statue size.

*Santons* and *santibelli* depict, on one hand, the people of Provence gathered around the Holy Family, and on the other hand, all the saints honored by nineteenth-century popular devotion. But unlike the *santons* that more often than not were painted in bright, primary colors, the *santibelli* received a very different palette of colors. Strangely, orange and yellow contrasted with a pale emerald green are the more frequent colors: often in combination, these are found on many statuettes. The architectural stands, recalling those of ancient reliquaries, are always in rich polychromes. Finally, it seems that in these colors there is always a small amount of white, as if, whether consciously or not, the statuette makers had added to the color the powerful symbol of light that the color white represents. For the same symbolical reason, the *santibelli* representing Saint Mary, Saint Joseph, or Jesus, and some protagonists of sacred history such as the Archangel Michael, or Saint John the Baptist, were completely gilded except for the face and the hands, because gold is, above all, light.

*This detail from a stitched bedcover shows the exuberance of 19th-century printed fabric decorations (page 166).*

# Color Index

# Useful Addresses for the Colors of Provence

The following is not meant to be a complete, detailed guide to all the useful Provence addresses, as each village has color surprises. Rather, I wish to lead you into the stores where I love to spend time, the restaurants where I feel at home, and the hotels where I send my friends. You will find in the following addresses everything, all mixed together, that made the illustrations in this book possible.

**Jean-Claude Appy**
**Tree Nursery**
Route de Joucas
Roussillon
Tel. 90 05 62 94
From a small pot of flowering thyme to a stately, centuries-old olive tree, gray or green santonicas, round-shaped boxwood, and wisteria.

**Patrice Arnoud**
**Interior Decorator**
Mas Piédache
Oppède
Tel. 90 76 99 08
A color magician, from the first concept to the perfect achievement of color dressing for your home.

**Association Rouge et Jaune**
124, rue Consolat
Marseilles

Tel. 91 08 59 99
This association organizes magnificent expositions of traditional costumes and fabrics throughout Provence.

**Baldacchino**
**Butcher Shop and**
**Delicatessen**
9, rue de la République
L'Isle-sur-la-Sorgue
Tel. 90 38 00 04
Alain Baldacchino makes, among the many marvels of his cuisine, the best *caillettes au vert* of the whole region; you can devour them with your eyes on page 85.

**La Maison Biehn**
7, avenue des Quatre-Otages
L'Isle-sur-la-Sorgue
Tel. 90 20 89 04
Renowned for its old *boutis* and fabrics. Everything that makes up the charm and color of Provençal tradition can be found here: ocher powders, lavender spindles, waste silk fabrics, glazed pottery, Marseilles, soap and green tomato preserves.

**Brocante 11**
**Antiques**
11, avenue des Quatre-Otages
L'Isle-sur-la-Sorgue
Tel. 90 38 21 02
In this tiny shop Philippe and

Marlise de Font-Réaulx have collected a great number of strange, charming, and witty objects.

**Yves Boussin**
**Antiques**
7, avenue des Quatre-Otages
L'Isle aux Brocantes
L'Isle-sur-la-Sorgue
Tel. 90 20 69 93
All the yellows and greens of the glazed potteries from Provence and Languedoc.

**Danièle Capia-Taillant**
**Antiques**
7, avenue des Quatre-Otages
L'Isle aux Brocantes
L'Isle-sur-la-Sorgue
Tel. 90 20 69 93
Provençal furniture, glazed pottery and *santibelli*, as well as beautifully restored rush-bottomed benches.

**Ateliers Carbonel**
*Santon* **Maker**
47, rue Neuve-Sainte-Catherine
Marseilles
Tel. 91 54 26 58
All kinds of pretty hand painted, clay Nativity figurines.

**Bruno Carles**
**Centaure Antiques**
209-235, avenue du

Maréchal-de-Lattre-de-
Tassigny
Lunel
Tel. 67 71 36 10
Everything that used to
decorate the attractive
*bastides*, from Anduze
orange-tree urns to
stupendous rush-bottomed
benches and *radassiers*.

## Le Carré d'Herbes
**Restaurant**
13, avenue des Quatre-Otages
Le Carré de L'Isle
L'Isle-sur-la-Sorgue
Tel. 90 38 62 95
A pretty, ocher-red restaurant
in the heart of the
secondhand-store district, it
offers seasonal cuisine and an
arbor where you may enjoy a
light meal of tasty appetizers.

## Jean Chabaud
**Antiques—Old Materials**
ZI, route de Gargas
Apt
Tel. 90 74 07 61
Roof and floor tiles and
freestone with which to
restore your Provence home.

## Château de Roussan
**Hôtel**
Route de Tarascon
Saint-Rémy-de-Provence
Tel. 90 92 77 63
A wide tree-lined lane *(see
page 97)* and a lovely garden
provide coolness to this
timeless *bastide*.

## Bertrand Colombier &
## Bruno Dion
**Antiques**
7, avenue des Quatre-Otages
L'Isle aux Brocantes

L'Isle-sur-la-Sorgue
Tel. 90 20 69 93
Cheerful orange ceramics and
striped fabrics from 1950s
Provence.

## Les Délices du Luberon
**Provençal Sauces**
Avenue du 8-Mai
L'Isle-sur-la-Sorgue
Tel. 90 38 45 96
A family-run kitchen that
turns out *tapenade*, the
delicious black or green olive
purée that goes so well with
before-dinner drinks; also
unforgettable is the *pistou*
sauce for fresh pasta.

## Maison F. Dervieux
**Antiques**
5, rue Vernon
Arles
Tel. 90 96 02 39
All the lovely polished walnut
furniture, the *buffets à
glissants* and the large
armoires chock-full of old
linens and *boutis*.

## Château de Brantes
Route de Vedène
Sorgues
Tel. 90 39 23 36
This beautiful *bastide* garden,
close to Avignon, opens its
gates to visitors on weekends
*(see pages 98–99)*.

## Librairie Dumas
16, rue des Marchands
Apt
Tel. 90 74 23 81
Simply the best bookstore in
the region; here you will find
the most interesting works
written about Provence.

## Bernard Durand
**Antiques**
7, avenue des Quatre-Otages
L'Isle aux Brocantes
L'Isle-sur-la-Sorgue
Tel. 90 20 69 93
For the sky blue, coral-rose,
gray, and gold of 18th-century
Provence. Small furniture and
objects display their charm in
a natural-wood-paneled,
natural-colored linen store.

## Marius Fabre
**Soap Maker**
148, avenue de Grans
Salon-de-Provence
Tel. 90 53 24 77
Since 1900 it has been
making the celebrated
Marseilles soap following
genuine traditional methods.
Santon Fair
Every year, starting
December 4 in Marseilles, on
top of La Canebière, in Aix,
or in Aubagne *(see page 162)*.

## Fornaroli
**Caterer**
1, rue de la République
L'Isle-sur-la-Sorgue
Tel. 90 38 19 75
The delicious, traditional
multi-colored *crespeou* is a
must. It's an omelet-based
torte to be eaten cold with a
tomato purée.

## Le Fournil
**Restaurant**
Place Carnot
Bonnieux
Tel. 90 75 83 62
An inviting place where the
colorful cuisine is seductive in
its tasty simplicity.

**Grand Hôtel Nord Pinus**
Place du Forum
Arles
Tel. 90 93 44 44
Mythical place of bullfighting
lore, redone with cheerfulness
and color by Anne Igou, the
animator of this unusual
hotel, on one of the town's
prettiest squares.

**Le Grand Magasin**
24, rue de la Commune
Saint-Rémy-de-Provence
Tel. 90 92 18 79
Today's Provence and an
array of objects, lamps,
tableware, and jewels chosen
with talent, humor, and
feeling by Francis Braun.

**Hostellerie
de Crillon-le-Brave**
Place de l'Église
Crillon-le-Brave
Tel. 90 65 61 61
This hotel encompasses
several village houses
snuggled around the church.
The view is divine, the
surroundings calm and
luxurious.

**Le Jardin des Lavandes**
Hamlet of Verdolier
Sault
Tel. 90 64 14 97
Open in July and August. In
this lavender botanical
garden, you may enjoy the
infinite palette of lavender
colors and buy lavender and
all other officinal plants.

**Kayak Vert**
Fontaine-de-Vaucluse
Tel. 90 20 35 44
For those who may wish to

canoe down the Sorgue, the
best way to enjoy the beauty
of this limpid river, which has
its source at Fontaine-de-
Vaucluse.

**Lilamand
Confectioner**
Route d'Avignon
Saint-Rémy-de-Provence
Tel. 90 92 11 08
For the lovely preserved fruits
made by this family business
using traditional, old-
fashioned methods.

**Luberon Investissement**
Quartier La Combe
Gordes
Tel. 90 72 07 55
The perfect guide to put you
on the roads of Provence in
search of a corner of paradise.

**Maison Garance
Guest House**
Hamlet of Bassacs
Saint-Saturnin-les-Apt
Tel. 90 05 74 61
A happy guest house all
colors, smiles, and food-loving
pleasures.

**Maison Louis Sicard-Amy**
2, boulevard Emile-Combes
Aubagne
Tel. 42 70 12 92
The famous maker of faïence
cicadas is still producing
traditional yellow tableware
decorated with hawthorne
fruits.

**Coustellet Farmer's Market**
Every Sunday morning, from
April to November.
One of the prettiest vegetable
and fruit markets in

Provence, where you will find
several nursery stalls and
Popo's delightful dried-flower
arrangements.

**Le Mas Tourteron
Restaurant**
Les Imberts
Quartier Saint-Blaise
Gordes
Tel. 90 72 00 16
In the prettiest of gardens,
Elisabeth Bourgeois
entertains her guests and
makes the colors and flavors
of this country sing.

**Usine Mathieu
Applied Ocher and Pigment
Repository**
OKHRA Association
Route d'Apt, D 104
Roussillon
Tel. 90 05 66 69
A former ocher mill where
visitors can be initiated into
the world of pigments. The
repository has many visitors
all year round and organizes
practical summer workshops
that teach all the coloring and
plastering techniques (see
pages 56 and 57).

**Edith Mézard
Embroidery Workshop**
Château de l'Ange
Lumières
Tel. 90 72 36 41
On the grounds of the castle
(see page 17), Edith Mézard
displays all the beautiful
house linens in cotton, hemp,
and linen.

**Musée de Château-Gombert**
5 place des Héros
Marseilles

Tel. 91 68 14 38
The museum houses a rich collection of *santons* and *santibelli* and Provençal customs and furniture. Not to be missed.

## Musée du Vieux Nîmes

Place aux Herbes
N"mes
Tel. 66 36 00 64
This is the museum for indigo, blue-dyed textiles, cashmere shawls, Languedoc earthenware—all the objects of daily life—in this town located at the entryway of Provence *(see pages 24 and 108)*.

## Museon Arlaten

Rue de la République
Arles
Tel. 90 96 08 23
Established by Frédéric Mistral, this museum gives a passionate account of Provençal traditions and displays objects, tools, and fabrics that are very rare today, especially some superb spun-glass Nativity scenes and an astonishing collection of popular magic objects *(see page 160)*.

## Objets de Hasard

Antiques
13, avenue des Quatre-Otages
Le Carré de l'Isle
L'Isle-sur-la-Sorgue
Tel. 90 38 54 58
It's like a pirate's treasure trove or an ancient drug store, a bric-â-brac shop, or a dictionary of symbols. In brief, it's magic.

## L'Oustau de Nadine

Fruits and Vegetables
Place du Château
Gordes
Tel. 90 72 09 47
Shelves of small wooden crates overflowing with the most beautiful fruits and vegetables of the surrounding area, one of the more interesting and unusual sights in the village of Gordes.

## Bernard Paul

Antiques — Interior Architecture
Rue de la République
Eygalières
Tel. 90 95 92 38
Combining wide knowledge and incomparable charm, Bernard Paul will help you find the perfect combination of colors, materials, and proportions.

## Musée Charles-Demery

39, rue Proudhon
Tarascon
Tel. 90 91 08 80
This museum, established in memory of the founder of Maison Souleiado, the incomparable colorist of Provençal fabrics *(see pages 6 and 7)*, houses a remarkable collection of *santibelli*, textile historical records, costumes, *boutis*, and stitched bedcovers.

## Sous l'Olivier

Fine Groceries
16, rue de la République
L'Isle-sur-la-Sorgue
Tel. 90 20 68 90
For olive oil and *épeautre*, whole-pistil saffron, traditionally made *pastis*, rose

hip preserves, and the best *tapenades*.

## Terre d'Oc

10, rue Grande
Forcalquier
Tel. 92 75 44 63
A box full of pigments and ochers is on sale in all the Nature et Découvertes shops (for points-of-sale list, telephone [1] 39 56 01 47), designed to introduce all lovers of Provence to decorative painting.

## La Terre Salée

Inn Dining Room
Quartier Pont-Blanc
Les Saintes-Maries-de-la-Mer
Tel. 90 97 72 15
By the salt ponds, Mimi Desana celebrates Camargue with a generous, amazing, brave cuisine that has the greatest respect for tradition.

## Vernin

Carreaux d'Apt
Route nationale 100
Bonnieux
Tel. 90 04 63 04
One hundred and sixty colors for handmade and hand-enameled tiles.

# Photography Credits

The photographs in this work are by Heinz Angermayr, with the exception of those of the following photographers, all residents of Provence, who devoted long hours to photograph it in all its colors.
In alphabetical order:
Giles Abbeg/Terre d'Oc, p. 16 *(left, top and bottom)*, 56 *(top)*; J.-M. Blaché-Mission/Ernoult Seatures, p. 148; François-Xavier Emery, p. 149; Philippe Giraud/Terres du Sud, p. 10, 11 *(top)*, 12–13, 36, 61, 116 *(top)*, 136 *(left)*, 152 *(bottom)*; Vincent Motte, p. 15, 97, 98–99, 121, 153 *(left)*; Hans Silvester/Rapho, p. 21 *(top)*; Gérard Sioën/Rapho, p. 11 *(bottom)*, 18, 33 *(top and bottom)*, 62–63, 117, 154–155; Marc Walter, p. 1; Dominique Zintzmeyer, p. 20 *(top)*, 22, 31, 92 *(top)*, 102, 116 *(bottom)*, 122–123, 128 *(left)*, 129 *(bottom)*, 150.

*photo caption, page 2*

*Indigo-dyed loto cards.*
*Loto has been a very popular*
*game in Provence*
*for a long time.*

# Bibliography
## Works quoted by the author

Bec, Serge, *Fêtes de Provence*, Edisud.

Benoit, Fernand, *La Provence et le Comtat Venaissin*, Aubanel.

Biehn, Michel, *En jupon piqué et robe d'indienne*, Jeanne Laffitte.

—, *Le Cahier de recettes provençales*, Flammarion.

Boulard, Michel, "Biologie et comportement des cigales de France," in *Insectes*, No. 69.

Bredif, Josef, *Relations commerciales entre la manufacture Oberkampf de Jouy-en-Josas et la Provence*, CEITA, Bulletin No. 65.

Charles-Roux, Jules, *Le Costume en Provence*, Marcel Petit editor.

Chevalier, J., and A. Gheerbrant, *Dictionnaire des symboles*, Editions Robert Laffont.

CNAC, *L'Inventaire du patrimoine culinaire de la France: Provence, Alpes, Côte d'Azur.*

Deguillaume, Marie-Pierre, *Secrets d'impression*, coll. Les Carnets du textile, Editions Syros.

Demery, Jean-Pierre, and Philippe Renaud, *Santibelli*, exposition catalog, Michel Aveline editor.

Dumas, Marc, *Les Faïences d'Apt et du Castellet*, Edisud.

Fontan, Pierre, *La Crèche provençale*, Toulon, J. Labrosse editor.

François, André, *Santoun*, Serg/Berger-Levrault.

Galtier, Charles, and Jean-Maurice

Rouquette, *La Provence et Frédéric Mistral au Museon Arlaten*, Joël Cuénot editor.

Garcia, Michel, and Marie-France Delarozière, *De la garance au pastel*, Edisud-Nature.

Grosso, René, *Paysans de Provence*, Coll. Paysans de France, Editions Horvath.

Guerre, Gérard, and Vincent, *Les Arts décoratifs en Provence du XVIIII^e au XIX^e siècle*, Edisud.

Itten, Johannes, *L'Art de la couleur*, Dessain et Tolra.

Jacqué, Jacqueline, *Andrinople, le rouge magnifique*, Editions de la Martinière.

Joannis, Claudette, *Bijoux des régions de France*, Flammarion.

Jones, Louisa, and Vincent Motte, *Splendeur des jardins de Provence*, Flammarion.

Lambergeon, Solange, *Un amour de Sade, la Provence*, Avignon, Editions A. Barthélemy.

Lefort, Jean-François, *Les Paperoles des carmélites*, Editions Jeanne Laffitte.

Lenclos, Jean-Philippe, and Dominique *Les Couleurs de la France*, Editions du Moniteur.

Massot, Jean-Luc, *Maisons rurales et Vie paysanne en Provence*, Serg/Berger-Levrault.

Mihière, Gilles, *Les Bastides marseillaises*, Jeanne Laffitte.

Millin, A.-L. (cité par Régis Bertrand), *Crèches et santons de*

Provence, Editions A. Barthélemy. Frédéric MISTRAL, *Lou Tresor dou felibrige*, exposition catalog.

*Peintres de la couleur en Provence*, Meeting of national museums.

Musées de Marseille, *Sublime Indigo*, exposition catalog, Office du Livre.

Musée du Vieux Nîmes, *Bleu de Nîmes, Jeans denim, le bleu populaire*, exposition catalog, Electa Edition.

*Ocres*, Coll. Images et Signes, Edisud.

Pascal, Odile and Magali *Histoire du costume d'Arles*.

Pastoureau, Michel, *Couleurs, images, symboles*, Le Léopard d'or.

—, *L'Etoffe du diable*, Librairie du XX^e siècle, Le Seuil.

Rocchia, Jean-Marie, *Des truffes en général et de la rabasse en particulier*, coll. Du goût et de l'usage, Editions A. Barthélemy.

Roux, Annie, *Le Textile en Provence*, Edisud.

Roze, Suzy, and Marie-Noëlle Cavasse, *Or, oranges, orangeries*, Ipomée/Albin Michel.

Toussaint-Samat, Maguelonne, *Douceurs de Provence*, Coll. Du goût et de l'usage, Editions A. Barthélemy.

Valade, Daniel, and Marcel Pol, *Un siècle d'avenir en Camargue, La Manade Laurent*, E.N.D., Nîmes.

Verdier, Yvonne, *Façons de dire, façons de faire*, Gallimard.

173

# Table of Contents

# Table of Recipes

# Acknowledgments

Four years ago, Nicky Chavaux led me on the tracks of this book and guided my first steps. She finds here the expression of my deepest gratitude.

My friends Pierre Bergé, Robert Merloz, Jasmine Thollon, Vladimir Bellot, Bernard Paul, Jacques and Martine Machurot, Bruno Carles, Lionel Guibal, Jacques Lebrun, Bernard Durand, Patrice Arnoud, Jacques Le Roy, Mrs. Walther-Duck, Danièle Capia-Taillant, Edith Mézard, Martine Nougarède, Puce and Dan, Yves Boussin, Thierry Guien, Jean-Pierre Demery, Lillian Williams, Serge Liagre, Patricia Pepino, Aline Vidal, Maison Garance, and Michel and Nicky Chavaux all opened the doors of their homes, their gardens, and their collections so that we could take the photographs in this book, and I thank them.

My thanks to Henri and Annie Laurent, who were my teachers in *bouvine* matters; Thierry Guien, who taught me *palangrotte* fishing; Philippe de Font-Réaulx, who told me the tale of the preserved fruits and the Marquis de Sade; Magali Pascal; Jacques Chiffoleau, curator of the Papal Palace; Mathieu and Barbara Barrois; and Marcel Dérosier for their precious advice.

Finally, I wish to thank Heinz Angermayr with whom for over a year I walked the paths of Provence and who captured with his lens the lovely images in this book.

Also, without Gisou Bavoillot holding the reins, or Marc Walter organizing the dream, this book would have never been born.

To all, thank you.

The publisher wishes to thank all the Provence photographers who consented to be part of this work, in particular Vincent Motte (in Monteux), Dominique Zintzmeyer (in Villeneuve-Loubet), Philippe Giraud (in Venasque), as well all those who made possible our discovery of the infinitely riche ocher ores: Mathieu Barrois (Usine Mathieu), André Guigou (Sociéte des ocres de France in Apt), Gilles Abbeg and Valérie Roubaud (Terre d'Oc, in Forcalquier), Emmanuelle Carraud (in Mazan), Anouk Lautier (Sud Restauration), the Lorenzi workshop who kindly tinted the plaster cicadas of the Sedap Company with their ochers, and Corine Russo of the Cavaillon Tourist Office. The publisher also extends his thanks to the whole team that concurred in the making of this book: Marc Walter, Olivier Canaveso, Margarita Mariano, Sophie Pujols, Murielle Vaux, Véronique Manssy, Anne-Laure Mojaïsky, Anne-Stéphanie Trollé, Katia Bourdelet, Marilyne Willaert, Pascaline Sala, Mariane Perdu, and Florence Boury.